PICASSO'S BRAIN

PICASSO'S BRAIN

CHRISTINE TEMPLE

ROBINSON

ROBINSON

First published in Great Britain in 2016 by Robinson

Text copyright © Christine Temple, 2016

1 3 5 7 9 8 6 4 2

A CIP catalogue record for this book
is available from the British Library.

ISBN: 978-1-78033-428-8 (paperback)

Typeset in Adobe Jenson Pro by SX Composing DTP, Rayleigh, Essex
Printed and bound in Great Britain by
CPI Group (UK) Ltd, Croydon CR0 4YY

Papers used by Robinson are from well-managed forests and
other responsible sources

MIX
Paper from
responsible sources
FSC® C104740

Robinson
is an imprint of
Little, Brown Book Group
Carmelite House
50 Victoria Embankment
London EC4Y 0DZ

An Hachette UK Company
www.hachette.co.uk

www.littlebrown.co.uk

Contents

Introduction by
Frederick Mulder CBE

I first met Christine Temple in early 2010 when I was presenting a Picasso linocut to Linacre College, Oxford in honour of the retiring Principal, Professor Paul Slack. Christine and I had both studied at Linacre, but at different times.

After my talk I was approached by a striking, fine-featured woman with a recognizably Scottish accent and a charming but no-nonsense manner. It was Christine. 'I'm interested in seeing your Picassos,' she announced. I mentioned the fact that as an art dealer I would be exhibiting at the London Original Print Fair at the Royal Academy in a few months' time. 'Oh, but I don't want to wait that long,' she responded. We made an appointment for a couple of weeks hence; Christine came by, we looked at prints, talked Picasso, and became friends. She was curious, vivacious, argumentative, and intensely involved in whatever interested her.

On her second visit she bought a Picasso etching from his famous Vollard Suite from me, and also walked away with several books which I loaned her from my Picasso library. On

her next visit she announced that she wanted to do a book about Picasso's brain, and asked would I help her, please?

Christine loved art, architecture, music, any product of human creativity. As a neuropsychologist she was fascinated by how brain structure and brain chemistry were involved in the kind of creativity that Picasso showed so clearly. She had been Founding Professor (at 33 the youngest-ever holder of a UK Chair in Psychology) and first Head of the Department of Psychology at Essex University. She had been instrumental in the emergence of the field of developmental cognitive neuropsychology, had published widely, and had written a well-received book, *The Brain*. She had also recently stepped down as a pro-vice-chancellor of Essex University, and had 18 months sabbatical.

Christine had always written about cognitive impairments (one could say about how the brain does things badly), and found the idea of writing a book about creative genius (how the brain does things exceptionally well) an attractive one. Who better than Picasso, creative genius personified, to use as a subject? She also liked the fact that I was a Picasso expert, that I had access to the Picasso family, and that she would be able to use a decent Picasso library (mine), which I was only too happy to share with her.

Picasso as a subject offered another advantage: his offspring were still alive, his DNA pool still accessible. I offered her an introduction to one of Picasso's grandchildren.

'Not enough of Picasso's genetic material,' she said. 'What about one of the children? Preferably a male child.'

'There is only one,' I replied, 'Claude [Picasso's son by Françoise Gilot]. I know him but not well – shall I ask if he would meet with you?'

'Would he be willing to sit for a battery of tests?' she asked.

'Unlikely,' I answered. 'He is in charge of the Picasso Administration and has the responsibility of authenticating Picassos from all around the world.' We put an introduction to the Picasso family on hold, but we continued to talk about the book at our frequent meetings.

Fast forward to October 2014; the month Christine died of cancer. She was 56. Having survived one bout of serious cancer in 2012 she developed another, completely unrelated, kind, to which she succumbed in the space of less than a year. In the meantime, she concentrated on making provision for her two teenage sons. She longed to do a further edit of the book before submitting it to her publisher but couldn't summon the energy. I trust the careful reader will therefore forgive some flaws in the book that Christine herself would have dealt with had she been able to do so.

My last visit with Christine was not about the book or indeed about Picasso, but involved a visit to the Matisse Cut-Out show at Tate Modern in London, which I longed to view with her (and she longed to see), though she was already very frail. I sent a car to her home in Wivenhoe in Essex to bring her to the Tate, where we had lunch, and where I then wheeled her round the show in a wheelchair. 'Further forward, further back!' she would direct as we went round the cut-outs, as if born to this situation, appreciative of the ride but occasionally critical of its execution. We talked about what a wonderful show it was. 'There won't be another Matisse show like this in my lifetime,' she said, then suddenly realised it wasn't much of a prediction and laughed grimly. But her

spontaneous response to the show had said everything about her considerable taste for life and that she couldn't quite take it in that she wouldn't still be around for a good long time.

I think of *Picasso's Brain* as her legacy.

Genes for Genius and Picasso at Play

'It took me four years to paint like Raphael, but a lifetime to paint like a child.'[1]

Picasso

In the dusty, sanded paths of the square Plaza de la Merced, where Picasso lived as a child in Barcelona, he played games with the other local children, tracing arabesques, Moorish decorative patterns, with a stick. The game involved starting at any point and coming back to the beginning without lifting the stick.[2] He also learnt how to start a picture of an animal at any point and then draw the animal with a single line. Later, in his ink drawings, these animals look a bit like cartoons, with a simple flowing line. Like cartoons, they are astute and perceptive in capturing the key features that make an animal recognisable, but unlike cartoons, Picasso's creatures are woven from a single line of uninterrupted ink. It is like the difference between peeling an apple in strips and peeling an apple in one unbroken strip that simultaneously forms a perfect structure.

But drawings in the sand do not make a genius. If Picasso was a genius, would it be evident right from the start or does genius emerge over time? Picasso's mother, María Picasso

López, said that Picasso could draw before he could speak, and paint before he could read. At first this seems an extraordinary claim, demonstrating something exceptional, but in reality children differ widely in their milestones and some are late to speak and early to scribble, without it being of great significance later. As for painting before reading, Picasso had no great affinity with reading,[3] with the evidence pointing to dyslexia. Certainly, Picasso was late to read, and so the emergence of earlier painting is not quite the achievement it first seems.

Picasso did show considerable early talent in art but he exaggerated his childhood prowess in light-hearted banter. At an exhibition of children's drawings he commented, 'It took me four years to paint like Raphael, but a lifetime to paint like a child.'[4]

How early can genius express itself? Is it reasonable to expect it to be conspicuous in the first few years? At my first school, I had a brilliant friend. Hannah stood out from the crowd right from the start. I remember one occasion in particular from when I was just five. It was at a parents' meeting, and my mother was looking at the display of my class's artwork. There among the childish renditions of boats, houses and animals was Hannah's picture . . . of Marie Curie discovering radium!

Hannah was not a brilliant artist but she was a big thinker. In one of the first conversations that I remember with her, we were standing at the low-level wash-basins at school. Side by side, washing our hands, we both looked into the mirror. Aged around five or six, I had long blonde hair that fell in ringlets to my waist and big blue eyes, a look that by adult standards of the time was 'sweet'. 'You are prettier than me,' Hannah declared in a matter-of-fact style, and then added reflectively, 'but at

least I will not have to watch my looks fade away with age.' In practice, of course, appearances at this age are no great guide to adulthood, so Hannah's assumption was conjecture, but her projection of deterioration and decline with age demonstrated a depth of thinking that is unusual for a young child. She was thinking not simply about what it would be like to grow up but also about the feelings and experiences of growing older. Nowadays, as I see my face becoming lined, I reflect ruefully on Hannah's early perceptions about 'fading'.

So what happened to Hannah? Did the brilliant child become a brilliant adult or did she falter? And was her talent specific? Did the big-thinking child become a big-thinking adult? Well rather amazingly, yes, she did. Hannah, a fabulous and big thinker in early childhood, is still a fabulous and big thinker in adulthood. She is now a professor of philosophy at a leading university in the USA. The seeds of her later accomplishments were expressed early, which brings us to the broader issue of prodigies.

PICASSO THE PRODIGY

There are no surviving infant drawings by Picasso, so we can only speculate about the quality of his artwork as a very young child. We do not actually know whether in his first years he would have been able to draw a spectacular boat or house or perhaps even a realistic person. One surviving line drawing is of a statue of Hercules drawn when Picasso was nine years old. Picasso himself described it as having been done at the age of six, which would have been impressive, but for a nine-year-old it is very good but not brilliant. John Richardson,[5] Picasso's most detailed biographer, describes it as simply what one would

expect of a gifted child, 'gifted' indicating above-average ability for his age but not genius. Professor Neil Cox of the University of Edinburgh agrees that Picasso 'was an able but not dazzlingly talented child artist'.[6]

More compelling evidence of emerging and precocious talent comes a few years later from the precise and beautiful drawings of casts of antique sculptures and torsos that Picasso made in La Coruña, a Spanish town on the Atlantic coast where the family had moved. Picasso was now around twelve to thirteen years old and the drawings are not simply accomplished but seem to have the 'power of giving the faded models back their life, a life that had been there when the statues were first carved and that his [Picasso's] pleasure in the act of drawing restored to their degraded plaster shadows'.[7] The drawings are realistic, conveying both precision and skill in representation, but they also have an aesthetic beauty. Throughout Picasso's life, he continued to produce classical drawings, often incorporating Greek themes that echo this early skill.

A couple of years later, when the family moved to Barcelona, Picasso sat the entrance exam for the higher art school La Llotja, the minimum age for admission to which was actually twenty. It was September 1895, and Picasso was not quite fourteen years old. Never tall, he must have seemed even smaller surrounded by adults in the exam studio. Undaunted, Picasso concentrated on the life model in front of him, a small, slightly stocky man draped in a sheet, and started to draw, using crayon. Then he drew a second life study of the man naked, muscles taut. Finally, he took up his crayon again to draw a study of a classical plaster cast from torso to knee, mysteriously balanced on its armless side. It did not take long

for the drawings to be judged. Despite his age, Picasso was offered immediate admission to the higher school.

The dexterity, quality and beauty of Picasso's realistic drawings are striking, his skill in classical art surprising people during his lifetime and continuing to surprise now. Picasso could draw perfectly, but the purpose of an artist is not to be photographically accurate in drawing or painting. His later styles are a deliberate choice. He may have claimed that it took him 'many years to draw like a child' but his later drawings were of course not really like those of children at all. It is not precocious development of accurate drawing that accounts for Picasso's genius and distinct quality. Something else was unfolding.

The extraordinary abilities of some prodigies stand out very early in life. Mozart was composing music from the age of five years. In mathematics, Pascal was carrying out complex geometric proofs by the time he was twelve. By sixteen, he had invented his own theorem and by nineteen, he had invented a calculator. Even younger, Kim Ung-yong, a Korean genius, started to talk at four months old and was reading four languages by the age of four when he started to attend university physics courses. By any standards, this is extraordinary. By the age of eight, he was invited to work with NASA and he was awarded his doctorate at sixteen. Also in science, Tathagat Avatar Tulsi, an Indian physicist, acquired his first university degree by the age of ten. Equally hard to beat is William James Sidis, who could read at eighteen months and had written four books and learnt to speak eight languages fluently by the time he was eight years old, progressing to even more languages in adulthood. He went to Harvard at eleven, graduating at the age of sixteen.

All of these people showed astonishing talent from the outset.

The media sporadically focuses on child prodigies who falter in adulthood, failing to deliver on expectations, but it would be a mistake to generalise from these. Mozart remained a genius throughout his life; Pascal in adulthood excelled not only as a mathematician but also as a writer, philosopher and theologian; Kim Ung-yong shifted from physics to civil engineering and still carries out innovative scientific research as a professor at Chungbuk National University in Korea. Kim's case and that of Pascal also show that the exact manifestation and expression of developing talent may not be fixed to one field.

For those who falter, weak social integration may be a contributory element. For example, William James Sidis – whose career in adulthood was mundane, despite his multilingual abilities – had problems fitting into his academic community, particularly in coping with the attention, teasing and press hounding that resulted from his fame as a prodigy. Sadly, he was asked to leave his university post and sank into obscurity in low-level clerical employment. His brain and life did not just dissolve away, though. Quiet and unprepossessing though his adult life may have been, he had good friends and found time to work on diverse projects, including writing numerous books – mostly unpublished – which spanned a wide range of subjects, from the history of American Indians to cosmology to thermodynamics. Sidis, then, did excel privately in life; he just never enjoyed the success and recognition that his prodigious ability had predicted.

Many creative individuals manage to juxtapose a detached and self-contained adult life with success. For example, the artist Lucian Freud was famously solitary. He was not a hermit

– having his own circle of good friends – but he was self-contained, enjoyed privacy and liked to be tucked away, avoiding communication devices such as the telephone – a lifestyle that, by contemporary standards, verged on the eccentric. Social isolation, however, caused by them being discerned as different from others, can lead prodigies to falter. Some, indeed, may even deliberately underachieve in order to fit into society and thereby avoid isolation.

What else may prevent early talent being realised later in life? One conjecture is that an innate talent in music, maths and science can emerge earlier in life than in other disciplines, as art and literature are, by their essence, fields that draw upon a breadth of understanding and experience that requires greater maturity. Another conjecture is that prodigious early talent reflects highly developed skills and abilities, whereas true creative excellence in any field – whether it be music, science, art or writing – comes later with the maturation of critical brain circuits during adolescence.

While the age patterns and life trajectories of prodigies differ, a striking characteristic many have in common is that they are highly intelligent as well as highly creative, and this raises the question of whether intelligence and creativity are inextricably related.

CREATIVITY AND INTELLIGENCE

Picasso believed that intelligence was relevant to the creative process, saying 'Painting is a thing of intelligence. One can see the intelligence in each of Manet's brushstrokes, and the action of the intelligence is made visible . . . when one watches Matisse draw, hesitate, then begin to express his thought with a sure

stroke.'[8] Picasso himself was highly intelligent. Although we have no formal psychometric assessment of him, the perception of his high intelligence was pervasive among his friends and colleagues. If this evidence seems like mere hearsay, his intelligence is also reflected in the enthusiasm with which he surrounded himself not by celebrities, but by big thinkers, philosophers, poets and writers. He liked to talk about and discuss ideas and he was quick, sharp and perceptive. But the ultimate evidence of his intelligence lies in the thousands of pieces of work that he created, some light and fun but many that are complex, new and full of ideas and thoughts, such that their emotive impact persists and the reading and interpretation of them continues decades later. Picasso was clever, really clever.

High intelligence has been linked to genius and creativity in lots of studies. Back in 1869, when the idea of intelligence testing was just developing, Francis Galton said that genius depended upon unusually high intelligence at the upper end of the normal spread.[9] This historical idea has been tested in different ways. One way is to start with people who are highly intelligent and then look for creative genius among them. Another method, for those who have the patience, is to test children and spot those who are exceptionally intelligent and gifted, then wait and see what happens when they become adults. Lewis Terman[10] did this kind of early longitudinal study across the decades from the 1920s to the 1950s, looking at the effects of early high intelligence in childhood on later achievement. He concluded that exceptional intelligence in childhood did indeed normally result in extraordinary accomplishments in adulthood.[11]

Another way to look at intelligence and genius is to approach it the other way round by looking at lots of people who are

geniuses and then finding out whether they are particularly intelligent. In another historical study back in 1926, Catherine Cox looked at three hundred 'geniuses' who were eminent creators and leaders in the West.[12] Cox estimated the IQ of each person from the ratio of their real chronological age and their mental age. She then rated their eminence by seeing how much space was devoted to them in reference books, and argued from these measures that IQ scores did indeed relate to degree of eminence.

Although some of Cox's methodology was a bit haphazard, more recent studies using different measures of intelligence and eminence have shown that her basic early finding is reliable and that intelligence and eminence are indeed significantly related.[13, 14, 15] Recently, a study of Hungarians also found that high IQ significantly affected levels of real-life creative accomplishments.[16] So the link is not simply to eminence but also to creativity.

But although high intelligence may facilitate creativity, it does not create genius; as Clive Bell, the art critic, said: 'Two people I have known from whom there emanated simply and unmistakably a sense of genius: one is Picasso ...' Virginia Woolf was the other. Bell pointed out that he knew many clever people but that 'Virginia and Picasso belonged to another order of beings: they were of a species distinct from the common; their mental processes were different from ours; they arrived at conclusions by ways to us unknown.' How different were their mental processes? Were they really different species altogether? Throughout this book, Picasso's different mental processes will be assessed and compared to what we know about our own mental processes. Clive Bell meanwhile also cautioned against

too much admiration of genius, saying: 'Genius worship is the inevitable sign of an uncreative age.'[17]

Leaving the theme of prodigies, it is evident that genius and prodigious talent may emerge early and this undoubtedly results from a combination of genetic inheritance and environmental context. Picasso's first words were supposed to have been 'piz, piz' – baby language for 'lapiz', meaning a pencil. Was this genetic inheritance driving early behaviour and interests and seeking out the capacity to draw? Alternatively, was this because Picasso's father was an artist and, even as a baby, he had seen his father drawing with a pencil? When Picasso developed his single-line drawings in ink, was this just a skill that he learnt from practising in the sand, or did his early drawings in the sandy squares mark out the drive and early expressions of genes depicting genius?

PICASSO'S GENES

One way to address the issue of genes for genius is to ask whether there is any evidence in Picasso's backgrounds of relevant roots. Is there artistic talent running through the family suggesting the inheritance of unusual ability, or is there evidence of an environment tuned towards the arts that might have helped to foster his creative interests?

We know that Picasso's paternal grandfather, Don Diego Ruiz y Almoguera, was the ninth of eleven children and although of noble descent, joined the bourgeoisie and became a glove-maker and tradesman in order to keep his own large family of nine surviving children fed, watered and educated. Although glove-making is not without design elements, Don Diego – who played the double bass in the local orchestra and

enjoyed drawing – was frustrated, as he had really wanted to be a musician or a painter. Financial and pragmatic pressure constrained his career options. As Don Diego did not get the chance to pursue an artistic career, we do not know just how strong his artistic talents may have been and what genes he conveyed to the following generations and to his grandson Picasso. What we do know is that Don Diego was attracted by the creative arts, worked in an area involving the talents of a skilled craftsman, and had the capacity to persevere in the face of thwarted aspirations. Perseverance is a theme that is also significant in Picasso's personality, and the personality of geniuses generally, of which more later.

Grandfather Don Diego's strong interests in drawing and music created a home in which similar interests in his children were incubated. First, Picasso's eldest uncle, also Don Diego, grew up to enjoy painting still lives, saints and copies of classical paintings by Rubens and Velázquez. Then, Uncle Pablo, who shared his nephew's name if not his genius, took an early course in drawing and subsequently, although he became a priest, continued to collect religious paintings and sculpture. Picasso's Aunt Matilde is described as artistic and his Uncle Salvador also loved the arts and was proud to marry the daughter of a successful sculptor.[18] Finally, and most significantly, Picasso's father Don José became an artist and art teacher, with skill in drawing and illustration, and a particular enthusiasm for pictures of pigeons that flew onto the balcony of their flat. Yet even he did not have the exceptional talent that was to mark the work of his son. We can discern indications of relevant genes in Picasso's father, together with a family history conducive to art, but nothing that on its own would herald a genius in the making.

Picasso's genes were the product of those of the art teacher José Ruiz Blasco and María Picasso López. For nine months after conception, his brain grew and developed, preparing critical brain circuits while bathed in a soup of hormones until Picasso was finally born on 25 October 1881. He was christened on 10 November at the church of Santiago, in Malaga, where he was given a string of names after a constellation of family members and saints, including those whose days fall on 25 October: Pablo (his uncle) Diego (his paternal grandfather and his uncle) José (his father) Francisco de Paula (his maternal grandfather) Juan Nepomuceno (a cousin and godparent) María de los Remedios (another cousin and godparent) Cipriano de la Santísima Trinidad Martyr Patricio Clito Ruiz y Picasso.[19]

Given this mouthful of names, it is not surprising that Picasso decided on a short version of his name. Like all children in Spain, Pablo carried both his mother's family name, Picasso, as his last name and his father's family name, Ruiz, as his second last name. Normally, Ruiz would pass on down the line but Picasso picked his mother's family name instead. Some people have argued that Picasso's choice reflected conflict with his father but the evidence for this is scant. More significantly, the name Picasso was rare and distinctive, whereas Ruiz was a relatively common Spanish name. It was easier to be remembered and to stand out from the crowd with the name Picasso. As Patrick O'Brian, one of Picasso's more accurate and evocative biographers, points out, the distinctive name set Picasso apart from others and that feeling of being different was strengthened by 'that isolating genius which soon made it almost impossible for him to find any equals'.[20]

Exploring Picasso's genes involves not just his parents and grandparents but also his children and descendants. Paloma, his second daughter, became a successful jewellery designer, and Claude, his second son, was an imaginative photographer, before running the Administration Picasso. Javier Vilató, Picasso's nephew, one of the six children of his sister Lola and her husband Dr Juan Vilató y Gómez, was also a talented painter.

This means that there was artistic and design talent in at least three, possibly four generations, but only in Picasso did it reach the level of genius. There was no simple dominant genius gene running up and down his family. However, there may have been a genetic predisposition to be creative that in Picasso's case became more explicitly expressed, or perhaps there were multiple genes that had creative influence, some of which we see expressed in different family members but which Picasso was lucky enough to inherit a cocktail of, many predisposing talents being combined uniquely within him.

GENES FOR GENIUS

Looking beyond Picasso, what is the evidence for a genetic basis to the inheritance of talent and giftedness? In the 1990s, I worked with some identical twins. One pair, who I'll call Paul and Philip, were gifted with high IQ. They originally came to see me because they were having difficulties with arithmetic at school, but as part of the background to looking at their problems with numbers, I looked at some of their other skills. It was a very strange experience to assess them. Not only did I struggle to tell them apart physically but also the things they found easy and difficult, and the way that they behaved, were so

similar that it felt like I was in that film *Groundhog Day*, where the day just keeps repeating.

Both Andrew and Robert were strongest in general knowledge and weakest in arithmetic. They were unusually good with vocabulary and understanding the meanings of words and were also highly adept at analysing pictures and constructing patterns and designs. They had wonderful memories for both stories and patterns. Yet each of them was slow at the methodical translation of a written set of coded symbols and both had major problems with learning tables in arithmetic. They were also both weak at spelling, eighteen to twenty months below their age level, despite their very high verbal IQs. Not only, then, were their high levels of intelligence similar but their profiles of specific strengths and weaknesses were also closely matched.

Identical twins raised in the same home, like Andrew and Robert, share environment and cultural experience as well as genes. Twin studies that explore the effects of genes versus environment have been carried out in *kibbutzim*, where there is a common shared environment; regardless of whether those studied are identical twins, non-identical twins or typical siblings. By looking at whether identical twins in such an environment are more similar to each other than non-identical twins in the same environment, we can more easily tease out the influence of genetics and tell whether it is genes, rather than the common environmental background, that are driving similarities.

Another way to look at the same issue is to look at adoptions in which identical twins, with identical genes, are brought up in different environments, though it is unusual now for identical

twins to be divided in such contexts, so most of these studies are historical. The question again is whether identical twins are more similar to each other than non-identical twins. This tells whether genes are driving similarities despite very different adoption environments.

Typically, what these studies show is that there is a strong genetic influence on intelligence but this is moderated by the environment. The genes seem to specify a possible range of intellectual ability but then the environment influences the point that is reached within the range.

Beyond intelligence itself, is there other evidence that genes may play a more specific role in the development of exceptional talents? I work with children who have genetic disorders and, although they often have problems, one of the things I have discovered is that some genetic changes can actually lead to exceptional talents. One of the syndromes I study is called Turner syndrome. It occurs in 1 in every 2,000 girls, so in the UK that means about 14,000 cases and worldwide it is about 1.5 million. Most of us have twenty-three pairs of chromosomes that carry our genetic code, the last pair of which is the sex chromosomes XX for girls and XY for boys. Children with Turner syndrome are girls, but where their final pair of chromosomes should be XX, instead they have the second X either missing or partially deleted, sometimes written as 45XO.

Girls with Turner syndrome have normal intelligence spanning the usual levels and most go to ordinary schools. Studies of these girls and women have traditionally focused on the difficulties they have with some so-called spatial tasks like map-reading, sense of direction and memory for visual patterns and designs. I have often been struck, though, by how fluent

and articulate they are, with excellent vocabulary, and they often seem to progress into language-based careers, finding employment as translators, administrators, librarians or speech therapists.

On average, girls across the world speak slightly earlier than boys and have slightly larger vocabularies and stronger language skills. This is not necessarily true for any one girl or boy that you pluck out of the population, but the results show up when you look at the average performance of large groups of girls and boys or men and women. Amazingly, girls with Turner syndrome are even better. They have some language skills that are actually stronger than other girls'. We have discovered that on average, ten-year-old girls with Turner syndrome have better vocabularies and understand the meaning of more words than their peers. They are also better at understanding unusual words,[21] and are often very good at reading.

Whereas children with dyslexia read at a level that is below what you would predict from age and intelligence, ten-year-old girls with Turner syndrome read at a level significantly above prediction from age and intelligence.[22] Rather than having dyslexia, they have what is called *hyperlexia*.

The girls with Turner syndrome are exceptionally good at certain aspects of reading. First, they are significantly better than their peers at 'sounding out' and pronouncing long words. This means that they are good at phonics in reading. Second, they are better than their peers at recognising bizarrely spelt irregular English words, like *yacht* and *colonel*, which do not conform to the pronunciation rules of English. This means that they have what psychologists call *word-specific knowledge*, which is used heavily when we rapidly read familiar words.

In Turner syndrome, these excellent skills in reading aloud are not isolated performance skills, like some kind of puppetry; the girls with Turner syndrome are also very good and better than their peers at understanding what they are reading. So they show genuinely elevated strength in all areas of reading with pervasive *hyperlexia*. They differ from some children with hyperlexia who have poor understanding. Ten-year-old girls with Turner syndrome who are missing a whole or significant part of one of the X chromosomes are actually better than normal in the number of words they know and in their reading skills. A genetic disorder has resulted in a literacy talent. Again, these effects show up when averages are compared across groups, and may not apply to each and every girl or woman with Turner syndrome. Nevertheless, it's a surprising result.[23]

One of the strange things about our genetic code is that in normal girls, one of their two X chromosomes is essentially switched off all the way from the top to the bottom, except for certain points where it is switched on and the matching point on the other X chromosome is switched off instead. In Turner syndrome this pattern of switch-on and switch-off is disrupted, as they only have one X chromosome in the first place that is in good shape from top to bottom. In my studies, I have shown that the effect of this disruption is to create a brain that develops in a way that works better than normal for some aspects of language like vocabulary, reading and verbal memory but works less well for language tasks that are unusual or require very quick responses. This means that the development of the different elements of language is modulated by factors linked to the X chromosome.[24]

In recent work with my colleague Elizabeth Shephard, we

have also shown that young girls with Turner syndrome in the very first year of school already show significant elevation of language very broadly across a standard battery of tasks that looked at both speaking language and understanding.[25] We also looked later in life and showed that in early adulthood, young women in their twenties who had Turner syndrome still had exceptionally good language development, particularly in naming, vocabulary and verbal memory. This is just around the time when they are starting at college or university or entering employment.

Another interesting discovery was that not every language skill was high. Some so-called *executive* language skills were not so strong. So, young women with Turner syndrome were not as quick as other women at speedily naming and finding words in their vocabulary, even though their vocabularies themselves were large.[26] But, unless they were commentating on a race, this would not be a problem in day-to-day situations.

Another task that they found tricky is called the Hayling Sentence Completion Test.[27] This task starts easily. You listen to a sentence that is missing a word at the end and then have to finish the sentence; for example, 'The captain went down with the sinking . . .' Completing these sentences was easy for women with Turner syndrome. Then the task gets a bit harder. You have to listen to some more sentences and then finish them with a word that does not fit in the sentence at all. So you have to stop yourself from filling in the sentence correctly and answer with something that will sound odd. In the sentence about the captain you must not say 'ship' but could perhaps say 'marmalade', 'skyscraper' or 'daffodil'. Psychologists call any response like 'ship' that would have fitted the sentence

well a *prepotent response,* and this is what has to be inhibited or suppressed. This is another *executive* language task. Young women with Turner syndrome found it really hard. They could complete the sentences sensibly in the first part of the task but found it harder than their peers to find an ending that did not really work. Their use of language was more constrained and their ability to inhibit a sensible word in favour of something unusual was weaker than usual. It's true that for all of us the latter is a strange task, but then that is a feature of many *executive* tasks: they often have novel or unexpected aspects to them. So girls and women with Turner syndrome are exceptionally good at some language tasks, much better than their peers, but are poorer at other executive language tasks.

These studies with Turner syndrome highlight the subtle effects that genes can play in the development of exceptional talents and abilities. Genes may enhance not simply language but particular parts of language but then create problems in another area of language, all in the same person. Neuropsychologists are really interested in these patterns where cognition is carved up at the seams, with both abilities and disabilities emerging, as they reveal the architecture of the building blocks on which our thoughts and knowledge are based. The Turner syndrome studies show that the building blocks of both exceptional talent and weakness in language are linked to genes on the X chromosome.

It is not just in language areas that hyperskills are influenced by genes. Another genetic disorder that I have studied is called Klinefelter's syndrome. This occurs in boys and men who have all the normal chromosomes but also have an extra X chromosome, so that rather than the typical male genotype

46XY, they have the genotype 47XXY. They are tall and have intelligence beyond the normal levels. The majority of cases are never explicitly diagnosed but we know from genetic studies of consecutive births that the incidence is quite high at 1 in 500 to 1000. Again, most previous studies have tended to look at the difficulties associated with Klinefelter's, but I have been equally interested in their talents. In one case study, there was unusual talent in problem-solving and planning when patterns and shapes were involved. This showed that spatial understanding and ability was advanced. The person in question also had an exceptionally good visual memory and could remember details of patterns much better than would normally be seen.[28]

These studies of Turner's and Klinefelter's syndromes show that genes linked to the X chromosome play a role in some exceptional talents.

GENES FOR CREATIVITY

We have seen that genes may influence specific talents and abilities, but might they also control a predisposition to creativity that is not confined to a specific area? Picasso was an artistic genius but could he have been a genius in another field as well or did it have to be art? In his case, there is little evidence of genius outside art. For example, he did not play a musical instrument, sing or take particular pleasure in listening to music, apart from some evocative flamenco music from his childhood. Similarly, in creative writing, although he did write some plays and poetry I would personally rate these as poor, at times almost incomprehensible. What is notable, however, is the extraordinary range of Picasso's visual artistic expression: painting, drawing, etching and lithographs, sculpture, collage,

ceramics, linocuts, stage-scenery, jewellery, silver dishes and photography; and within each of these areas, extraordinary diversity. So, although Picasso's genius appears to be restricted to artistic creation, there is vast variety in its mode of expression. Few creative artists have engaged with such depth and success in so many different forms and styles of art.

Other evidence for genetic influences on wide creative genius comes from families where the range of exceptionally creative skills encompasses completely different spheres, yet the concentration of creative individuals is very high, suggesting genetic strands. An obvious and outstanding example is the Freud family. By any standards, Sigmund Freud, born in mid-nineteenth-century Vienna and the founder of psychoanalysis, was exceptionally creative in the formulation of his new theories, and was one of the great thinkers of modern history. He was actually a neurologist, not a psychologist or psychiatrist by background, and before he developed his psychoanalytical theories he had already written a book full of insight called *On Aphasia* about language disorders in adults who have suffered injury or disease. Freud's ideas have been enormously influential, and although the therapies that have evolved from his theories remain controversial, his ideas made people think in a different way and in so doing had a major influence in literature and the arts, as well as in psychology. We take discussion about the unconscious so much for granted nowadays that it is hard to remember the role Freud had in making us aware that we might not always have conscious access to the way in which our brain is operating and our mind is affecting our behaviour.

In the 1960s, 70s and 80s, studies of so-called 'split-brain' patients added to understanding unconscious influences. These

patients were being treated for epilepsy, a condition that is quite common and usually can be treated effectively with drugs. But sometimes the drugs didn't work well and the patient continued to have intractable epilepsy with multiple seizures. In extreme cases, where the seizures were very frequent and problematic, doctors found that cutting the major fibre tract that joins the two halves of the brain together could stop the seizures from starting altogether. This major fibre tract, called the *corpus callosum*, is also the major communication highway between the two halves of the brain, and severing it cuts off most of the flow of information from one half of the brain to the other. Studies of split-brain patients showed that although they could talk about and were aware of information and thought that was based in the left half of the brain, they could not describe in words many actions influenced by the right half of the brain. In simple terms, it was as if the right half of the brain, the right hemisphere, has influence of which we are not conscious. This is a simplification, as not being to talk about something is not the same thing as not being conscious of it, but absence of awareness was a characteristic in many of these studies.

More recently, it has been found that the way in which the brain processes things, consciously or unconsciously, is more complicated than a simple left/right dichotomy. Numerous studies continue to explore the area of conscious and unconscious thought, Freud's original conception of unconscious influence thus finding echoes in contemporary work. Today, discussion of what are now called *implicit processes* remains a major focus of research in neuroscience.

Sigmund Freud's most famous grandchild was probably Lucian Freud, a brilliant painter with a unique and riveting

style, considered to be one of the most important twentieth-century figurative painters. Born in December 1922 in Berlin, Lucian's father Ernst was an architect and Sigmund's second son. The family moved to London in 1933, when Lucian was ten years old, in order to escape from the emergence of the Nazis. Lucian is best known for his paintings of nudes that convey not simply the personality of the sitter but also, in graphic depiction, their physical blemishes – a view of nakedness that has a harsh reality about it. He is the opposite of flattering but his honesty in representation gives an emotional immediacy which grips the viewer in a way that more gentle and flattering depictions of sitters seldom evoke. As he himself said, 'I paint people not because of what they are like, not exactly in spite of what they are like, but how they happen to be.' The recognition of Lucian's originality, distinctiveness and anticipated long-lasting appeal is reflected in the prices that have been paid for his work, with $33.6 million (£20.6 million) paid in New York in 2008 for his painting *Benefits Supervisor Sleeping* – at the time, a world record for a painting by a living artist – which depicts a naked woman, Sue Tilly, on a couch (see plate section). The purchaser was said to be the Russian billionaire Roman Abramovich. Lucian took absolutely ages over his portraits, with people often sitting for him regularly for a year. If, like me, you are not an artist, it is quite hard to imagine how any painting could take that long but Lucian said that it took him time to get to know his subjects and the results of his concentrated efforts are remarkable.

So we have an extraordinary theoretician of the mind in Sigmund and an extraordinary artist in Lucian, his grandson, but that is not all in this family. Bella, one of Lucian's thirteen

children, is a successful fashion designer. Esther, another daughter, is a successful novelist, and his daughters Rose and Susie are also both writers. Annie, a further daughter, is a poet, and she has a double dose of creative genius genes as she is also the grand-daughter of the sculptor Jacob Epstein. Lucien's daughter Lucy is also an artist, who started winning competitions when she was ten, and Frank Paul, his youngest child, is an artist as well, while his daughter Jane McAdam is a sculptor. That makes eight of Lucien's thirteen children active as artists, sculptors or designer, several having become household names due to their achievements. This certainly cannot wholly be attributed to his paternal environmental influence, as cohabitation with his children was very limited and family life was not his forte.

Away from the creative arts, other members of the Freud family have been successful in politics and media. Clearly, then, this is a very talented family, with a disproportionate number of members involved in careers in the creative fields, whether intellectual, artistic or literary. A compelling aspect of the family history is the wide range of fields within which they have achieved an unusual degree of success. The Freuds may have genes that are highly responsive to their environment and their environment may have encouraged independent thought and a sense that achievement was possible. Such families support the notion of genetic influence behind creative success, although not necessarily aligned to a specific area of expression. This idea is supported by evidence from twin studies where, contrary to some popular assumptions, identical twins seldom succeed as adults in exactly the same field.

THE MECHANICS OF GENES FOR GENIUS AND CREATIVITY

Let's suppose that creativity and genius at least have contributory genes that enhance and allow such thinking to develop and that inherited traits contribute to creative expression. How does inheritance of genes for genius actually work? Like many areas of science, genetics seemed relatively simple not so long ago, but then, as more was discovered, the situation became vastly more complicated. Developments are worth summarising here, as they are relevant not just to Picasso's genes but also to the way in which environmental factors may have further or interactive impact.

Forty or so years ago, standard theory was roughly as follows. Inherited characteristics are carried on genes that sit on 23 matched pairs of chromosomes. Only one gene in each pair is expressed but the double dosage provides protection so that if one gene fails there is the other to fall back on, a bit like second engines in aviation. Many traits are carried in a straightforward way on genes and are expressed via the mechanism expounded by Mendel. If the genes in each pair are the same, then that is what is expressed, but where the genes differ, the *dominant* characteristic is expressed and what is called the *recessive characteristic* is not. For example, brown eyes are dominant and blue eyes are recessive, so when paired together brown eyes will be expressed. The only exception to these symmetrical chromosome pairs is in the last pair of chromosomes, which are XX for girls and XY for boys. The Y is shorter than the X, so in boys there are bits of X that don't have a fall-back partner, meaning that with no dominant partner to cancel them out, X-linked recessive genes are often expressed in boys. These include things like colour-blindness. When egg and sperm cells

are made, all the pairs of chromosomes split apart, and a child ends up receiving one half of each chromosome pair from its mother and one half from its father.

On this view, genes for exceptional talent or creativity might be dominant or recessive. To explain why such talents do not seem to pass in a straightforward way down families, we could argue for the involvement of multiple genes that might contribute different elements to creativity but that enable genius only in a certain combination. This may indeed be what happens, and what happened for Picasso. Creativity and genius may be multi-gene traits that hit the jackpot combination only rarely. There are further complications though, one being the discovery of imprinting.

Imprinting involves the parent adding some extra tags to certain genes in the egg or sperm. When tagged – or, in the jargon, *imprinted* – the gene is essentially switched off, which means that after conception, the imprinted gene is silent and its partner in the pair will definitely be expressed, regardless of whether it is dominant or recessive. Imprinting emerged in the animal chain with the development of live births, and quite a lot of imprinted genes have to do with growth. The *competition hypothesis* suggests that in mammals, where litters might carry offspring from more than one father, males imprinted their genes to increase growth in their own offspring and push out the competition in the litter, whereas females imprinted their genes to reduce growth and deliver all the litter healthily. Whatever is true in terms of origins and rationale, imprinting enables one parent disproportionately to affect the expression of genes. Many imprinted genes also seem to be involved in behaviour. We don't know yet how many imprinted genes there

are in humans but it is thought, for example, that they may be relevant in the expression of bipolar disorder, of which more later. They are clearly a strong contender for links to creativity.

Even more complicated than imprinting are new biological discoveries that the expression of genes can be influenced by what happens in the environment. Environmental factors can cause mutations that squeeze DNA, constricting genes and reducing the likelihood that they will be expressed.

Not only, then, may multiple genes be involved in producing creativity and genius, but the parental origin of the genes may matter if some of them are imprinted genes, and early environment may alter the degree to which relevant genes are expressed. So there are three genetic factors: the number and identity of genes; imprinting effects; and environmental influence.

Picasso may have struck the jackpot in terms of the combination and interaction of genes that enhance creativity. If some relevant genes are recessive, their expression might also have been increased by imprinting silencing their partner. Combine this with a fortuitous environment that enables expression of the genes without constriction, and a perfect brain for creative work may have developed in Picasso.

We also know that the cocktail of hormones that swirls around the baby's brain during foetal development moderates the circuits that are laid down, beyond direct genetic effects. Some of these relate to sexually-linked behaviours that will be triggered in adolescence but others link to more immediate cognitive and social behaviours, one of which, for instance, is the strengthening of spatial abilities. Picasso's brain may have developed in a particularly favourable hormone soup.

We are not yet at the stage of identifying exactly which genes, in whatever combination and affected by whatever imprinting, are significant. As our understanding of human genetics surges forward, so the answers to their linkage to creativity and genius will become more evident.

PICASSO'S NURTURE

As we have seen, the environment itself may modify genetic expression by constricting genes. It may also have other influences on the development of learning, memory and thought. What do we know of Picasso's environment in childhood? We know that Picasso's father was an artist who both taught and encouraged his son to draw. Genes may still have been involved in Pablo's response to this. The *dynamic eco-niche* theory argues that genes drive a child to modify his or her environment, and thereby to maximise the expression of their genetic strengths. The idea here is that an innately artistic child like Picasso may respond and attend to artistic opportunities. Parents, like Picasso's father, then respond to this interest and enthusiasm from their child by giving more opportunities and encouragement in art. The genes drive the child's initial behaviour but then the parent responds by altering the environment to increase exposure to relevant stimuli and experiences. The genes literally drive the environment.

A similar thing could happen with a child who is musical. The musical child responds and attends to music and shows lots of interest in musical activities. Their parent then responds to this musical interest by providing more music, perhaps giving the child lessons in a musical instrument and taking them to music performances. Again, the genes drive the environment.

Picasso was fortunate in both the quality of his environment and its interaction with his genetic strengths; together, these enabled the development of his extraordinary talent.

Environmental influences that may have helped to shape Picasso's work include: regularly going to bull fights with his father (bulls and bullfighters feature frequently in his work, from exceptional childhood drawings through to innovative linocut prints in his later years; his father's general persona (Picasso said, 'Every time I draw a man, automatically, I think of my father . . . as far as I am concerned the man is Don José and that will be so as long as I live . . . I see all the men I draw with his features more or less'[29]; the significant disparity of his parents' ages (Picasso would be drawn to women considerably younger than himself throughout his life, in itself not such an unusual trait but in Picasso's case one that was to be given robust expression); the vitality and optimism of his mother, which helped the family to weather financial hardship (Picasso demonstrated relentless drive throughout his life); Italian blood passed on through his mother's grandfather (though Spanish and Andalusian culture affected Picasso deeply throughout his life, as well as the work of many Spanish artists, like Velázquez, El Greco, Goya and Murillo – in his late seventies he declared, 'A man belongs to his own country for ever'[30] – cross-cultural influences had an effect on Picasso throughout his childhood and were later combined with French influence in Paris); the emphasis in Andalusian culture upon privacy (Picasso was a private individual who valued confidentiality highly; later in life, a sense of betrayal overwhelmed him when his former lovers began to write books about him, describing personal aspects of his character and behaviour).

Specific environmental events in childhood, such as the loss of a sibling or of a parent may also impact strongly on development. Picasso's sister Lola was born in 1884 and then Conchita was born in 1887. Picasso adored Conchita and when she died in 1895 of diphtheria, at the age of seven, Picasso, then a young teenager, was affected profoundly. One of his earliest works concerned a deathbed scene, and both death and loss haunted his life and work.

Picasso, then, was given the opportunity and encouragement to express his artistic talents from a young age. We know that in early childhood, the environment affects the maturation of the brain. The brains of animals raised in zoos are 20–30 per cent smaller than those of animals raised in the wild, for instance; similarly, abused and neglected children, seldom touched, seldom hearing language, have brains that are 20–30 per cent smaller than those of their peers. The internal connectivity of our brains may be even more significant than their overall size. The connections between brain cells, called synapses, multiply more than twenty times in the first three months of life and by three years old a child has double the connections of an adult.

Perhaps surprisingly, after the effort of making all of these synapses, they are then pruned down. By the age of ten we have around 500 trillion synapses left, roughly an average adult level. Enriched environments significantly increase these synaptic connections, producing brains with more complex, underlying networks. Yet, though the learning experiences and childhood environment of exceptionally creative individuals like Picasso may be significant, it is clear that many people who grow up in enriched environments do not become exceptionally creative. A rich environment might be an essential prerequisite for

extraordinary levels of creativity but it is not, in isolation, causal or there would be many more Picassos around us.

PICASSO AT PLAY

Most people as they grow up tend to lose their childlike sense of excitement and fascination with simple things – oil on puddles, perhaps, or pebbles on the beach – but, as Patrick O'Brian[31] notes, Picasso managed to retain a sense of captivation with such things. He was not immune to the cultural influences around him but he also retained the capacity to look at the world and sustain the exploration, interest and fun of a child. Picasso liked to laugh and all his life he played, both in his personal life and in his work.

At the most simple level of play and somewhat unexpectedly, Picasso liked to dress up with comic hats, false noses and silly masks, even in his nineties.[32] He even had a huge pile of masks and funny hats in his home, and visitors would sometimes have to choose a disguise and then wear it for most of the day, with Picasso joining in.[33] Lee Miller, the distinguished American photographer who was a great friend of Picasso, records these zany days in her photographs.

Picasso was also a splendid mime and mimic and a very good host. John Richardson, Picasso's friend and author of the most detailed biographical volumes of Picasso's life, talks in interview about how Picasso was excellent company. He never put on an act or took himself too seriously, and he was full of tricks; for example, unexpectedly creating the sound of a frog from a piece of cutlery against the table in the middle of dinner and then feigning ignorance as to its origins. At lots of different levels, he was entertaining, lively and engaged.

Picasso also entertained his own children and those of his friends. As well as producing his single-line drawings of animals, he could also make a single weaving cut in folded paper and create clever paper cut-outs[34] of people or animals. These creations were not masterpieces but they were clever, quick and entertaining. Picasso was exceptionally good at generating them rapidly and he enjoyed the pleasure they gave. They illustrate how he used creative expression both to play and to foster creative expression. For Picasso, the two were tightly interconnected.

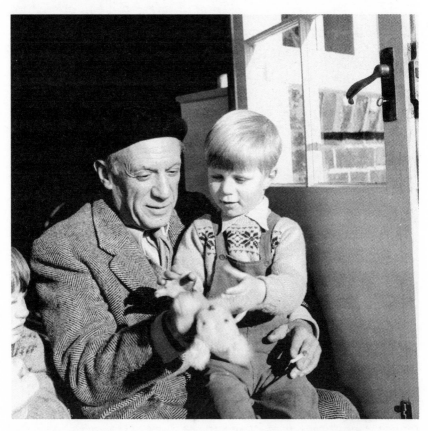

Lee Miller's photograph of Picasso playing with her son, Antony Penrose.

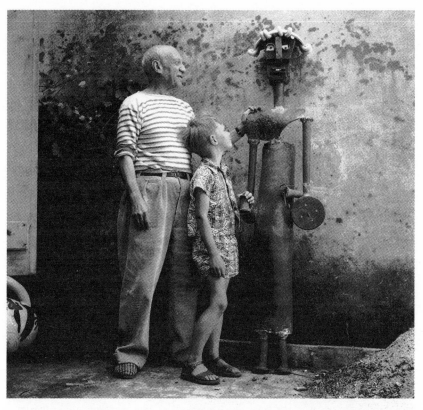

Lee Miller captures Antony Penrose with Picasso and one of his sculptures

Picasso's ability to see the world through children's eyes, joining in their play and inventing and creating things that amused them, gave him a rapport with children. His creative humour and child-like engagement were evident to Antony Penrose, the son of Lee Miller and the writer and painter Roland Penrose. Antony[35] talks about visiting Picasso in the south of France with his parents when he was a child, and two of Picasso's children, Claude and Paloma, were there with their mother, the artist Françoise Gilot. Lee took lots of photographs on these visits and in one you can see a sculpture by Picasso of a metal lady with funny eyes and a hat, but you can also see how

Picasso is smiling and laughing at the sculpture, while Antony is both smiling and absorbed at the sight.

Antony also talks about his fascination with another of Picasso's sculptures: that of Esmeralda, Picasso's goat, which slept in the house, in a crate outside his bedroom. This sculpture of Esmeralda had a tummy that was made from an old basket and a palm tree branch formed her spine. It incorporated a sense of fun and irreverence. As Antony notes, Picasso liked making sculpture from old junk and was 'always experimenting, always inventing and always making things', the results often being creations that are witty as well as meaningful.

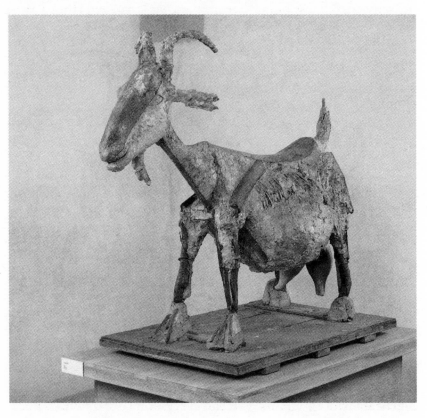

Picasso's sculpture of Esmeralda the goat.

Another famous sculpture by Picasso that used objects in new ways and turned playing with junk into creative expression involves a monkey cradling her baby (see plate section). Picasso took two of his son Claude's toy cars and turned them into the head of the monkey. The first car became the top of the monkey's head, with the windshield framing its eyes, the bonnet becoming the nose, and the grillwork forming the upper mouth. The second model car, a Renault, was placed upside down and back to front, its boot and back bumper becoming the monkey's lower jaw. A large pottery jar was then used to form the ape's body. The animal's ears were made from the handles of jugs or cups and the shoulders from handles detached from a large bowl. For the legs he used scrap wood and for the tail an old car spring. Picasso was playing but the creative result is not merely a joke. Ultimately cast in bronze, this sculpture sold for $6.7 million at a New York auction in 2002.

Picasso had four children of his own. The first, Paulo, was born in 1921 after his marriage to Olga Khokhlova. Pablo adored the child, although his involvement with him was curtailed by Olga entrusting him to various governesses, but he stayed close to Paulo throughout his life and in later years Paulo, who loved cars, acted as his chauffeur. Picasso also took great delight in his daughter Maria Concepción, known as Maya, born to a later lover, the young and beautiful Marie-Thérèse Walter. Picasso continued to see Maya regularly for a couple of days each week throughout her childhood and formed a strong and enduring bond with her. His two other children, Claude and Paloma, were born to Françoise Gilot when he was aged sixty-five and sixty-seven. Surviving photos show him still painting with the children, and making toys

and games. Sadly, in later life Picasso was estranged from these two youngest children, largely due to what he saw as an invasion of his personal privacy when Françoise, their mother, published her book *Life with Picasso*.[36] Apart from one awkward interview, Claude and Paloma did not see their father again, so they never had an adult relationship with him, a loss on both sides.

In June 1956, Picasso started to sketch some grasshoppers and insects on plants in sketchbooks which later formed part of the 2010 London exhibition, 'Picasso, The Mediterranean Years', curated by John Richardson at the Gagosian Gallery. These sketches in turn led to a number of drawings, paintings and a linocut of a large plant that at first glance looks as though it has small insects, possibly grasshoppers, sitting on its stems. On closer inspection of the linocut, you can see that what seemed like grasshoppers are not insects at all but are actually tiny bulls, with the point emphasised further by the way in which the stems of the branches of the plant are bending under the weight of their tiny bulks (see plate section).

Further examples of Picasso still at play come from his more serious interpretations of great painters from earlier eras. Picasso always admired Diego Velázquez, for instance, a fellow Andalusian painter whose 1656 masterpiece *Las Meninas* he recreated in varied Picasso-style forms. In *Las Meninas* a large, serious-looking mastiff dog sits towards the front of the scene. In Picasso's many versions, the mastiff is replaced by Lump, a small and not serious-looking dachshund given to him by the photographer David Douglas Duncan.

Given the importance of play in enabling children spontaneously to explore the world, several theories have linked

creativity in adults with the retention of a childlike, playful mindset and with displays of spontaneity,[37] just as illustrated by the activities of Picasso. Given a small collection of objects, for instance, young children will spontaneously start to play with them, exploring their characteristics, making the objects interact, and will often use them to represent other items. This drive to spontaneous play is thought to be a critical element that causes the child to learn about the world and its objects, concepts and laws of matter.

As we age, for most of us, if not Picasso, such spontaneous play reduces. Adults will still sometimes explore a completely novel item but they will seldom play with or explore the familiar. Part of that reduction in play is thought to be related to the development of explicit concepts and knowledge about things, i.e. the adult already knows about an item and so does not need any further information in order to use or understand it.

Play is also about forming novel associations and connections in an uninhibited way. A child will link things and also use an item to represent another. As all parents who have studiously avoided giving their children toy guns will know, umbrellas, walking sticks, plastic dinosaurs – and even hands – may be used to represent weapons, and children will interact with such items as substitutes when the whim arises. As illustrated above, Picasso also used novel representation by assimilating his children's toys or household junk into his sculptures.

Children also play within novel, imaginative worlds where the normal laws of physics, finance or human abilities may not apply. When these behaviours decline, they are associated with a decline in the open-ended, creative and imaginative elements of play. As we become more goal-directed and rule-driven, our

mental flexibility is undermined[38] and our creative expression is inhibited. Indeed, the reduction of play and creativity starts within childhood itself, and higher levels of artistic creativity and aesthetic expression are found in pre-school children relative to older children.[39] Picasso was alert to these changes and the way in which rule-bound behaviour can stifle creativity: 'To blossom forth, a work of art must ignore or rather forget all the rules.'[40] 'Every child is an artist. The problem is how to remain an artist once he grows up.'[41]

PICASSO'S INHIBITION

The decline of open-ended exploratory play and the strengthening of inhibition as children grow up are partly attributed to the maturation of the *frontal lobes* of the brain, as this is the region that controls inhibition. The frontal lobes are the most highly evolved part of our brains. Progress up through the animal kingdom, through species that have evolved more recently, and what you find is that the volume of the outer covering of the brain, our so-called *cortex*, increases. Yet as you progress through the primates up to man, the area that proportionately increases the most is the cortex around the frontal lobes.

The frontal lobes, however, are not fully wired up at birth. New synapses continue to form and this so-called *synaptogenesis* continues at least into toddlerhood. Then, there is the long phase of synapse *pruning*, where synapses that are being used are strengthened but those that are not needed are eliminated. For the frontal lobes, this process of pruning and elimination keeps going right into adolescence and even into early adulthood. So although the frontal lobes are active at birth, what they can do changes as the child grows up and the neural underpinnings of

the frontal lobes mature. This is relevant to child, teenage and adult modes of operating in the world.

Another physical process that continues after birth and affects the way the frontal lobes work is the formation of a substance called myelin, which is a fatty compound that forms around the long strands of nerve cells called axons. Myelin is like a kind of insulation and when it is added to nerve cells it speeds up the way they communicate messages. The process of building up myelin is called *myelination* and although it occurs all over the brain after birth, the myelination of the frontal lobes keeps going into the teenage years and even early adulthood. These two processes of synaptogenesis and pruning, and also myelination, mean that the mature structure and pathways of the frontal lobes emerge gradually, and what the frontal lobes can affect in terms of behaviour also emerges in the same way. The developing moral, personal and social awareness that occurs in adolescence is also in part attributed to maturation of frontal lobe circuits.

Although the maturation of the frontal lobes leads to strengthening inhibition and increasingly rule-bound and constrained behaviour that can stifle creative expression, Picasso clearly wasn't held back by this, and showed evidence of varying his inhibitory behaviour. On the one hand, he retained the capacity for exploratory play and novel associations, in a very uninhibited way, yet he was simultaneously capable of inhibiting irrelevant distraction and responses to events that were not of interest, in order to be able to sustain very lengthy periods of intense concentration working at a creative artistic task. He was a living example of the complexity of inhibitory processes, and displayed immense skill in varying their operation

in different domains, suppressing unhelpful inhibited behaviour but sustaining inhibition of external distraction. The frontal lobes are of further significance here as they are both critical for the inhibitory processes that reduce exploratory play but also enable us to suppress irrelevant distraction and inhibit inappropriate responses and behaviour.

Picasso's capacity to inhibit irrelevant distraction relates to what psychologists call *latent inhibition,* a term used to refer to the ability of the nervous system to tune down and reduce responsiveness to information that has been experienced before and has not been relevant. It enables us to focus on critical things and behaviour that is directed towards a goal and it stops attention being wasted on irrelevant things. We don't want to notice and pay attention to everything. We want to concentrate on the bits of information that are important. If you buy a new kettle, you may initially find when you go into the kitchen that the kettle seems to stand out from other things. The kettle has significance because it is new and is not part of the background with which you are familiar. But you don't want to keep noticing the kettle indefinitely, no matter how much you may like its design or usefulness.

Similarly, I once lived in a college flat in central Oxford that was high up and surrounded by spires and bells that chimed loudly every hour. When I first moved in, I thought that I would never be able to sleep or work through them. Yet after a short time, I didn't seem to hear the bells and only noticed them when visitors pointed them out. The point is our attention focuses on things that are new and on information that is significant to what we are doing. Inhibition of irrelevant information is a key aspect of the development of human

cognition. This declining responsiveness after repetition is called *habituation*. Along with *latent inhibition*, it is controlled by the frontal lobes of the brain.

While inhibition of the irrelevant is important, there are contrasting advantages to low levels of latent inhibition for creativity. Low latent inhibition allows more memories of words, images, concepts and events to generate cross-associations and contribute to novel and original insights or creative associations. Lower latent inhibition is linked to the personality traits *openness to experience* and *extraversion*, both of which are markers of creativity. Carson and colleagues in a study of Harvard undergraduate students showed that the most distinguished creative accomplishments are seen in people who have low latent inhibition but high IQ.[42] This result was repeated in a different study conducted in Hungary.[43] Creativity may therefore be associated with an ability to remember and link information that is otherwise screened out and ignored.

Another aspect of inhibition is important in helping us to do things in a different way. So if you have lived in a particular house for years and then you move house, when you are driving home you have to inhibit your usual plan to drive automatically to the old house. Psychologists, as mentioned earlier, call these over-learnt, almost automatic behaviours *prepotent*. In a laboratory situation, they can sometimes be assessed using sentence completion tasks.[44] These, you'll recall, involve subjects being given a sentence with a word missing at the end and being asked first to fill in a suitable word that could end the sentence (a prepotent response), then to inhibit this response by finishing the sentence in a way that doesn't make sense at all. Here, inhibition of prepotent answers allows flexible responding.

Another way to look at these inhibitory processes that allow change is to get people to keep changing how they will respond. First they have to respond one way, then in another. This sounds easy but can be tricky, particularly if you are trying to do more than one thing at once. You can try this out yourself with your hands. If you take one hand you can easily alternate between putting it flat on the table in front of you and then on the table as a fist. So you can alternate, flat–fist–flat–fist–flat by spreading your fingers out and then curling them up in a fist. Suppose though, at the same time, you take the other hand and while the right hand is flat you make a fist with the left hand. Then you change them both at the same time. So the right hand curls up to make a fist and the left hand spreads out to be flat on the table. Keep doing this as quickly and smoothly as you can. You will find that you have to concentrate much more than with one hand. This is the Luria Hand Alternation Task, devised by Russian neuropsychologist Alexander Luria, and it requires complex inhibition, as with each movement switch you have to both inhibit a previous move and initiate the opposite, yet the same movements are involved overall. It's a task controlled by the frontal lobes of the brain, and recent imaging studies suggest that such alternating and reversal tasks may be particularly controlled by the underside of the front part of the frontal lobes, the so-called *orbitomedial prefrontal cortex.*

All this means that there are different kinds of inhibition that may be important for creativity. Low levels of latent inhibition are important to remain open, playful and able to make novel associations, but strong inhibition is important to reduce distraction. Inhibition of prepotent responses is essential to allow unusual and unexpected responses that are actually

creative. The capacity to control these inhibitory processes so that they can be relaxed at times and focused at others enables a flexible mode of thinking. Picasso was a master in all these elements of inhibition, demonstrating the capacity to use each to advantage, not simply switching from one to the other but engaging in more than one form simultaneously.

THE CHILD IN ALL OF US

So, if the mindset and less inhibited approach of a child facilitates creative originality, and if Picasso was able to retain this capacity, could it also be more accessible to the rest of us? In 2010, Zabelina and Robinson,[45] academic psychologists in the USA, explored our ability to facilitate creativity by encouraging a child-like mindset. In one experiment, they asked adult students to imagine what they would do if their courses were cancelled for the day. They divided their study group into two sets of students, each being asked to be detailed and specific in their written answers – the only difference being that one group was also told that : 'You are seven years old.' Whereas the 'adult' condition evoked responses involving additional sleep and catching up on work, the 'child' condition evoked greater pursuit of desires and more spontaneous and playful thinking.

Before they had finished the task, the students were interrupted and given a more formal test of creative thinking, known as the Abbreviated Torrance Test for Adults (ATTA).[46] This showed that more original responses were made by the people in the 'child' condition than by those in the 'adult' condition.

Earlier the students had been given a personality test that distinguished between *extroverts* and *introverts*. When these results were looked at, it was clear that the 'child' manipulation

had significant impact on those who were introverted, and correspondingly less impact on the extroverts. Thus, a simple injunction to people to imagine themselves behaving as a child was shown to produce more creative behaviour in individuals whose natural personality was less spontaneous. This suggests that by shifting mindset, from adult back to child, it may be possible to evoke greater creative and original output.

Zabelina and Robinson also replicated a previous observation that *openness to experience* – one of the five major traits used to explain personality[47] – was significantly related to high creative originality: being imaginative, sensitive, curious and enjoying variety. Clearly we cannot all become creative geniuses, but we can boost our creativity by being more curious about and open to the world.

Picasso's Phenomenal Memory

'He had an unequalled visual memory, a power of draining the essence of what he saw and storing it up.'[48]

PICASSO THE HYPERMNESTIC

Picasso as a young man loved to sit around in cafes in the evening with his friends in Barcelona, Madrid or Paris, talking about art and poetry, philosophy and the world at large. Though he was close to penury, his persuasive personality enabled his work on the cafe wall to act occasionally as a credit note against expenses. Throughout his life, Picasso loved to paint, draw or sketch portraits of his friends, dealers and lovers, and he achieved the reputation of being able to execute these works without the sitter being present. When living in Paris, he took to exploring Parisian hospitals housing a cross-section of the sick and suffering. He talked of seeing a dead woman and then going home to paint her from memory. Patrick O'Brian tells us that Picasso did not usually require a model but 'drew upon his astonishing visual memory for any head, body or scene, however complex.'[49]

Would an exceptional visual memory give Picasso an edge in his capacity for artistic excellence? Certainly, artistic excellence can be linked to exceptional visual memory, but although many artists score higher on visual memory tests than non-artists,[50, 51] the chicken-and-egg question is whether strong visual memory predates artistic development or arises as a result of all the artistic work. One source of evidence that having a good visual memory may aid the development of artistic excellence is when the impact can be seen at a young age. Studies show that the drawing ability of children does correlate with their visual memory, so that those who are good at one are more likely to be good at the other.[52, 53, 54] Chris McManus and colleagues in London found that drawing ability was related both to how easily someone could immediately remember a complex design just after they have seen it and also to how well they could still remember the design after some time had passed, and Chris argued that visual memory comes first and is the substrate upon which drawing is built.[55]

Picasso knew that the strength of his memory was of fundamental importance: 'a painter's most useful adjunct'[56]. And while Picasso's biographers may vary in their assessments of some of his behaviour, they are united in describing Picasso's visual memory as being extraordinarily good. There is reference after reference to the exceptional strength of his visual memory from his biographers, as illustrated by just a sample of quotations:

> Picasso had a prodigious memory, both for forms and for events.[57]
> ... he had an unequalled visual memory, a power of draining the essence of what he saw and storing it up.[58]

a portrait without a model was nothing to him[5.9]
Picasso had 'phenomenal visual memory.'[60]
Picasso had almost total visual recall.[61]
Picasso's memory, tactual as well as visual, was prodigious.[62]

Picasso's biographers clearly believed that his memory was extraordinary. The implication from the anecdote about drawing a dead woman is that seeing a person once was enough to allow Picasso to subsequently paint or draw them. Is single-exposure memory like this really a viable capacity? We know today that such feats are indeed feasible, and one strand of evidence for this comes, perhaps surprisingly, from the astonishing talents seen in autism.

SINGLE-EXPOSURE MEMORY IN AUTISM

Autism has four cardinal characteristics: language disorder; a sense that a child is self-contained and 'alone'; absence of imaginative play; and a predisposition to routines. In about one in ten cases, these characteristics surprisingly coexist with an exceptional gift. There are several theories about why this happens and it has been suggested that the 'mind blindness' of the child with autism – a difficulty in thinking about what others are thinking – may allow such children to operate unselfconsciously, without regard for peer groups, and with an entirely untrammelled focus.[63] Individuals with autism are preoccupied with detail, which seems to mean that they do not generalise or extract broad principles in the same way that the rest of us would. Psychologists call this *weak coherence* and it affects the way that people with autism look at and respond to the world. This eye for detail may have advantage in some areas

and is evident in the fine detailed drawings of artists, one of whom is Stephen Wiltshire.

Stephen Wiltshire, a well-known British artist with autism, had severe language difficulties and was mute until the age of nine, communicating only through his drawings. Yet, flown over the New York skyline for the first time in 2009, and then only for twenty minutes, he was able to produce an extremely detailed depiction of the scene. Similarly, after a visit to St Pancras railway station in London, he was able to generate a highly accurate and detailed depiction of the beautiful internal architecture. Artists like Stephen who have autism are also particularly good at depicting perspective.[64, 65] Such talent in autism demonstrates that it is possible for single-exposure learning to be allied to a very elevated and detailed high-quality visual memory and retention capacity. In the case of such autistic savant artists, over-learning, with repeated exposure to the same material, is not needed to retain the fine detail of visual scenes.

Exceptional visual memory may provide an underlying basis that supports this talent.[66] If visual memory is a critical substrate for drawing, then exceptionally good visual memory will provide the potential for exceptionally good drawing. This is one explanation for the extraordinary structural drawing skill seen in cases of children with autism.

A number of children with autism have exceptional memories that also manifest in other areas. They may have a rapid ability to memorise, variously, extremely large numbers, train timetables, all the notes in a concerto or the fine detail of visual scenes. Most of us try to extract the key details of what we have to remember, dismissing detail that our brains consider

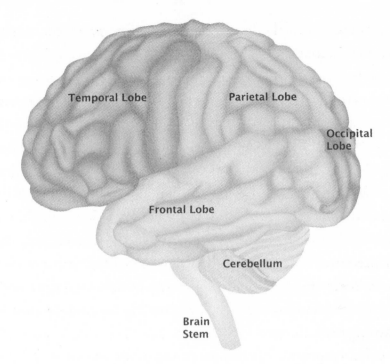

The outer layer of the human brain.

unimportant. By contrast, the brain of the autistic prodigy will encode, store and recall all of the fine detail, sometimes ignoring the bigger picture or the overall *gestalt*.

The exceptional abilities of some of those with autism have been linked to a different organisation in their brains. The outer layer of the brain, the cortex, can be divided into four areas called lobes that are identified by the geography of where they sit: the areas at the back of the head particularly involved with vision are called the *occipital lobes*; at the front, sitting under the forehead, are the most recently evolved areas called the *frontal lobes*; in between lie the other two zones. Above the ears on either side lie the *temporal lobes* involved with memory; and then on top of the head on either side lie the *parietal lobes*.

Studies – using a type of brain scan called functional magnetic resonance imaging (fMRI) – of unartistic people attempting to draw show activation of the parietal lobes on both sides.[67] Drawing by normal adults is also improved when a technique called continuous *transcranial magnetic stimulation* (TMS) is applied in a way that partially switches off the left fronto-temporal region.[68] The idea here is that signals from these areas on the left normally inhibit other parts of the brain, reducing their activity. Switching these inhibitory signals off allows these parts to be more active. The suggestion with autism is that, due to unusual organisation in the left half of the brain, the normal inhibitory signals are disrupted, allowing expression of drawing talent to be seen in some cases.[69]

Single-exposure learning in autism, allied to an elevated and detailed retention capacity, produces very literal interpretations. In a BBC programme some time ago, a musically gifted girl with autism played the piano after listening to a piece played by Glenn Gould, the Canadian pianist. Fascinatingly, she replicated Gould's exact emphasis and pacing, mirroring not simply the notes but also the precise interpretation. There was no creative change. One of the defining characteristics of autism is literal interpretation, and the absence of the imaginative or creative play that was seen as fundamental to later creative expression, even for Picasso.

The high-level talents associated, then, with autism fail to incorporate the innovation and novelty that are fundamental to creative expression. Such innovation and novelty varies, of course, in degree. Some creativity involves little more than the next step of development in an already unfolding chain. The

next novel mathematical algorithm in a chain of mathematical proofs, say, or the next novel experiment in the laboratory that follows from a preceding series. Other expressions of creativity seem to reflect a step-change. Picasso, even in his classical representational work, did not simply generate literal interpretations: he created something new, and much of his work reflects a step-change from what had gone before. Picasso's development of Cubism would be an example. A single-exposure literal memory would not in itself account for his visually creative genius, but an exceptional visual memory might be one of many tools at Picasso's disposal that contributed to his genius.

PICASSO'S GAZE AND DEEP ENCODING

Descriptions of the very intense way Picasso looked at things suggest another facet of his behaviour that is relevant to his memory. There are lots of quotes from his biographers commenting on his deep gaze. Picasso had incredible eyes – women, apparently were captivated by them – and he used these to great effect in looking at the world. In her book about Picasso, Gertrude Stein, his friend and collector, commented that he was 'dark, alive with big pools of eyes . . .'[70] He had a strong and intense gaze and, in the style characteristic of traditional southern Spain, he was happy to stare and use his eyes intently whether looking at people or paintings, so that people often refer to the impact of this gaze. Patrick O'Brian talks of Picasso's 'unparalleled concentration of eye and spirit'.[71] He refers to a conversation that Picasso had with Jaime Sabartès, his friend and later secretary, in which Picasso said:

People never concentrate enough . . . the reason why Cézanne was Cézanne is that he did concentrate: when he was confronted with a tree he looked hard at what was there before his eyes; he looked at it as hard as a man with a gun aiming at his quarry. If he fixed his eye on a leaf, he never let it go. And since he had the leaf, he had the branch. And the tree could never get away. Even if he only had the leaf, that was worthwhile. Often enough painting is no more than that . . . You have to put your concentration into it . . . Oh if only everyone could do just that![72]

Leo Stein (Gertrude's brother) also observed that Picasso had piercing eyes; he looked so intently at a print or drawing, she said, and his gaze was so absorbed, that afterwards it seemed surprising that there was actually anything left on the paper.[73] Picasso himself noted how incredibly important this was for his own painting. It seems that Picasso processed visual information, people and pictures intently and with focused attention. This supports the idea that his memory was affected by the depth of initial *encoding*, a factor that we know influences the quality of memory over time.

In a classic experiment back in the 1970s,[74, 75] Fergus Craik and Robert Lockhart showed that the degree to which you remember words depends upon how you think about them initially. In condition 1 of their experiment, they asked those taking part to look at words and just judge whether they were in capital letters or not. This judgement about the typeface required a shallow level of processing. In condition 2, the people taking part had to decide whether or not words rhymed with another. This required them to think about the sound, what psychologist and linguists call the *phonological aspects*,

of the words. In condition 3 of the experiment, participants had to decide whether a word fitted into a sentence. This involved thinking about what the word actually meant, and was considered to need a deep level of processing.

Regardless of which condition they were being tested under, the participants were then unexpectedly asked to remember the words. Those who had processed deeply, thinking about meaning, remembered the words better than those who had moderately processed them, thinking about the phonology or sound of the words, and they in turn performed better than those who had shallowly processed the words, judging only the capitalisation. So, the words that had been processed most deeply initially were remembered best.

Many later variations on this original experiment have confirmed the overall effect. If you think hard about meaning or think about images near other familiar images, you remember things better. Similar effects have also been shown in relation to pictures of faces, where more detailed and deep processing of such pictures leads to better recall of them later. In other words, the deeper that information is encoded in the first place, the better it will be remembered, whether the material involves words or pictures of faces. The more the information is processed at initial exposure the better the memory. The richer the visual code and thinking about meaning, the better the memory. Recent studies also suggest that very focused attention, thinking about the meaning of items, is significant too. So, Picasso's exceptional memory may not simply have been some biologically driven photographic capacity, but may have resulted from the way in which he deeply processed and encoded visual information in his brain.

When it comes to Picasso, we are talking not just about good memory but about *extraordinarily* good memory. Do we have any evidence that the way information is encoded can relate to truly exceptional memory? To answer this question, where better to look than at participants in the World Memory Championship.

ASTONISHING MEMORIES

Each year, people enter the World Memory Championship in London where individuals carry out extraordinary feats of memory. Participants represent the upper levels of human skill, whereas most of us typical focus on the lower levels. We are all aware of how critical our memories are for day-to-day life, friends, family, work and play, when we see the devastating effects upon memory of Alzheimer's disease and other dementias that eat away at the store of facts and knowledge we have about the world, leaving the sufferer bereft of the anchors of meaning that give structure and coherence to life.

World Memory Championship competitors seem to have exceptionally good memories. Eleanor Maguire[76] and her colleagues in London, who include a couple of my own former colleagues, Elizabeth Valentine and John Wilding, with long-established interests in human memory, wondered what it was that enabled the memory competitors to be so incredibly good at memory tasks.

One possibility would be that the competitors are actually just incredibly intelligent, and that this might drive all sorts of superior abilities, including memory. Another possibility is that there is something structurally different about the brains of people with superior memories; something that has either

been there from birth or is the result of all the work they have put into memory tasks. A third possibility is that those who excel at memory tasks use different areas of the brain for some of these; if so, this might reflect different circuitry rather than different structures, or might reflect the use of a special strategy or approach to the memory tasks.

So the London group took eight participants from the World Memory Championships and added two other people who they already knew had amazingly good memories, to make up a group of ten, and then did an imaging study using fMRI, which shows the extent to which different parts of the brain are active at any time.

What they found was that the competitors were not any cleverer than other people. They did not have exceptional intelligence, each scoring at a high-average level on general tests of cognitive ability, whether verbal or non-verbal. So the idea of their exceptional memories being driven by exceptional intelligence can be rejected. Further, looking at performance on clinical memory tasks rather than those set in the championships confirmed that the group of ten were indeed better than a control group at remembering sequences of numbers and stories read to them, but the two groups did not actually differ in their results in a visual test for memorising a pattern. This agrees with results from other studies that show that memory for words and verbal material seems to be quite differently organised in the brain from memory for patterns and designs. So the group that we are looking at here have high memories for verbal material but seem to be just normal with *non-verbal material*; that is, material not easily described in words.

The study then looked at the structure of the brains of those with exceptional memories and compared them with ordinary people using a static type of MRI that lets one examine differences in the size of the brain. They did not find any differences between the two groups. It wasn't, then, that those with superior memory had been born with some kind of huge memory structure in their brain that had given them an advantage, nor had their memory structures got larger through them carrying out all their memory tasks. That might sound a crazy idea anyway, but there is evidence that London taxi drivers, who have to learn an incredible number of routes through London, actually have structural differences in the size of their *hippocampi*, the horse-shaped structures that sit in the middle of the brain and that are relevant to laying down memories.[77]

The next thing was to look at which areas of the brain were active in the World Memory Championship competitors when they had to remember (1) strings of digits, (2) unfamiliar faces, and (3) pictures of snowflakes, with snowflakes inevitably being particularly difficult to distinguish. Each of the subjects was scanned using fMRI during each of the three tasks. In terms of performance, the researchers found no difference at all between the competitors and the control group in terms of remembering the snowflakes, but the Championship competitors remembered the faces slightly better and the digits significantly so.

The scanning took place while the numbers, faces or snow-flakes were being learnt so the researchers looked particularly at encoding. They found increased brain activity in the competitors in three areas normally implicated in spatial memory and navigation: the *parietal lobes*; the *splenium* (the back of the huge

fibre tract, the *corpus callosum*, that joins the two halves of the brain together); and the right *hippocampus*.

Given that the Championship competitors were particularly good at remembering digits, why was it that those areas of their brains related to spatial memory and navigation displayed greater activation on all the tasks? The answer seems to lie in how those with really good memory approached the tasks. The authors of the study argue that those with exceptional memories used the famous route strategy called the 'Method of Loci'. This works by thinking of a familiar route and as you travel along it in your mind, for each item that you have to remember you mentally place it at a location on the route. Then, to retrieve the list, you just mentally imagine you are walking, driving or cycling back along the route and retrieve the items that you have mentally put there. Some people using this strategy do it with rooms in their house, placing a different item in each room, which is fine if the list is short or your house is very big. It is a robust technique and the origins are attributed to the Greek poet Simonides of Ceos, in 477 BC, so it has certainly lasted the course. Nine of the ten competitors with superior memories said afterwards that they used the Method of Loci in some or all of the tasks. Clearly, then, the use of a spatial learning strategy activated areas of the brain critical for spatial memory.

Another brain region active in all the competitors was an area around a big dip in the brain, called a *sulcus*, in the frontal lobe. The cortex of the brain is a bit like a large rug that has been scrunched up to fit under the skull. This has lots of continuous folds in it; if you go down a dip (a *sulcus*) you will come back up onto a surface bump (a *gyrus*). The different bumps and dips

have names that are generally and confusingly described by their location. The critical dip here was the *left posterior inferior frontal sulcus*, a large dip on the left-hand side of the brain, at the back (*posterior*) and at the bottom (*inferior*) of the frontal lobe.

Studies have shown that this region is involved in learning new associations between things. In the study referred to above, all the subjects reported trying to make some kind of association; for example, linking the feature of the faces to someone they know or trying to link bits of the snowflakes to actual objects. Only the Championship competitors, however, tried to link digits to images, and it is this which seems to explain their superior memories. Interestingly, among the control group, it was only in this single task of learning digits – in which they did not report making any associations – that the left posterior inferior frontal sulcus was not activated.[78]

The results of this study, which hone in on strategies that generate an advantage in memory, actually suggest that we could all significantly improve our memories by making more use of mnemonic devices.

The Method of Loci involves linking verbal material to visual images. It has a multi-sensory element where information is encoded in ways that go beyond what is normal, linking verbal and visual domains across modalities. This cross-modality linkage may be significant. The last quote about Picasso's exceptional memory from above was that 'Picasso's memory, tactual as well as visual, was prodigious.'[79] In his work we see parallel ideas and themes expressed in drawing, painting, sculpture and pottery. One day he would paint something, the next he might develop the same theme in sculpture, which, of course, has a major tactual element. When he was working on an idea its

expression was manifested via different modalities, and in later years he returned to earlier themes, moving from painting to sculpture to prints and back. Visual and tactual memory across modalities underpinned Picasso's work.

EXCEPTIONAL MEMORY IN ASPERGER'S SYNDROME AND SYNAESTHESIA

A disorder related to autism is *Asperger's syndrome*. Those with this condition typically exhibit normal intelligence, but they have difficulty with social interaction and interpersonal communication and are often unusually focused on certain areas and interests. There are arguments about whether Asperger's syndrome is a high-functioning variant of autism or a distinct disorder, lacking the language delay that is one of the hallmarks of autism. One particular subject with Asperger's syndrome, referred to as DT, has been studied by Daniel Bor and colleagues in Cambridge, UK. Not only does DT have Asperger's syndrome; he also has what is called synaesthesia.[80]

Synaesthesia occurs when stimulation of one of the senses triggers a perception in another sense. So, for example, a person with synaesthesia might see colours when they hear spoken words. They hear the word normally but may also see a colour as well. We know that when this happens, the brain area that would normally be activated by truly looking at colours, called V4, is activated by the spoken words, even though there are no external colours linked to them. So where most of us experience sensation as a result of related stimulation by sight, sound, touch, taste or smell, synaesthetes have multi-sensory experiences in response to only a single sense being stimulated.

Synaesthesia may not be as rare as was once thought. Usually it is evident from a very early age, and it is thought to reflect unusual wiring in the brain resulting from genetic factors.[81] The idea that synaesthesia might sometimes lead to exceptional memory feats was raised in an early study by the Russian neuropsychologist Alexander Luria,[82] who studied a man called Solomon Shereshevsky, who had synaesthesia and was a mnemonist (an expert in the use of mnemonics able to recall unusually long lists of data). Solomon's synaesthesia was multi-sensory, stimulation of one sense triggering responses from all of the others. Like the participants in the Memory World Championships referred to earlier, he did not have an unusual level of intelligence – just an exceptional memory, meaning he could remember long descriptions word for word and also complex mathematical formulae after seeing them only briefly.

Daniel Bor's study of DT showed that he had an exceptional memory for numbers and calculation. Where most of us struggle to recall that the sum of π – the ratio of a circle's circumference to its diameter – is, after two decimal places, 3.14, DT can remember π to 22,514 decimal places, making him the European champion. He can also easily and rapidly multiply two six-digit numbers together, something that few of us would even attempt without the aid of a calculator.

When DT is given a stream of numbers to look at, he says that he experiences a complicated three-dimensional landscape that varies in colour, shape, texture and size. He experiences each number up to ten thousand with a distinctive colour, texture, feel and shape. When he does complex calculations in his head he experiences the answer in another complex

landscape. Not only does DT have an experience that involves complex visual and tactual elements, he also seems to assign emotions and personality to numbers. Some are ugly. In contrast, 25 is energetic and would be worth inviting to a party. Clearly his experience of numbers has a multi-sensory and multi-cognitive aspect that is dramatically different to most of us.[83]

One question that Daniel Bor was interested in was why DT was so good at memory tasks, as most people with synaesthesia do not have exceptional talents. He wondered whether something else might be happening in DT's brain other than his synaesthesia simply triggering additional sensory responses. Daniel then explored other possible explanations of DT's exceptional memory. First, he considered *chunking*, which is where material is reorganised and grouped together in a meaningful way; a technique known to improve both expertise and memory. For example, *chunking* is used by chess players to remember sequences of moves. Imaging studies show that the lateral *prefrontal cortex* (side areas of the front of the frontal lobes) underpins chunking skills. DT might be using chunking to remember streams of numbers; if so, brain activation in the lateral prefrontal cortex would be expected, not just the brain activation in sensory areas expected in someone with synaesthesia. Also, in those with Asperger's syndrome, there is a preference to attend to local details rather than the overall picture. This has been shown in experiments using hierarchical stimuli. Tests, for example, using a *Navron figure* – a large letter composed of smaller ones – show that those with Asperger's syndrome tend to focus on the smaller component features that make up the Navron figures.

```
AAAAAA              HHHHHHH
AAAAAA              H
AA                  H
AAAAAA              HHHHHHH
AAAAAA                    H
AA                        H
AAAAAA              HHHHHHH
AAAAAA

   EEEE             S       S
 EE   EE            S       S
EE      EE          S       S
EEEEEEEEEE          SSSSSSS
EEEEEEEEEE          S       S
EE      EE          S       S
EE      EE          S       S
```

Examples of Navron figures

So Daniel decided to give DT two different tasks to do. In the first task, strings of eight digits were presented that were either unstructured or that included chunks grouped like 2, 4, 6, 8, and at the end of each string DT had to say the numbers back aloud. While DT was doing this task he was scanned in an fMRI scanner and his performance compared against control subjects. The controls found it easier to remember the chunked strings than the unstructured ones, and 85 per cent of them noticed the chunking. In contrast, DT did not notice the chunking and his performance did not differ between the chunked and unstructured strings. Under the scanner, DT showed greater activation than did control subjects in the lateral prefrontal cortex, both for the chunked strings and for the unstructured strings, with no difference between the two. Among the control subjects, only the chunked condition led to more activation in the lateral prefrontal cortex.

What this suggests is that DT's brain processes strings of numbers in a way that imposes some kind of structure upon them, similar in effect to chunking, but that can be used whatever the nature of the number strings. Interestingly, DT did not show any greater activation of V4, the colour area of the brain, than others when he saw the digit strings. His brain is engaging the frontal lobes rather than sensory areas.

In a second task, using Navron figures, DT had to press a button to indicate whether the letter A was present or not. The Navron could be a big A made up of small As, or another big letter composed of small As, or a big A composed of another small letter, or a large letter made up of small letters none of which are As. The results showed that DT attended to the local level most; that is, he paid particular attention to the small component letters and was less aware of the large letter than most people are. He was using the cognitive style typical of people with Asperger's syndrome; namely, attending particularly to detail and component features.

Overall then, DT's exceptionally good numerical abilities seem to be associated with particular attention to detail coupled with increased brain activation in the lateral prefrontal cortex that may be associated with the imposition of chunking or some other kind of organisation and meaning onto digit strings. This combination of attention to detail and automatic imposition of organisation and structure to what has to be remembered somehow enables extraordinary achievements in memory.

One way to enhance memory, then, is to link the information to be remembered to pre-learnt sequences of visual images, as in the Method of Loci. Another is to chunk and group information in a way that enables more to be assimilated. For Picasso,

all this suggests that when he was staring intently at subjects, he may also have been organising and absorbing them into his memory, whether consciously or not. His lateral prefrontal cortex may have been active in structuring visual and tactual information and integrating them coherently into his memory and knowledge base.

Other gifted artists seem to have used an intense and concentrated gaze. Lucian Freud characterised his own early work as the result of 'maximum observation by staring at my subject matter and examining it closely'.

PICASSO'S OVER-LEARNING

While Picasso may have had an uncanny ability to remember things after just one gaze, his memory was often developed by multiple exposures to a single image or picture. Françoise Gilot – Picasso's friend, lover and partner from 1944 to 1953 – describes how when Picasso was preparing to reinterpret a favourite grand master painting, he would repeatedly go to the Louvre and stare for ages at a single painting. [84] Only later would he start work on his own interpretation. Françoise also remembers how Picasso would adopt a similar approach before painting or drawing her. He would stare at her for extended periods, but ultimately produce his actual paintings when she was not there.

Picasso, then, *over-learnt* the picture. When you over-learn something, you don't just look at it, think about it and try to learn from or remember it. Instead, you look at it (or listen to it) again and again until it becomes completely familiar. If you were going to a concert you might listen to a CD of the relevant work beforehand, which would help you to recognise

Gertrude Stein and Picasso's portrait of her from memory.

some elements of the music. If you listened to the CD every day in the car for a month, you would probably find that you could anticipate the notes before they were played, or that you were humming the tune to parts of the music before you even reached the concert hall. Over-learning enables memory to work much better and in much greater detail.

Picasso adopted a similar approach for his influential portrait of Gertrude Stein, a good friend and collector of his work. Gertrude sat for him many times – about ninety sittings from the autumn of 1905 through to the summer of 1906 – during which Picasso must have had ample opportunity to over-learn her appearance. This over-learning enabled him to paint the final version of her portrait from memory, after returning from a trip in the summer of 1906.[85]

Gertrude had a slightly unusual concept of the creative process. She thought that creativity was excretory and involved

Picasso emptying himself. 'Picasso was always obsessed by the necessity of emptying himself . . . he can never empty himself of being Spanish, but he can empty himself of what he created . . . the moment he has completed emptying himself he must recommence emptying himself, he fills himself up again so quickly.'[86] Picasso echoed this idea of Gertrude's: 'I go for a walk in the forest of Fontainebleau. I get "green" indigestion. I must get rid of this sensation into a picture. Green rules it. A painter paints to unload himself of feelings and visions.' What these quotes capture is not only the drive and need to express a creative idea but also the forcefulness of the influence of memory, in this case of the green forest.

Like most of us, Picasso used back-ups to remind him of details. These included postcards, prints and photographs. In his homes in the south of France he used projectors to display the pictures that he was studying on the walls of his studio.

MEMORY'S IMPACT ON CREATIVITY FOR PICASSO

It is important to emphasise that Picasso did not use his visual and tactile memory to produce exact copies of what he had seen. For example, his portrait of Gertrude Stein was influenced both by that year's Louvre exhibition of Iberian sculptures and by other early sculptures from classical times. As Patrick O'Brian puts it so lucidly, the face is like a 'mask, immobile and intent, with severe, uneven, asymmetric eyes . . . thus acquiring a strange haunting value, another reality'.[87] The glacial serenity of the artist Jean-Auguste-Dominique Ingres is also evident in the portrait, and John Richardson believes that an Ingres retrospective exhibition, staged in 1905 at the Salon D'Automne in Paris, had a significant influence upon it.[88]

Sadly, we do not have brain scans of Picasso at work but one fascinating study examined the brain-activation patterns of an accomplished portrait artist working on a face. The control subject was an amateur attempting the same task.[89] Compared to the amateur, the expert showed enhanced activation of the *right-middle frontal cortex*, the part of the brain that has the capacity to make associations between things, to manipulate visual forms, and to plan and organise the fine motor responses required for drawing and painting. What this suggests is that for those involved in portraiture, or paintings that incorporate interpretations of appearances, really good creative art may not relate to visual memory per se, but to the way in which these memories are then used and linked to other ideas.

Picasso, then, used his memories and changed them into something new, combining the originals with other ideas and influences. Look at his adaptations of old master paintings, for instance, and you can clearly see how he retained the characteristics of the originals while altering their focus, size or structure. It was this dynamic aspect to the use of his memories, combining different images in the creation of something new, which marked Picasso's genius.

Back in the 1980s, I became fascinated by those who cannot recognise or remember faces. This condition is called *prosopagnosia* and can result from brain injury or disease. I had just completed a doctorate on children with developmental dyslexia, comparing their reading difficulties with those of soldiers who have suffered bullet, missile or shrapnel wounds to the brain. Given that these reading disorders exist in childhood, in otherwise intelligent children, I wondered if there might be other

intelligent children who had face-recognition problems. That was when I met Dr S, a woman of exceptional talent who nevertheless experienced severe face-recognition difficulties throughout her life, these being confirmed in laboratory assessment.[90] Other complex visual stimuli also caused her problems, notably an inability to recognise her own house in her own street. On first encounter, though, there was something else exceptional about Dr S. What struck me forcibly was the way she talked. Indeed, she talked so fast that at times it was a struggle to extract the individual words from the flow of her conversation and work out what she was saying. Dr S was the most fluent, rapid-speaking and talkative person that I have ever met.

Dr S also had a huge vocabulary. In formal words tests, she defined all the terms she was given perfectly, always attaining top-of-the-scale scores. In another test, asked to name as many animals as possible in the space of a minute, Dr S – despite being in her sixties – generated thirty-five animals on one occasion and forty-two on another. The average number of animals that most healthy people of this age can name in a minute is between fourteen and nineteen, with twenty-five being unusually good, even for the highly educated.[91] Dr S's performance was all the more impressive given that she was tested in English, which was not her first language. Overall, her language skills were stunning. Her difficulty with recognising and remembering faces and places was combined with talent in terms of knowledge and memory for words.

Dr S is just one example of the sharp dissociations that can be seen in neuropsychological cases between memory ability for different types of material. Picasso, then, did not need to have an exceptional memory for everything but only for those

scenes, people, faces, and the works of other artists that he drew into his own creations.

In linking his work to previous memories and knowledge, Picasso was of course influenced by memories of other artists whose work he had seen when he was growing up or later in galleries, studios or the houses of his sponsors. He brought the memories of their work into his own creative constructions. This established memory of the work of other artists – what psychologists would call *semantic knowledge* or *semantic memory* – would typically be stored in the temporal lobes of the brain. In creating new work, Picasso retrieved some of this semantic memory but then altered, adapted and extracted elements to feed into the creative ideas he was developing, using his frontal lobes.

We referred earlier to Picasso's interpretation of Velázquez's 1656 masterpiece *Las Meninas*. Picasso produced at least fifty-eight interpretations of this, a number of which focus particularly on the child at the front of the painting, thought to be the eldest daughter of the Queen, the infant Margaret Theresa. The child's appearance in the original painting influenced all of Picasso's subsequent paintings of her, but he took the knowledge, changed it creatively and made it his own (see plate section). This creative adaptation would have taken place not in the temporal lobes but in the frontal lobes.

Many other classical artists significantly influenced Picasso. Concerning his friend and rival Henri Matisse, he said, 'I refuse to let you say anything against Matisse, he is our greatest painter.'[92] And Picasso was to work so closely with the French artist Georges Braque in the development of Cubism that it is hard to derive where memory of Braque's work influenced Picasso and vice versa.

When one artist influences another, part of what happens is that the memory of the work of the first artist is stored in the brain of the subsequent artist, who then retrieves that memory and feeds it in as one element that underlies their own subsequent creative process. It is the interaction of temporal and frontal areas of the brain that enables that extraction of prior knowledge and then new creativity influenced by it.

Feeding memory into the creative process also involves recalling emotive personal experiences. Autobiographical memory is generally thought to be organised differently from semantic memory in the brain but it plays a key role in the creative process. For Picasso this influence was particularly significant, his work being dominated by autobiographical reflections on his personal relationships, homes, animals, friends, sense of cultural identity with France and Spain, and political allegiances. From early days, when the memory of the death of his sister, Conchita, fed into paintings of households with sick incumbents, through to the war-ridden events in his homeland, and, at the last, fear of his impending death, autobiographical memory integrated with more explicit semantic memory.

The integration of autobiographical and semantic memory is also evident in the work of Peter Howson, the UK's official war artist during the Bosnian conflict in 1993. Howson – diagnosed with Asperger's syndrome – produces highly original and creative paintings of people worn down by life – street people, boxers, and the war-wounded – all of whom are painted in harrowing form with strong creative expression (see plate section). Autobiographical memory for visual experiences feeds into the pictorial images generated. These paintings demonstrate the capacity of those with Asperger's to express emotions, even

if their ability to get inside the heads of other people and properly understand them remains at some level a struggle. In high functioning autism the *medial prefrontal areas* have been shown to be activated in a way that differs from normal, and this may be relevant in such cases of creative expression.[93] Howson's work goes beyond any literal depictions and reflects his own experience of life and war. In Asperger's syndrome, exceptional visual memory can be combined with autobiographical knowledge and novel creative expression that goes well beyond a mirrored skill.

Before leaving the issue of visual memory and Picasso's creative work, it is only fair to note that even Picasso's phenomenal memory had its limitations: 'Even Picasso's astonishing memory could not encompass eighty years of ceaseless activity: he could not recall, for instance, just when he had made some of his undated sculpture.'[94] His memory for visual images may have surpassed his autobiographical memory for time. And when Picasso developed Cubist portraiture, the challenge of the tasks was such that, as Patrick O'Brian notes, he had a greater need of sitters who were actually present, making them pose for long and repeated sessions.[95] Here, the memory demands of the novel task upon which Picasso embarked affected even the capacity of his visual memory to deliver all that was required. Picasso was a genius but not superhuman.

Picasso Sees the World

'Cubism is neither a seed nor a foetus, but an art dealing primarily with forms, and when a form is realised it is there to live its own life.'[96]

Picasso

It was 1907 and Picasso ushered three of his close friends, including Guillaume Apollinaire the poet, into his studio to see a new canvas. The scene depicted a brothel with five figures, probably all women, but the unprecedented forms were distorted and foreign, the depictions harsh, even ugly. This was no sensuous erotica or depiction of the beauty of the female form. The painting, *Les Demoiselles d'Avignon* (The Women of Avignon – see plate section), shows the first mixing of perspectives, with a face painted in profile simultaneously having an eye facing front, and full faces simultaneously having noses in profile. The bodies are made up of straight lines and angular planes, as though partially chiselled from wood. A figure on the right has a severely distorted face, with features jumbled and turned round right onto her back. Above her is another figure with elongated features, and on this half of the canvas the angular planes are sharper and more definite.[97] Picasso believed he had formulated a masterpiece, but the painting was greeted with incomprehension by his friends. It

was an awkward moment, and the tension in the air must have been palpable.

Les Demoiselles d'Avignon was the first explicit rendering of the style of art called Cubism and, despite the reservations of his friends and the negative media critique of Cubism that unfolded, the painting endured, shaping the future of art. It marked the onset of a new era in modern art and was later described as 'one of the most dynamic, liberating pictures of our age'.[98] Picasso recognised the significance of this step-change in his work: 'Every now and then one paints a picture that seems to have opened a door and serves as a stepping stone to other things.'

Picasso's drawings and sculptures in Cubism and beyond demonstrate sophisticated understanding of three-dimensional forms, reflecting his highly tuned ability to reflect upon and decompose the visual images that he saw. As the artist Poussin, much admired by Picasso, observed:

> You have to understand that there are two ways of seeing things, the one by just looking at them and the other by gazing at them with real attention. Just looking is merely the eye's natural reception of the shape and likeness of the thing seen. Gazing with real attention is not only that but also an intense study of the means of acquiring a thorough knowledge of the object. So it might be said that what I call just looking is a physical operation and what I call gazing is an operation of the mind.[99]

PICASSO'S DISCUSSIONS WITH GERTRUDE STEIN

Also there at the birth of Cubism was Gertrude Stein. She was an American whom Picasso met in Paris and she became

his friend, supporter and collector, though not his lover.[100, 101] Gertrude was an unusual person – clever, idiosyncratic, art-loving, rich and excited by new ideas. Picasso and Gertrude hit it off immediately. They energised each other so much that Gerald Murphy, the American painter, said, 'She and Picasso were phenomenal together. Each stimulated the other to such an extent that everybody felt recharged witnessing it.'[102]

Writing retrospectively in 1938 about their discussions, Gertrude said of Picasso, 'when he saw an eye, the other one did not exist for him and only the one he saw did exist for him . . . one sees what one sees, the rest is a reconstruction from memory . . . the Cubism of Picasso was an effort to make a picture of these visible things'.[103] Gertrude here points to Picasso's understanding of the influence of viewpoints upon the physical reality of what is actually seen.

To a neuropsychologist like me, one of the amazing things about Cubism is that it anticipated ideas in theories of visual perception that arose much later. Picasso anticipated the fundamental ideas within the theory of David Marr, a British psychologist and neuroscientist, whose work at the Massachusetts Institute of Technology in Boston in the late 1970s and the 1980s became hugely influential in the development of cognitive psychology and visual perception.[104] To understand the significance of the unusual way Picasso was thinking involves a bit more discussion about theories of visual perception.

PICASSO ANTICIPATES DAVID MARR

Historically, there have been two broad groups of ideas about how we analyse and recognise objects in the world around us. The first is a bottom-up, data-driven process that involves

building recognition from pieces of sensory information that are then integrated and combined; in effect, building up a picture from more and more complex pieces. By contrast, perception as a top-down process involves using our prior knowledge in the interpretation of visual information. We know that such top-down processes are involved. Ask people to judge the degree of greyness of a patch of colour, for instance, and they will judge it as being greyer if it is in the shape of an elephant rather than randomly shaped. Expectation – in this case, a prior knowledge of elephants – shapes the way in which that grey is experienced.

Strong support for the theory of bottom-up processing came many decades ago in the 1960s, with the discovery of individual cells, stacked in columns, in the visual areas of the brain that are sensitive to lines and edges at particular angles of orientation. These columns of cells are arranged in a clear pattern; as you move from one column to its neighbour, the angle of the line that makes the cells in that column respond shifts slightly, like moving round the spokes in a stationary bicycle wheel. So, if the first column responded to a vertical line, the next would respond to one tipped slightly away from the vertical, and so forth. This work attracted huge interest and led to a Nobel Prize.[105] Studies in this field appeared to provide evidence for bottom-up processing in the brain, building from fragments of partial information.

Nevertheless, the degree to which top-down processes are also significant was reconfirmed in the 1970s and 80s, when the development of cognitive science led to attempts to model human visual recognition in machines, or simply to enable machines to recognise visual shapes and objects. One evident difficulty in these early formulations was the fact that the image

an object creates is significantly influenced by the angle at which it is viewed. If you look at a chair in your house and then take a step to the side and look at it again, the chair remains a chair as far as you see it; you do not perceive any dramatic change in its form or character. Yet in practice what you have seen *has* actually changed completely. It is not simply that the pattern of light and shade has altered but, by shifting the angle of view, the relative position of the legs and seat that generate the edges of the structure, and the pattern of occlusion that hides part of the chair, will have changed completely.

Our perception of the constancy of the object and the continuity of its form is a consequence of top-down processing based on prior knowledge. This enables us to have what is called an *object-centred* view in which the chair sustains its form even when its view to us changes. By contrast, machines that build up an image of an object from its parts are *viewer-centred*, with the image changing as the view changes. Even now, the iris-recognition systems which have been installed at some airports experience difficulties because of this *viewer-centred* machine orientation. If the machine looks at an iris straight on it can recognise it rapidly and indeed in a way that no ordinary human could match. In this sense the machine vastly outstrips human ability. However, if the machine looks at an iris that is not perfectly aligned, recognition may fail and this creates a very slow person-processing system for airport customs or immigration queues.

This difference between *viewer-centred* perception and *object-centred* perception was discussed in pioneering work in the 1980s by David Marr. Working at the Massachusetts Institute of Technology,[106] Marr provided much of the foundation for our contemporary study of visual cognition, developing a theory in

which the brain formed an initial sketch made up of changes in texture and intensity. These fed into the extraction of what he called a two-and-a-half-D representation that was *viewer-centred*. However true visual recognition only occurred, he believed, when a 3D representation that was *object-centred* had been achieved.

At the same time, in the Neuropsychology Unit at Oxford University where I was working, case studies were being carried out with individuals who had sustained brain injuries, many of them gunshot wounds, some of whom were found to have retained the capacity to have a *viewer-centred* perspective but had difficulty with *object-centred* viewing. This meant that their ability to recognise was easily disrupted if an object was presented partially occluded or at a slightly unusual angle. We've probably all encountered quizzes that show photographs of objects taken from an odd angle, or with only part of the object visible, and all of us have difficulty recognising things if the information is sufficiently constrained or unusual in viewpoint. However, the Oxford patients experienced problems in recognising simple objects that we would normally find straightforward. The areas of brain injury in such studies show that the capacity to attain an *object-centred* representation appears to depend upon a specific region of the brain near the junction with those involved with vision, perception and memory.

Picasso, years earlier, in the development of Cubism, wanted to take away the effect of the knowledge-driven, top-down interpretation by the brain, which essentially equates to the 3D *object-centred* representation proposed by Marr. Instead, he wanted to focus on the reality of the visual stimulus and what the viewer actually sees, which in Marr's terms would be the

viewer-centred perspective: 'If only we could pull out our brain and use only our eyes.'

Even earlier, in 1857, John Ruskin, the English writer on art and social issues,[107] had argued for the importance of this approach in drawing. He argued for an 'innocence of eye' to enable the artist to draw what he sees and not what he knows, by which he meant that the artist should not allow his own interpretation to alter reality. Picasso took this approach to its limits, stripping out the artist's interpretation, knowledge and concepts of the world to drill down to what is actually seen. What this necessitated was stepping back from his own automatic perception and detaching himself from its object-centred focus, instead thinking about the pieces from which an image is constructed. This can be seen, for example, in Picasso's 1909 Cubist painting, *Jeune fille à la mandoline* (Young girl with a mandolin) in which he separates the image into component fragments (see plate section).

In this painting, the girl's breasts and shoulders are reduced to geometric forms that retain elegance and beauty. The head becomes a square with a large eye and rises above the pear-shaped mandolin. Although Cubist, the picture is very accessible and representational in the sense that there is no doubt as to the subject or the content. Patrick O'Brian particularly loves this work, saying, 'the picture is among the most delightful that he ever painted' and that it is what 'even the most sullen and dogged opponents of Cubism confess to be a masterpiece of its kind'.[108]

PICASSO AND BRAQUE

The term Cubism is said to have derived from the painter Matisse's observation that Georges Braque's work looks as though it has

been built up from little cubes. Louis Vauxcelles, an art critic, adapted Braque's observation, coining the term *Cubism* just as he had earlier coined the term for another art movement, *Fauvism*.[109] There were different phases of Cubism. These started with *Les Demoiselles d'Avignon*, running into full *analytical Cubism*, then developing into *synthetic Cubism*, where the image was built up rather than broken down and the first collages took form, and finally reaching *rococo Cubism*, where colour was richer and the components more ornate. In the first phase, Picasso worked closely with Georges Braque, during which time Cubism was becoming increasingly analytical.

Working with similar aspirations and drive, Picasso and Braque cooperated in their work. Aiming to take the artist out of Cubist work altogether, between 1908 and 1913 they often signed their pictures on the back of the painting rather than the front. One consequence for the gallery viewer is that certain Braque and Picasso paintings from this period are a challenge to distinguish. Picasso emphasised this importance of removing the artist from his work when he said, 'They ought to put out the eyes of painters as they do goldfinches in order that they can sing better.'[110] Braque and Picasso also developed other similarities; for example, they both favoured oval canvases for a time, as a way of dealing with corners so that the lines and angles of an ordinary frame did not repeat or impact upon the geometrical forms in their work.[111]

As *analytical Cubism* developed, its sculptural quality reduced, with greater use of flat planes that were in turn fragmented into tinier facets and components. The original object remained. Although at first glance some Cubist works look entirely abstract, an explicit relationship between the initial

reality of the object that evoked interest from the artist and the final reality of the picture is a fundamental essential. As Picasso said, 'There is no abstract art. You always start with something. Afterward you can remove all traces of reality.'[112]

In *higher Cubism*, the works become even more drilled down to essentials, with depictions of figures, musical instruments and a narrow range of objects such as bottles, pipes and glasses, and in many of these works it becomes harder and harder to discern the original subject. As Patrick O'Brian notes, by 1911, in an exhibition organised by Alfred Stieglitz for Americans, a Cubist nude was actually taken to be a fire-escape.[113] As Picasso thought more deeply about Cubism, he said, 'I paint objects as I think them, not as I see them.'[114] Picasso's early collage works were the forerunners of what became synthetic Cubism. Yet even in the most abstract depictions among Picasso's Cubist work, there remained a figurative reference; you could, for instance, despite the implication of the fire-escape error, always tell whether the painting was of a landscape or a person. Picasso never completed totally abstract work, and this was true throughout his life, even in the later days when highly abstract art became fashionable in the 1960s.

PICASSO AND CUBISM

For Picasso, Cubism was a way of communicating in a different language that felt right to him. When asked what his aim had been he said, 'To paint and nothing more. And to paint seeking a new expression, divested of useless realism, with a method linked only to my thought – without enslaving myself or associating myself with objective reality.'[115]

'Many think that Cubism is an art of transition, an experiment which is to bring ulterior results. Those who think that way have not understood it. Cubism is not either a seed or a foetus, but an art dealing primarily with forms, and when a form is realised it is there to live its own life ... Mathematics, trigonometry, chemistry, psychoanalysis, music and what-not, have been related to Cubism to give it an easier interpretation. All this has been pure literature ... We give to form and colour all their individual significance, as far as we can see it; in our subjects, we keep the joy of discovery, the pleasure of the unexpected; our subject itself must be a source of interest.'[116]

Picasso's reflections about perceptual input and the representation of images are based less upon anything innately or physically unusual about his own visual perception, and more upon the self-reflective and higher-level problem-solving capacities of his frontal lobes.

The Cubist use of differing perspectives within the same picture was not restricted to portraits or figurative work; landscapes and still lives were given the same treatment. For some the resultant fragmented landscapes with differing perspectives simultaneously present, generated paintings that actually look similar to the portioned arable and farming land of Picasso's native Andalusia. Still lives included pictures in which the table would be seen simultaneously sideways and from the top. As Braque said of the Renaissance to John Richardson,

the hard and fast rules of perspective ... were a ghastly mistake which it has taken four centuries to redress ... Scientific perspective is nothing but eye-fooling illusionism; it is simply a

trick – a bad trick – which makes it impossible for an artist to convey a full experience of space, since it forces the objects in a picture to disappear away from the beholder instead of bringing then within his reach as painting should.

Traditional perspective ... has its origins in a single viewpoint and never gets away from it. But the viewpoint is of little importance. It is as if someone spent his life drawing profiles and believed that man was one-eyed.[117]

The transformation of style that Cubism represents can't be understated. As the art critic John Golding[118] said, pointing out that portraits by Raphael and Renoir are more alike than those of Renoir and the Cubist Picasso, it was 'the most important and certainly the most complete and radical artistic revolution since the Renaissance . . . from a visual point of view it is easier to bridge the three hundred and fifty years separating Impressionism from the High Renaissance than it is to bridge the fifty years that lie between Impressionism and Cubism'.

Nevertheless, Cubism was met with considerable critical resistance, and even when it was finally being accepted in Paris itself, resistance remained elsewhere. The London *Times* in 1912 noted: 'his [Picasso's] purely theoretical experiments are unintelligible to the eye and to the mind . . . They depress us as if they were diagrams of a science about which we know nothing.' But, as Patrick O'Brian notes,[119] sixty years later the same newspaper said he was 'a draughtsman of genius, and there is probably no single artist except Giotto or Michelangelo who can justly compare with him in being responsible for so radically altering the course of art in his time'.

In 1912, there was a substantial display of Cubist paintings in Paris in which Juan Gris, also a Spanish painter and the third leading proponent of Cubism after Picasso and Braque, showed his work *Homage to Picasso*, a portrait of Picasso executed in a Cubist style (see plate section). This was the start of Juan Gris's development of Cubism in a structured and mathematical way that partly derived from his own background studying mechanical drawing and was later to incorporate the use of a much richer colour palette than that used by Picasso or Braque.

The mathematical approach to Cubism used by Gris actually involved making calculations and physically using protractors and compasses to structure his work. It seems that he wanted to hide his use of these: after his death Gris asked his wife and his dealer to destroy the preparatory drawings that revealed the underlying mathematical principles, so only a few that provide evidence of his mathematical analyses survive. The scaffolding and grid that were part of some of Gris's work influenced the structure of certain subsequent works by Matisse.

The scientific analysis and thought that underlies elements of Cubism were important to Picasso, but he did not like those who started to theorise about Cubism and were dogmatic about its underlying principles. Picasso himself never adopted the rigorous mathematical approach that Gris had absorbed. Nor did he agree with the excessive interpretation of symbolism and representation that many placed upon Cubism, though he did admit to seeing women as guitars. He said, 'Critics, mathematicians, scientists and busybodies want to classify everything, marking the boundaries and limits . . . In art, there is room for all possibilities.'

TWO SIMULTANEOUS PERSPECTIVES

The 1912 Paris exhibition in which Gris showed his *Homage to Picasso* also included work from a newcomer, Diego Rivera, the Mexican artist, who brought with him a pre-classical, South American Tlatilcan sculpture – a female figurine – dating from 900–500BC (see plate section). Usually painted red and wearing a turban, band or other head ornament, such sculptures typically have either two heads or a dual face with two mouths, three eyes, and two noses, so that the full face can be seen at the same time as the profile, without discontinuity. The statue would appear to be a crucial precursor of Picasso's later very characteristic dual-perspective renditions of heads, and another example of the critical influence of ancient sculpture upon his work.

Some of Picasso's dual-perspective renditions combined different moods in full-face and perspective blend; a portraying of contrasting elements of the human personality that may have been influenced by Robert Louis Stevenson and his *The Strange Tale of Dr Jekyll and Mr Hyde*. Just as Stevenson presented two conflicting characters within the same man that could not both be recognised at the same time, Picasso often presented two different *viewer-centred* views within the same picture, even when he had moved on beyond Cubism. So, in a picture of a face, for instance, he would often present both a front and a side view at the same time. However, as we are not used to seeing two different views at once, these paintings produce an effect on the brain something like that of the challenge to perception posed by a Necker cube, which can be seen in one of two ways but not as both simultaneously.

Named after Louis Albert Necker, a Swiss crystallographer who first published a similar illusion in 1832, the Necker cube

A Necker cube.

is an ambiguous line drawing of a cube that can be seen in two ways, with one of the square faces either at the front or the back of the cube. If you look at a Necker cube it switches between one view and another. You should experience a sudden jump as one of the faces of the cube at the front flips to the back or vice versa. Keep looking and it will jump back. This effect is known to be dependent upon the frontal lobes, providing us with further evidence of top-down perception as the brain tries to resolve the competing interpretations of what it sees.

In Picasso's work, the simultaneous alternative perspectives often relate to faces or bodies. So, for example, in linocuts of his second wife, Jacqueline Roche, the face is shown both frontally and in left profile. In order to see the profile view clearly, your brain has to push the full-face side of the picture into the background. Just as with the Necker cube, the brain finds it impossible to see both perspectives simultaneously, as each is the outcome of a different decision by the brain about what the picture represents. On initial view, faces like these look distorted but what Picasso is actually showing you

is two different, *viewer-centred* views that would normally be integrated into a single *object-centred* view, but which he has left distinct. Interestingly, when the two views are less different in angle – for instance, as with two slightly different side views – it seems to be easier for us to achieve an integrated overall perception. This is evident in some paintings of Picasso's earlier muse, Dora Maar, which are inherently more attractive because of that easier integration.

Picasso was not the only artist to use alternative perceptions to create visual impact. A number of artists use visual illusions and one master of this approach is Bridget Riley. She uses lines of varying width and intensity to create varying sensations of depth, movement and perspective. Her paintings have a robust impact in black and white but also have strong emotive content in colour. Riley tricks the visual system, making it interpret the world in a way that is not accurate. For the viewer, we simultaneously know that what we 'see' is not real, yet we experience it all the same, and this contrast between reality and our own experience is thought-provoking and evocative. Many other artists have also cleverly made use of the mistakes in the interpretation by the brain that such visual illusions illustrate.

GESTALTS AND FEATURES

After Cubism, Picasso unexpectedly reverted to realistic drawings of classical mythological subjects and then colossal women, in which the proportions were shifted so that the perceptual impact is loaded. Simultaneously, he continued with some Cubist work, executing dramatically contrasting styles within the same time period. Indeed, in some drawings in the

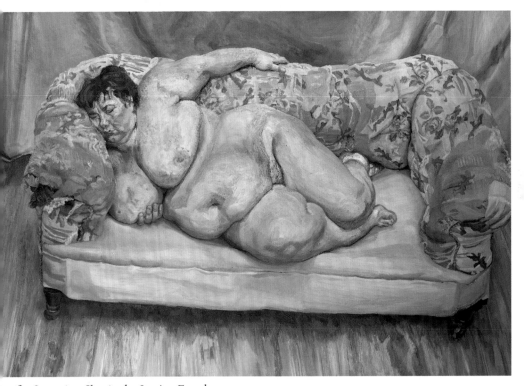

Benefits Supervisor Sleeping by Lucian Freud.

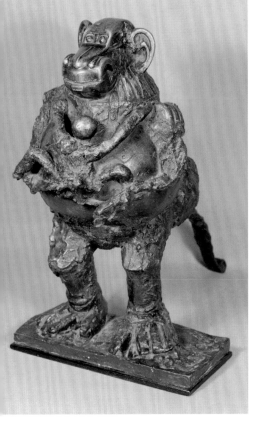

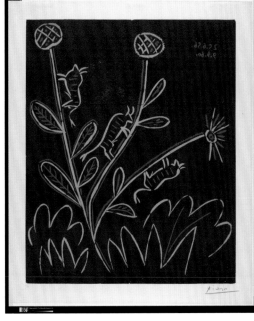

(left) Picasso's *Baboon and Young*.

(above) Plant with Little Bulls by Picasso.

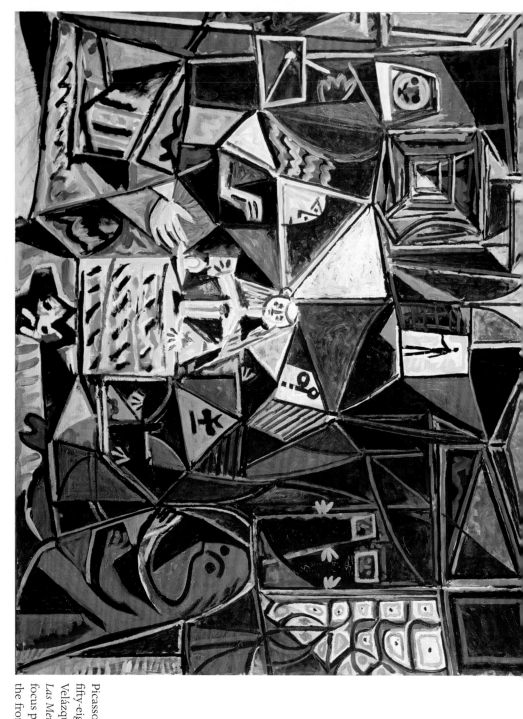

Picasso produced at least
fifty-eight interpretations of
Velázquez's 1656 masterpiece
Las Meninas, a number of which
focus particularly on the child at
the front of the painting.

An example
of Peter
Howson's
paintings of
the Bosnian
War, *Cleansed*.

Les Demoiselles d'Avignon by Picasso.

Picasso's 1909 Cubist painting, *Jeune fille à la mandoline*.

Homage to Picasso, by Juan Gris, a portrait of Picasso executed in a Cubist style.

A pre-classical, South American Tlatilcan sculpture – a female figurine – dating from 900–500BC.

Examples of Picasso's innovative style called *Curved Graphism*, depicting Marie-Thérèse Walter.

Anish Kapoor's *Cloud Gate*, and the *Orbit*.

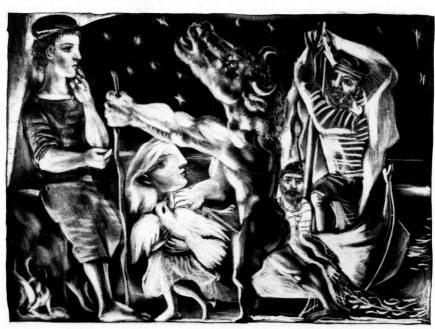

Blind Minotaur led by a Little Girl in the Night by Picasso.

ref Armagan with examples of his work.

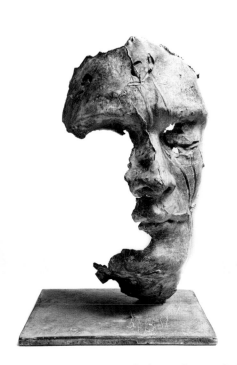

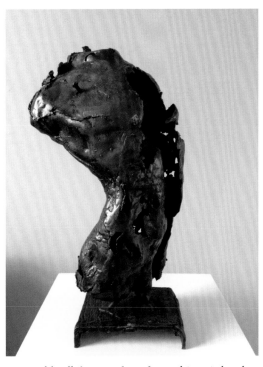

any of Simon Bacon's works have what psychologists would call *divergent laterality* – chimeric heads
th one side that looks explicitly like a head, while the other is abstract, enclosed and inaccessible to
rbal labelling, mirroring the hemispheric asymmetries of the brain.

William Notman was particularly known for his work with what were called *composite photographs*.

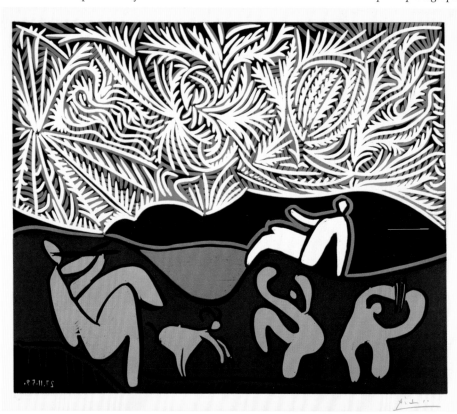

One of Picasso's 'bacchanale' linocuts, which depict mystic festivals, revelry and dancing, where he made use of what is called the *jigsaw technique*.

series of works called the *Vollard Suite*, he drew people in contrasting styles within the same drawing, one figure classical, the other Cubist.

Some of the most expensive of Picasso's works are the portraits of his young and beautiful lover, Marie-Thérèse Walter, who was not even born when the first Cubist paintings were produced. These are in a later innovative style called *Curved Graphism*, which, in common with Cubism, involves the abstraction of elements but in a completely different way that is visually very accessible to the viewer and easy to understand. As the name suggests, the portraits are reduced to curved lines, often bold and black, that are then filled with sections of deep colour (see plate section). They are not truly abstract but are clearly representational and recognisable, but again they shift normal proportions, with an emphasis on curves that create sensual elements. These works have particular impact upon the viewer but they are not so far from normal proportions and perspectives as to be difficult to understand. We know that people like pictures more if they can understand them easily, and we also know that people like curved objects more than angular objects.[120]

An interesting facet of Curved Graphism is that whereas Cubism emphasises component features and is less concerned with the overall shape, Curved Graphism emphasises the overall shape more, with fewer internal features. In psychology jargon, Curved Graphism encompasses more of the overall gestalt of an image, whereas Cubism emphasises the assembly of internal features. We know that these two different aspects are processed distinctly within the brain and, although normally combined, each can be individually impaired by brain injury or disease,

leaving the other process relatively intact. Such dissociation of perceptual ability can result from injury that is restricted to one half of the brain but can also appear as a consequence of developmental genetic disorders. So, in a childhood disorder that results from a genetic abnormality, Williams syndrome, there is a great focus on internal features and relative neglect of the overall gestalt, whereas in the better-known syndrome that also results from genetic abnormality, Down's syndrome, the reverse is true. This difference is illustrated in studies of the drawings made by some of these children, though, as with much of science, there are also some more complicated effects when you move beyond drawing. Picasso was a master of both perceptual processes, not simply integrating them in his own work but actually dissecting them in different styles throughout his artistic career, thereby creating utterly novel visual effects. In the normal healthy brain, we use both systems automatically, and Picasso's dissection of them makes his work violate automatic visual expectation.

Picasso's early capacity to extract key features and drill down to the fundamentals began with single line drawings with a stick, in the dust and sand outside his flat in Malaga. His skill in extracting signature features can similarly be seen in his Cubist work, as well as in drafts of other works that began as highly realistic but then progressed to highly abstracted and simplified depictions. In these works, Picasso drills down to essentials and extracts the key features, displaying much the same skill as modern-day cartoonists who extract and then exaggerate details to generate a more extreme depiction of a person than the reality. Indeed, later in his portraits, Picasso would slightly distort salient features in the manner of a cartoonist, galvanising the portrait with an immediacy.[121]

How pervasive is the ability to extract key features from what we see? In a 2010 study in New York, Aaron Kozbelt and his team explored the extraction of key features, examining art students alongside students from other fields.[122] The students were given a grayscale photograph of Samuel Beckett, the Irish writer, taken by Jane Bown and now held in the National Portrait Gallery, London. The photograph was placed inside a plastic folder and the students were given seventy short pieces of brown tape with which to make a 'drawing' of the face. The pictures were then rated for accuracy, and the results showed that those produced by the art students were significantly more accurate than those produced by the students from other disciplines. This is not so surprising, but there was also a difference in the style and form of what the students produced. The art students used significantly more pieces of tape for the internal features – eyes, nose, mouth – capturing the signature facial features, whereas the other students allocated more tape to creating the outline of the face and producing a more generic representation. This difference in approach reflects a fundamental disparity in the way that their brains were thinking about the image.

We know from Picasso's work that he, like the art students, could extract and focus upon internal features but also that he simultaneously analysed the overall structure or gestalt, developing each approach into unique styles of visual representation. He was aware of the perceptual impact of his work, saying, 'I'm out to fool the mind rather than the eye and that goes for sculpture too.'[123]

Picasso was reluctant to discuss the 'periods' of his work or its evolution. To him everything was integrated into a continuous

process and language.[124] 'The different styles I have been using in my art must not be seen as an evolution, or as steps towards an unknown ideal of painting. Everything I have ever made was made for the present and with the hope that it would always remain in the present.'[125] Indeed, one of the extraordinary aspects of Picasso's work is that so much of it does seem to be in the present. His works do not look like historic relics but continue to surprise us, many looking as though they were created recently even though some are nearly a century old.

PICASSO AS A 3D PERSON

Picasso's capacity to understand the subtleties of different perspectives and the relationship between two- and three-dimensional space extended beyond Cubism in sculpture, collage and ceramics. His genius as a creative artist was evident in painting three-dimensional forms in different styles but also dramatically evident in creating three-dimensional forms that require sophisticated visualisation of the ultimate design. These conspicuous 3D visualisation and realisation skills are evident in the many thousands of sculptures that Picasso created, from the humorous sculptures that incorporated the playful use of his children's toys, to the vast swathes of sculptural portraits of lovers, friends and animals, to the smaller intricate constructions and designs, and the large-scale studies such as the Chicago Picasso that dominates downtown Chicago. Together these highlight a capacity for advanced mental imagery and mental manipulation of 3D shapes and structures.

A classic psychological test of these abilities involves looking at pictures of three-dimensional forms that are made up of small cubes. Each picture has angles and strands running in different

Examples of the 3D forms used in mental rotation tasks.

directions. The challenge in the task is to match pictures that are actually of the same construction but viewed from different angles. All the pictures are similar but some, if turned around or viewed from a different angle, would not quite line up or might end up as mirror images rather than identical. Participants are asked to identify which pictures are the same figure viewed from different angles and which are different figures altogether. Some people find this much easier than others. Psychologists call these tasks of *mental rotation*. This ability is among the vital underpinnings of the work in which Picasso excelled.

Chicago is one of the best cities in the world for public sculpture, and in addition to the Chicago Picasso there is another large sculpture by the British sculptor Anish Kapoor called *Cloud Gate*, whose mirrored surface adds to its impact (see plate section). The actual process of constructing such vast sculptures is extraordinary to see and brings home the complex 3D conceptualisation that has been required in the creation of their design. When I travelled to London on the train in 2012, I passed the site of the London Olympic

Games and witnessed the gradual construction of the Anish Kapoor sculpture, *Orbit* that has a viewing platform at its summit (see plate section). With each trip to London, the sculpture had crept upwards slightly but only quite near the end was it really possible to appreciate its fabulous form. It is 115 metres tall, that is 22 metres taller than the Statue of Liberty in New York.

The *Orbit* is Britain's largest piece of public art and like the Leaning Tower of Pisa, it looks as though it is about to fall over. This is one of Kapoor's themes: 'a certain kind of disorientation that I hope reorients.' For the Orbit, he 'wanted to have the sensation of a certain kind of instability.' Just as Bridget Riley uses visual illusion to create unexpected impact, so Kapoor is interested in the impact of a 3D structure that seems to counter gravity. For such a complex construction, more than a sculptor is required and Kapoor worked with Cecil Balmond, an innovative engineering genius who develops new ways of operating. New techniques and ways of operating also contribute to the brilliance of Picasso's creativity, of which more later.

Anish Kapoor does not just design amazing 3D sculpture, he designs amazing 3D actions. In an earlier Royal Academy exhibition of British sculpture in London, his cannon firing large pellets of red wax that then splurged onto the wall mounting up to create an inherent sculpture of red wax, was a powerful 3D action experience that drew movement into the design process. In trying to understand these novel works, our own frontal lobes are active in forming associations, problem solving and evoking emotional responses. The surprise and novelty of the movement contributes to the impact of the art on the viewer.

It is not just sculptors like Picasso who have highly developed 3D visualisation and mental rotation abilities. Architects, engineers, applied mathematicians and scientists – involved in the micro-structure of biological and physical forms and the macro-structure of architectural forms – also excel in these skills that otherwise vary significantly in the normal population. Such 3D skills are demonstrated currently in the curves, windows and patterned forms of the work of the tri-national Canadian, Israeli, American architect Moshe Safdi in the National Gallery of Canada and the Montreal Museum of Fine Art; in the novel structural forms of the Italian architect Renzo Piano in the Pompidou Centre in Paris and the Shard in London; and in the tilting geometry that combines with slanted walls in the work of Daniel Libeskind, the American architect of Polish descent, and with curved walls in the work of Frank Gehry, the Canadian-American architect. These four leading architects illustrate the conspicuous 3D skills that underpin architectural genius.

LEFT-HANDERS AND EXCEPTIONAL 3D TALENT

Left-handers as a group typically have highly developed 3D visualisation and mental rotation abilities compared to groups of right-handers. Although not every left-hander will have these strengths, laboratory experiments reveal that many do.

We know that the brains of right- and left-handers are different but it is not simply that left-handers have a mirror image of the organisation of the brain of a right-hander: one of the complications in studying left-handers is that there are different kinds of left-hander. Some have brains organised in a similar way to right-handers, which means that most of their

language is controlled by the left half/hemisphere of the brain. Although this is the most common pattern, a smaller group have brains organised the other way round, most of their language being controlled by the right hemisphere of the brain. In both of these groups of left-handers, the difference between the two halves of the brain is not as big as for right-handers.

Evidence comes from looking at areas of brain activation in brain scanners that pick up blood flow or glucose uptake or changes in the magnetic field or electrical activity of the brain. You can also pick up differences between the brains of left- and right-handers in studies of the effects of brain injury. For example, left-handers are more likely to have a language disorder following a stroke or brain injury, but they are also likely to recover better. This is thought to result from the area of language control being spread out more in the left-handers, although it is more likely that an area involved with language will be hit, there is more residual capacity to recover, given that there are more areas of the brain involved with language.

Some theories of the brain predict that if language were more spread out in the brains of left-handers, using up capacity, then visual and spatial abilities might be squeezed out and reduced, but this does not seem to happen. In fact, some left-handed 3D thinkers are exceptionally talented. Something about the different organisation of their brains conveys advantage to at least some of them. Picasso himself was not left-handed, but there are lots of examples of left-handed genius. Einstein was a genius at 3D visualisation and he was left-handed. Leonardo da Vinci was brilliant at 3D visualisation and he too left-handed. Then again, with about 10 per cent of the population being

left-handed, you would expect there to be quite a few left-handers among the world's geniuses.

Another way to look at 3D talent and handedness is to look at the population of the gifted and talented who work in fields that depend on 3D thinking and see whether you get an increased number of left-handers among them. This was something I explored back in the 1980s, at the University of Oxford.

The study went as follows. I asked all of the members of the academic faculty in seven departments to take part: law, modern languages, mathematics, theoretical physics, theoretical chemistry, engineering and computing.[126] The study included a standardised questionnaire that assessed handedness. I attained a very high response rate of 95 per cent, meaning that about 350 academics took part. Law and modern languages were disciplines that were highly verbal and where 3D visualisation was unlikely to be relevant to success. The incidence of left-handedness in these two departments was 11 per cent and 12 per cent. Mathematics is another analytical discipline that is very logical and deductive. The incidence of left-handedness for the Mathematics department was just 5 per cent, quite low. The other four departments were sciences where 3D visuo-spatial skills might be significant. Here the rate of left-handedness was 16 per cent, significantly higher than for the analytical mathematicians, and above the normal level in the population. So there is evidence from this study that in a gifted and talented population of academics from one of the world's leading universities, there is an elevated rate of left-handedness in the subject areas employing visuo-spatial skills.[127] This supports an association between visuo-spatial talent and left-handedness.

Other studies of individual professions have backed up this concept.

Brain-activation studies show that the right parietal area of the brain underpins the mental rotation and 3D visualisation skills for which some left-handers seem to have a particular penchant. Highly creative activity in the professions that use these skills depends, however, upon their use in novel or innovative ways, and to achieve that, additional activation of frontal lobe circuitry is required.

Another individual difference that may be relevant is sex. Studies of groups of men and women have showed small average advantages for women in language tasks and small average advantages for men in visuo-spatial tasks, but this is not the same thing as saying that exceptional talent or genius for visuo-spatial skills will be more common in men. Looking back to my study of the Oxford academics, 19 per cent of the verbal academics were women but only 6.6 per cent of the other academics were women, a rate of 12.6 per cent overall.[128] While this might at first suggest lower rates of talented women in the spatial areas than the verbal areas, cultural elements are probably relevant. In the UK we know that there has been a steady increase in women studying sciences and mathematical disciplines, but that occurred too late to influence the levels among academics in my 1980s Oxford study. The overall level of 12.6 per cent also contrasts with the average UK level of female academics at the time of 22 per cent, indicating that fewer women were being appointed in Oxford than elsewhere. Social and cultural factors were likely to be pertinent at that time. Since then, the percentages for both the UK and Oxford have increased. So the question remains open. Its relevance to Picasso is the

issue of whether being male allowed his brain to develop in a way that gave him an edge in 3D thought, or whether it simply conveyed a cultural advantage in enabling greater independence of activity and action.

Picasso's own visuo-perceptual judgements and precision extended beyond art and creative fields. For example, he was very accurate at shooting. In his early trips to the rural uplands with the Pallares family, he learnt to shoot and rapidly became almost as good a shot as his much more experienced hosts. Living most of his life in cities, it was never a skill that he developed fully, but even as an older man, he would wow his very much younger second wife, Jacqueline Roche, with success and prizes from fairground shooting galleries.[129] Picasso retained these acute 3D visuo-perceptual skills and quick reactions into old age. Even his friends noticed his lasting speed and accuracy. As late as 1960, when he was seventy-nine years old, he was still able to catch a cigarette holder that a friend dropped before it touched the ground.[130]

COLOUR

Despite Picasso's extraordinary artistic talents, his use of colour was less astounding. It was Henri Matisse who had the edge in the colour stakes. Picasso and Henri Matisse met at Gertrude Steins' home in March 1906,[131] and so began a lifelong friendship, with Picasso saying of Matisse 'he is our greatest painter'.

Unlike many artists, Picasso was not inspired by the light effects created by the impressionists' use of colour, despite the potential of the new techniques. For Picasso, colour was often something added after the composition of a picture was formulated; he

confessed that he added colour to his work 'the same way one puts salt in soup'.[132] He was, though, fascinated by light effects, for example those created by overhead electric light that appeared in his later still lives to striking effect: 'Colours are only symbols and reality exists only if there is light.'[133]

For Henri Matisse, though, colour was a fundamental integrated part of the conception. So Picasso might add colour as a device to catch the eye and attention but Matisse would contrast colour hues to create fundamental effects of style and structure with emotional and aesthetic impact. Rich colour was integral to his work. His instinctive sensitivity and capacity to use colour had been enhanced by his extended exposure to rich colour as a child in the town of Bohain-en-Vermandois, in Picardy, an area of France that had been the centre of cloth and fabric manufacturing since the Middle Ages. From early days, Matisse collected swatches and scraps of coloured fabrics, savouring the pieces. Many of his fabrics actually appear in his paintings, not as exact copies but as derivatives in his own style that retain clearly recognisable designs and hues through which we can identify the originals from which they have evolved.

Colour permeates Matisse's work extensively. He was analytical and constructive in its use, as well as instinctive. Bohain was known for its experimentation with fabric design and Matisse would have seen the effects of dying fabrics in different colour combinations. Later, he would sometimes do this with his paintings, executing them in one colour combination and then in a different combination, as if he were dealing with textiles rather than a painting. His palette of colours was not simply rich but also bold, innovative and structured with contrasts.

In contrast, Picasso had a background involving exposure to Spanish paintings, such as those of Velásquez, that are dominated by blacks, greys and browns, once saying, 'The only real colour is black . . . If you don't know what colour to take, take black.'[134] Picasso was aware that he had not grasped colour with the same ease as Matisse. He said to Matisse, 'I've mastered drawing and am looking for colour; you've mastered colour and are looking for drawing.'[135]

So for all the genius of Picasso, Henri Matisse had greater genius with colour. Whatever facets gave Picasso genius, colour was not essential to them. The brain of Matisse drew colour into the creative process and was as integrated with the original conceptions as the composition and content. Even with artists like Picasso and Matisse, working on related themes in the same era, the mode of their creative process differs subtly but significantly.

PICASSO AND BLINDNESS

Picasso was acutely aware of the critical importance of his vision and perceptual skills in developing and expressing his art. For an artist to lose this vision would be the ultimate sensory loss and perceptual devastation. Concerns with blindness permeate Picasso's work and the theme was recurrent throughout his life, emerging in his early Blue Period work when blind and starving individuals appear.

Picasso's preoccupation with blindness may have had its roots in his early struggling days in Paris when he would have witnessed in the streets cases of blindness as well as starvation and deprivation. By the time he was in his early twenties, his father was also losing his sight. The personal immediacy of this

and its impact on his mother and family as well as his father's own life would have been very salient, including awareness that his father would no longer be able to derive pleasure and employment from drawing in the way to which he had been accustomed. Similarly, Picasso was horrified when Georges Braque was wounded in the First World War, the injury nearly blinding him.

In a later work from the 1930s, blindness appears in the guise of a blind Minotaur led by an innocent girl (see plate section). The child's face is that of his young mistress of the time, Marie-Thérèse Walter, which suggests that Picasso may have seen himself as the blinded Minotaur. The prospect of blindness terrified him, even when there was no imminent danger of any such development.

We know from various studies of those born blind that perception of the world is not necessarily dependent upon sight and, extraordinarily, it is possible to develop 'visual' imagery of a world you have never seen. In fact, it is even possible to become a visual artist without ever having seen the world. A striking example is Esref Armagan, who was born without eyes yet is a creative painter. He paints houses, landscapes, lakes, faces and butterflies; he uses colour, shadow and perspective; and he can paint things from different angles and viewpoints (see plate section). Yet he has never seen anything in the conventional sense.

Esref has learnt about the world simply by touch and by talking to people, with no visual experience. Unexpectedly, he became interested in drawing at an early age and developed the ability to paint and draw using a tablet that allows him to feel the lines of the images that he is constructing. While his use of colour has probably been learnt from what people have

said to him about colours, his ability to draw comes from skills he has developed without instruction from others, as he has had no formal training.

Studies undertaken in Boston showed that when Esref was given objects to draw, the areas of the brain that were activated included exactly those that would normally be triggered by visual experience itself. The primary visual cortex in the occipital lobes was activated, as well as parts of the parietal lobes involved in both recognition and drawing, and also the prefrontal cortex normally involved in demanding visually creative tasks. These areas of activation were triggered even though Esref's brain has never had visual input. In drawing, brain activation was also greater in the right hemisphere of Esref's brain than in the left.

The Boston studies confirmed that there was no response from the visual cortex to light, so it was not that visual information could somehow miraculously reach Esref's brain without going through his eyes. He was indeed totally blind, but the areas of the brain that would normally have responded to light and visual signals had not died; rather, they had been drawn into circuits with the rest of his brain and were activated when Esref engaged in tasks that would normally evoke visual imagery. Some of the areas activated when Esref drew overlapped with areas that were activated when he had to imagine the pictures he was going to draw, but the greatest activation was when drawing was actually taking place. These levels of activation were similar to those that a sighted person would generate when drawing.

Esref could feel a new three-dimensional object and then convert it into an accurate two-dimensional drawing. Many of us who are sighted struggle to do this competently. All of us,

however, make use of tactile signals to get a sense of space and structure around us, and when we are negotiating a familiar environment we can make judgements about space relatively automatically without actually looking. It's much easier, for example, to find your way around your own house in the dark or without your contact lenses, than it would be to find your way around a friend's house. We all have mental constructions of space and structure that can be accessed in the absence of visual information, but what is extraordinary about Esref is that he has been able to construct these without sight and then depict them on paper in a visual way that is accessible to the sighted population. When Esref explores objects by touch, 'visual' occipital areas of the brain are activated.

These results show that the main visual areas of the brain in the occipital, parietal and frontal regions, underpin knowledge about the appearance of objects and spatial understanding, even without visual experience. Esref can translate this knowledge, or what psychologists call *mental representations* of objects, into a form that is understood by sight. Perhaps Picasso would not have been surprised. He said, 'Painting is a blind man's profession. He paints not what he sees but what he feels.' Esref goes beyond painting what he feels. He paints what others can see, even when he cannot see in a conventional sense himself. In so doing, he raises questions about what it means to see.

CHAPTER 4

Picasso Gets Practical:
Technical Wizardry

'When art critics get together they talk about Form and Structure and Meaning. When artists get together they talk about where you can buy cheap turpentine.'

Picasso

CAPABILITY AND CREATIVITY

As a child, Picasso would sit looking at the pigeons that fluttered around the square where he lived, watching his father Don José drawing and painting them with sustained fascination. Like most fathers, Don José shared his interests with his son, giving him the physical apparatus for drawing – pencils, pens, paper and sketchbooks, as well as teaching him the first rudimentary elements of composition and execution. A strong predisposition by Picasso towards artistic expression may have strengthened the vibrancy of this parent–child dynamic; the *eco-niche theory* discussed in Chapter 1 arguing that genetic predisposition may lead a child to respond to particular things in the world, with the parent then noticing and responding in turn to the child's interest, so that a positive cycle ensues. In Picasso's case, his interest and enjoyment in drawing was evident and Don José and Maria responded by

giving him more materials, more opportunities and praising his drawing. So Picasso's genes may have intensified the cycle of parent–child activity in art; in this way, genetic predisposition may drive a child's environment to enable the early acquisition of skills that are necessary for success.

Picasso, then, had not only the interest but also the opportunity to develop his artistic skills from an early age. Learning to draw enabled him to acquire the skills that ultimately helped him to express his creative potential and generate the works that reflect creative genius. Picasso himself recognised that underlying skills and techniques were important for his work: 'The more technique you have the less you have to worry about it. The more technique there is the less there is.' Mastery of the relevant techniques frees up the brain to concentrate on the other facets of creative expression.

Well-practised skills and techniques may have been a necessary prerequisite for the expression of Picasso's art but this does not mean that repeated practice is the actual origin and basis of genius. Indeed, Picasso recognised that in the development of his art, he had to do things that were not well practised, saying, 'To blossom forth, a work of art must ignore or rather forget all the rules . . . Each time I undertake to paint a picture I have a sensation of leaping into space. I never know whether I shall fall on my feet. It is only later that I begin to estimate more exactly the effect of my work.'[136]

One theory, however, about gifted artists or any gifted individual is that they have simply practised and practised until they have built up an extremely large number of hours of experience. In this theory, the distinguishing characteristic between someone who is simply capable and someone who is exceptional

is the hours that they have spent on the task. Exceptional skills are thus seen as little more than a consequence of extreme practice. This theory has received a lot of attention recently and involves the idea that there are no such things as inherited genius or genes that predispose to genius or exceptional talent. There is no innate talent or biological predisposition, or necessary combination of multiple talents; instead, genius simply results from environmental influences and intense exposure, hard work and deliberate practice. The ideas build on research into expertise that has argued that it takes ten thousand hours of practice to become an expert.[137]

In some ways, the idea of practice leading to expertise leading to genius is an appealing theory, as it suggests that any of us might become a genius if we are just put into the right environment and then work really hard, with lots of practice and effort. It is also an appealing idea for parents, as it suggests that if they expose their own child to the correct environmental influences and encourage hard work and extended practice, then their child may become a genius too. The recent plethora of books addressing such a theory contain lots of self-help suggestions about how to bring out the genius in your child or indeed in yourself.[138] But is this an entirely rational or feasible path? In reality, lots of families try to create exceptional abilities in their children but few succeed in ultimately demonstrating genius. If excessive practice enables genius, why is there not more of it about? If correct environmental exposure and lots of practice were the fundamental basis of genius, a lot more children and adults would be geniuses. Enthusiastic parents nurturing their children by exposing them to lots of positive experiences and encouraging dedication and practice may

indeed enable them to learn to play a musical instrument or to become highly musically proficient, but genius itself does not necessarily follow. Being highly skilled can bring great pleasure, and accomplishment is both absorbing and satisfying, but this is not the same thing as being a creative genius.

One of the problems here seems to be confusion between something that may be essential or necessary to bring out genius, and the fundamental basis of the genius or talent. For genius to find expression it may be necessary to expose it to opportunities for that expression and, in some areas, a high degree of practice may be required, depending on the form of the genius. In the musical realm, many famous composers did indeed have high levels of musical exposure during childhood, including Wolfgang Amadeus Mozart, and a plethora of German composers, from the extraordinary and multi-talented Hildegaard von Bingen in the twelfth century who listened to monastic singing eight times a day, to Bach, Beethoven, Mendelssohn, Schumann, Richard Strauss and Wagner. The intensity of musical exposure may have been necessary to enable their musical genius to develop, but in each case there was something more.

Why do scientists think that there must be something more than exposure and practice? Well, one source of evidence is that there are lots of people who have put in ten thousand hours of practice and have not become geniuses or even reached the top of their own tree. For example, most professional musicians will have engaged in high levels of practice and have had a rich musical environment. John Protzko and Scott Barry Kaufman, academics from New York and Brussels, note in their review[139] of a book concerning practice leading to genius that the second

violinist in the Charleston Philharmonic has been surrounded by music since an early age and may have put in the requisite ten thousand hours of practice but is nevertheless not a genius. Similarly, they talk about Caroline Weber, who was the best female gymnast to ever come out of Austria and who possessed raw talent, determination and resilience. Caroline must have put in ten thousand hours of practice before she became part of her country's 2008 Olympic team. In the end, though, she came seventeenth, did not win a medal and has not advanced further since. Caroline, like the professional musicians above, is highly skilled and demonstrated real accomplishment and achievement, but she did not create the indelible mark of genius in history. As Protzko and Kaufman discuss, practice may be necessary for genius but it is not sufficient for genius. Something else is required. Exceptional genetic predisposition creates the root from which the environment and extended practice may draw out genius.

Genius itself is very rare. Given our contemporary liberal and meritocratic philosophies, we may like to believe that anyone can be a genius if given the right opportunity and practice, but really this is wishful thinking. The world is certainly full of rich possibilities but it may not be full of all possibilities.

CREATIVITY AND TALENT WITHOUT PRACTICE

Extreme practice may not be enough to elicit exceptional creativity, but is it even necessary? Could someone who has not practised for ten thousand hours nevertheless have such raw talent that exceptional creative ability emerges without practice? This would be an extraordinary find and history is not littered with obvious examples.

Simon Bacon is an exceptionally talented and creative figurative artist. His work is dark, gently menacing yet beautifully structured and emotive. It is representational, so you know easily what it is that he is depicting, yet it incorporates abstract sections that make you imagine (see plate section). So his work is classically rooted but innovatively evolved by combining classical sculptural proportions with his own form of contemporary abstraction. Many of his works have what psychologists would call *divergent laterality* – chimeric heads with one side that looks explicitly like a head, while the other is abstract, enclosed and inaccessible to verbal labelling, mirroring the hemispheric asymmetries of the brain. Torsos that arch in pleasure and pain, chest and back in parallel alignment or sometimes physically separated and diverging, with a seemingly active space between the two halves of the torso. These works have emerged in the last few years but their history is significant for theories of practice. Look back into Simon's childhood or earlier adulthood and there has been no practice.

There are neither ten thousand hours of experience nor years of refinement, practice and over-learning in Simon's background. As a child, he was taught a few skills by his mother and he drew a few horses' heads and the odd figure, but not many. He drew little, sculpted nothing and constructed only small wooden boats with his twin and a friend at the weekends.

Aged forty, Simon had produced no works of art, had never sculpted anything and had not produced an adult painting. Yet, when Simon started sculpting, he had intense raw talent from the outset. At some of his first classes, his teacher noted the quality of his work, which was conspicuous for someone who had

never done it before. But it was not simply that Simon sculpted work that was accurate in terms of the representation of the human body. Look at the work of any class or group involved with life drawing and several members will demonstrate talent in terms of accuracy and attractiveness of their depictions of the human form. Simon's exceptional work goes further. After only a few evening classes and short courses, and some academic study of theories and history, Simon's work rapidly matured into something exceptional. Looking at his work, you would have no idea that it had all emerged so recently. It is distinctive and new and compelling. When he was aged forty-three, a mere three years after picking up his first lump of clay as a hobby, a Cork Street gallery was knocking at his studio door.

The only relevant background for Simon in terms of experience comes not from art but from his detailed knowledge of bodies. Simon is also an osteopath and has spent many hours working with real human torsos. Many great artists – from the Italians Andreas Vesalius and Leonardo da Vinci to Picasso himself – have studied the anatomy of the human body visually or through dissection, but Simon had actually worked for years with human bodies, in a way that involves direct tactile experience. In itself this cannot be enough to explain his skills, or the fields of osteopaths, physiotherapists, doctors and masseurs would be awash with prolific artists, but it may have enabled the development of a foundation of knowledge on which Simon's subsequent work was built. He did not have to learn, as novice students of sculpture do, about the relative proportions of bodies, as he already had a well-developed knowledge in his brain of the three-dimensional characteristics of many, many bodies. This was knowledge that had been encoded from both

visual and tactile information; what psychologists would call *multi-modal*. Yet there had been no practice of art or sculpture itself, not even a thousand hours, let alone ten thousand.

So, if the quality of Simon's sculpture is not the results of practice in sculpture or art, can some of the roots be found in his biological foundations and his genes? This was something I set out to establish by tracing Simon's family tree.

One generation up, Simon's mother showed some artistic interest throughout her life but had little opportunity to develop these to any degree. She did sculpt Simon's head when he was a child and also worked on horoscope signs for friends; later, after her children had left home, she started to draw and paint more landscapes, figures and miniatures. So there was a latent interest, drive and ability but nothing that became established. Moving up his mother's family tree I discovered there were lace-makers, milliners and dress-makers, professions which involve clear design elements and tangible, technical skills, though these are limited by the work involved.

On Simon's father's side things become more compelling. Two of Simon's great-grandparents were artists. Margaret, his father's grandmother, had come from an affluent family and been well educated. She ran off to London, an unusually adventurous foray for the 1890s, and, unable to make a living as an artist, took work in a photographer's studio, painting the colour into early black-and-white photographs. There she met and fell wildly in love with Simon's great-grandfather, a portrait painter who also worked as a photographer. His name was Christopher Graham Notman and he had been born in Aberdeen, Scotland, where, along with his sister Agnes, he developed his early work as a photographer.

Moving back yet another generation, Agnes and Christopher Notman's father, also called Christopher Notman, was a wood carver, working the designs into Scottish Victorian furniture in his own father John Notman's cabinet-making business in the city of Glasgow. In the 1841 Scottish census, both Christopher the elder, aged around twenty, and John Notman, his father, are found settled there, contributing to the multiple generations of craftsmen and artists in Simon's family tree, evidence of predisposing genes for craftsmanship, artistry and creativity in the Notman family.

Meanwhile, in 1841, only a few miles away in an adjacent district of the city of Glasgow, another of the Notman clan, William Notman, was preparing to change the world of photography in Canada, the USA and worldwide.

NOTMAN, CANADA AND THE USA

In 1841, William Notman was a teenager in Glasgow. His father had prospered as a designer and manufacturer of Paisley shawls and William himself was to study at Glasgow School of Art but then join his father in the family business. However, famine struck Scotland in the 1840s, and the economy came near to collapse. The family business, not helped by William's contribution, went bankrupt and in 1856, along with many others from Scotland, William Notman boarded a ship to Canada in search of a viable life for himself and his wife and child. Arriving in Montreal, by December he had opened his first photographic studio using skills he had learnt in Glasgow. He was hugely successful. By the late 1870s there were Notman-derived studios scattered across Canada and spreading across the USA, with branches at Yale and Harvard,

and the photographers leading each of these studios had served their apprenticeship with William Notman in Montreal. He was a celebrity of the day, winning medals for his work in Philadelphia, London, Paris and, across the globe, in Australia. The keys to his success were great drive and creative originality in both photography and business, encompassing an incisive capacity to create what people wanted.

William Notman did a variety of things that caught the public imagination, including developing the first full-scale life-size photographs, smaller portrait photographs, and photographs in stereo through which he captured rare events like eclipses. He was particularly known for his work with what were called *composite photographs* (see plate section). These were large group photographs, but rather than doing a single group shot as we might now, he took individual photographs of each of the people in the group and then essentially cut and pasted the perfect individual shots into the composite so that everyone looked good at the same time. This is the kind of thing that has only recently become viable through digital technology, but it was particularly useful in the days of early photography when long exposure times were required and it was tricky to get everyone to maintain a good expression simultaneously that would stay in sharp focus.

Composites became popular with sporting groups and societies as well as gatherings of influential dignitaries, school pupils, clergymen, and families. For family photos, William Notman would photograph the room in their home first and then add the people later. This method is akin to some contemporary methods of cinematography. Family members who lived abroad or across the country could be added, provided

that they had their individual portrait taken under the correct conditions and then sent over. So the composites did not necessarily reflect an actual scene but depicted rather a desired scene or collation of relevant individuals; some were very large, incorporating hundreds of individual portraits, requiring a feat of coordination of technical aspects of distance and pose, as well as extensive work to develop the photographs.

William Notman also developed and promulgated what were essentially the first photo-ID cards for students and the public, though he could not have imagined that a time would come where so many people of the world would carry them. And he photographed landscapes and buildings, mass producing photographs that were sold in stores, hotels and railway stations.

William photographed the great and the good from princes to politicians to distinguished Native Americans but also ordinary Canadian people across the country working in different professions, creating a historical archive of the time. Queen Victoria was captivated by a present she was given of his work and referred to him as the Queen's Photographer. It is interesting to note that he was not simply an artistic and creative photographer; he was also original, driven and highly organised.

PICASSO'S TECHNIQUES

Like William Notman, Picasso was a master technician and meticulous craftsman who also repeatedly innovated with new techniques. He created previously seemingly impossible ways of doing things. He became a master of an extraordinarily wide range of techniques in drawing, painting, sculpture, ceramics,

stage scenery and costumes, and in each of these arenas he was not only a technical wizard, but also did things differently, experimenting, and not so much pushing boundaries as leaping over them. He was particularly prolific in his development of print-making techniques. Neil Cox, Professor of Modern and Contemporary Art at the University of Edinburgh, notes that Picasso became 'one of the most important printmakers of the twentieth century'.[140]

In the early 1900s, a number of small contemporary galleries opened in Paris whose clients were less rich than those linked to the big dealers but who still wanted to buy modern work. Consequently, there was pressure to find things to sell that were less expensive. Daniel-Henry Kahnweiler, one of Picasso's dealers, encouraged him to think about prints and illustrated books, realising that these could be sold for lower prices but could also bring in more money for the dealers as well as the artists. In 1909, Picasso engraved his first two plates, which were published in editions of a hundred prints. This was the inception of a prolific side of Picasso's work that lasted throughout his life and involved the mastery and then adaptation of a diverse range of techniques from lithographs to linocuts.

Despite Picasso's outstanding technical skills in print-making and beyond, he produced sculptures and collages that were extremely flimsy. He often used bad tools and perishable materials so that 'many of his constructions are now little more than wrecks'.[4] He glued together coloured paper and cardboard with thin metal, string and wood, and many of his creations that survive look crumpled, dirty and insubstantial, presumably having lost the freshness of their earlier days.[141] Yet some work – for example, in welded metal and even as part of collaborative

projects in concrete – was extremely robust. So there was a paradoxical mix to Picasso's approaches, with both care and casualness, detail and rough sketch, robustness and flimsiness.

It was Georges Braque who encouraged Picasso to take more interest in the quality of his materials and to use better canvases and paint, though Picasso did not have the patience to take Braque's advice and grind his own colours. Colour, for Picasso, was not the fundamental thing.[142] He followed Braque's guidance in using combs to generate wood-grain effects.[143] He also mixed his pigment with plaster, grit, sand and coffee, which Braque had suggested to him, and developed new ways of creating texture. He raised the surfaces of his work with these materials, creating sculptural qualities in his paintings. He did the reverse in some of his Cubist sculpture, where the structure is flattened, almost making it like a collage. As in so many areas of Picasso's work, this was new and different. Picasso was not simply using well-developed skills; he was driven to innovate and, for this, frontal lobe circuitry in his brain was critical.

PICASSO'S INVENTIVE WORKING METHODS

Throughout his life, Picasso was happy to learn different skills from anyone gifted in their trade; for instance, he learnt to work gold not from a goldsmith but from a dentist.[144] He learnt such new techniques incredibly rapidly but did not simply copy them directly. He adapted and transformed ways of working into something different and new and it was in this inventiveness that we see his genius and the creative slant of his brain even in practical and technical domains. Here also lay clues to the way his brain was working and the engagement of the novelty-processing regions of the frontal lobes.

There are multiple examples of Picasso's creativity with techniques. For example, he developed the technique of *papier collé*. Here, he constructed collages in which fragments of newspaper were not only painted or drawn within his pictures, but also stuck into them. In another domain, painting ballet scenery, he was affected by the scale of the activity, producing giant figures as well as Cubist costumes, creating a curious juxtaposition of real 3D people in clothes of segmented Cubist designs.

Picasso also borrowed the dot technique from the pointillism used by the post-impressionist artists and incorporated it into some of his work, but he did not used raised dots to generate light or shadow, like the artist Georges Seurat. Instead he used the dots to elaborate objects and certain areas in order to make them tactile and to produce greater activity on the surface of the work.[145]

Other examples of Picasso's innovation come from his development of linocuts, where he made use of what is called the *jigsaw technique* (see plate section). As the name suggests, this involves more than one piece being put together. So sometimes he would use two, three or four blocks, not one after the other covering the whole picture, but each restricted to a part of the picture. In some of his 'bacchale' linocuts, which depict mystic festivals, revelry and dancing, one block might work the sky and one the land, and the two would slot together along an angled jigsaw shape that in some cases depicted an angular horizon, with each jigsaw zone using a different colour palette. The impact is very simple but compelling. This jigsaw technique was ancient in terms of its previous use with woodcuts and was familiar in more contemporary woodcuts from the work of the Norwegian artist, Edvard Munch.

What Picasso did was to develop this woodcut technique and apply it in a new way in his new linocut domain, integrating the technique into the structural design of the final picture. He took a pre-existent technique (jigsaws) from another domain (wood-cutting), and took a pre-existent domain (linocuts), and then drew them together to produce something that goes well beyond any simple additive effect of technique and domain. He developed a new mode of expression. This is a simple example but it is repeated again and again, in all sorts of spheres, across Picasso's life. It is not just that the art he created was original; the way in which he created it was also original. He did not use a pencil or a paintbrush or clay in the way that people down the ages had done, and then create works of art with new content and representation; he rethought the techniques that gave expression to his art. In this way, he was an inventor, even if the focus of his inventions was always the creation of art.

Some inventors like Picasso create new ways of working that integrate ideas from different domains. Creative inventions can also involve a significant step that follows a chain of preceding steps, for sometimes the next step in an existing chain of development *is* that substantial leap. The American inventor, Thomas Edison, for instance, did not invent the first light bulb. Instead, he concentrated upon the fact that the earliest prototypes contained filaments that burnt too quickly, and that were therefore unsuitable for everyday domestic use. Edison and his team developed a light bulb with a filament that could burn using a small current, for a sustained period, and which was therefore capable of widespread domestic use. His endeavours in creating this were lengthy and at times tedious, involving a large number of trial-and-error efforts and failures. If applied

to himself, Edison's famous quote, that 'Genius is one percent inspiration and ninety-nine percent perspiration', can perhaps be considered rather modest. He patented the microphone and the telephone receiver, as well as many other pieces of scientific equipment still in use today. He also patented a helicopter design that was never actually built and flown but that was powered by an engine with kites attached to a mast by cables that formed a rotor. Like Picasso, Edison was relentless in the pursuit of new ways of doing things. In his lifetime, he patented an amazing 1,093 inventions.

Like Edison, Picasso's exploration of ways of doing things was endless. He said, 'I am always doing that which I cannot do, in order that I may learn how to do it . . . Go and do the things you can't. That is how you get to do them . . . It's always necessary to seek for perfection. Obviously, for us, this word no longer has the same meaning. To me, it means: from one canvas to the next, always go further, further . . .'[146]

In some spheres, creative innovation seems to come young and in others it may emerge with more experience and knowledge, but even for most creative people, as they get older they often drift or relax into familiar ways of working and the risk-taking and novelty of new ways of doing things declines. An astonishing aspect of Picasso's work was his sustained innovation and creativity in old age. He did not stop. In old age, Picasso literally took linocuts, which were printed then worked over with Indian ink, into the shower and sprayed water over them, semi-drenching them and creating completely novel print effects. Surprisingly logically, the resultant prints are called rinsed linocuts. Picasso first started taking the prints into the shower in 1964/65, a few years after he started his linocut phase.

First of all, he pulled out some old blocks, reprinted them in white ink, worked them over with Indian ink, then rinsed off much of the Indian ink, which had soaked into the paper but not into the areas inked in white. This resulted in dreamlike compositions with an air of randomness. Then he moved on to developing linocuts specifically for rinsing, and the character of these is subtly different, in terms of greater grading and hatching at the boundaries that depict edges and contours. The rinsing blurs the clarity of the sharp edges of the linocut prints, creating a more diffuse and varied colouring and also enabling in some cases more subtle emotive expression. It is worth noticing that this innovation in Picasso's linocut techniques happened when he was eighty-three years old. His quest to explore, take risks and innovate, doing things differently, was lifelong. In fact if you look at the photos that survive of Picasso in action rinsing his linocuts, it is really hard to believe that this focused, engaged, dynamic explorer of methods and techniques was in his ninth decade of life.

LEONARDO THE INVENTOR

Another genius, who was not only a painter but also an exceptional inventor and who also, like Edison, had a stab at helicopter design was the Italian, Leonardo da Vinci. We may think of the *Mona Lisa* when we hear his name, but back in the 1480s, over five hundred years ago, long before the invention of steam or combustion engines let alone cars or aeroplanes, Leonardo was sketching designs for flying machines, including one that looks quite like a contemporary hang-glider and one that looks quite like a helicopter. It was 1936 before history caught up properly and the first manned operational helicopter

actually flew. Leonardo's flying machine design suggests a structure like an aerial screw that rotated in total, rather than only a rotor turning, as in contemporary designs. Leonardo's notes suggest that he tried building the helicopter using starched linen, and that, if turned quickly, the contraption would rise into the air. Without the subsequent inventions necessary to feed into a full helicopter design, it was never feasible that a truly viable helicopter would be built in the fifteenth century but it is extraordinary that Leonardo's mind was creating machines of this type so very long ago. For all that, outstripping the precocious Leonardo, the Chinese, hundreds of years BC, were making toys from bamboo that had vertical flight.

In addition to designs for flying machines, Leonardo drew thousands of drawings of inventions in his notebooks. About seven thousand pages of these notebooks survive but this is thought to be only about one-quarter of his original work, of which there were fifty books and thirty thousand pages. We don't know exactly how many extraordinary creative inventions have been lost but we do know from those that survive that Leonardo's range was wider than could be imagined from inventors today. His designs are unusually diverse and include a submarine, aqueduct, aortic heart valve, calculator and robots.

While the content of Leonard's drawings is fascinating, the technique used in drawing them was also innovative. This is why Leonardo has been credited with actually developing the method of technical drawing. It is an example of an *enabling* creative development. Leonardo developed a technique of technical drawing that was then copied and employed by generations to come, enabling all sorts of other inventions to

be reliably recorded by other creative inventors of subsequent generations.

Leonardo's acute examination of nature and the assimilation of its elements into his original designs enabled him to invent extraordinary machines long ahead of their time. He combined the results of his observation with his ideas and experiences in other realms. The juxtapositioning and adaptation of these elements synthesised into entirely novel innovations. In both art and invention, Leonardo da Vinci demonstrated genius. His brain took the knowledge he acquired from observing nature, and made novel associations and applications that evolved in new directions. In these endeavours Leonardo's frontal lobes were engaged with exemplary prowess.

PICASSO'S PLANS

We have established that Picasso was highly skilled and also inventive in his development of the artistic techniques that underpin his work. In generating this, he was also much more organised than the image of an artist in a studio might suggest; in Picasso's case, his studios always appeared chaotic. Picasso did plan the development of his major pieces. He made use of hundreds of preliminary sketches for his major works, such as *Les Demoiselles d'Avignon*. He tried out ideas in different ways and explored whatever he was interested in from slightly different angles before he started on the full work itself. By the time he got going on the main painting, he had derived a plan from his multiple sketches as to how it should evolve. The planning process leading to this construction could be very lengthy both in terms of time and volume of preliminary output. By looking at the series of sketches in his notebooks for some of

his work one can almost trace the evolution and development of the final plan and observe the different elements that are being drawn together.

Some of the techniques that Picasso developed in his printmaking also required the use of complex internal plans. An example is the *reductive technique* with linocuts that was developed after Picasso moved from Paris to the south of France in the 1950s. Picasso had made a significant number of lithographs with the firm of Imprimerie Mouriot while he lived in Paris, but after moving had become exasperated by the delays involved in receiving the finished prints, generated from the lithographic plates that he was still sending back to Paris for printing. Sometimes these prints took weeks to arrive, which meant a very slow evolutionary process for the things that he was trying out. Conveniently, there was a local printer in nearby Vallauris called Hidalgo Arnera, with whom he had worked on the occasional exhibition poster, and it was with Arnera that Picasso started a dynamic phase of work on linocuts. Linocuts use a print-making technique that involves cutting away part of a large linoleum tile or surface. The linoleum side is cut away in a particular shape and then the cutaway is printed, in much the same way that children cut away part of a potato surface and then use it to print patterned shapes.

Before Picasso, a first cutaway or plate would typically be generated and then a second one on a different piece of linoleum would be produced that repeated the shapes in the first plate but added further cuts. This would then be printed with the second colour, and so forth, with further colours and plates. At the outset, the artist had to plan the series of plates and colours that would be required to generate the final picture. However

if any error was made, he or she could always backtrack to the first plate and work on again from there. Picasso did generate a few linocuts using this technique, the most significant being an interpretation of a painting by Lucas Cranach the younger, an exceptional sixteenth-century German painter. Although Picasso and Arnera are reported not to have considered their final Cranach print much of a success,[147] it is considered his most important linocut.

Picasso had taken to linocuts like a natural and Arnera could scarcely believe that he had not worked with them before[148] but the usual techniques rapidly became constraining and Picasso pushed the boundaries. He wanted a quicker method and started to experiment with a *reductive technique* that Arnera suggested to him, having seen it being used in Germany.[149] In this, only one plate is used from start to finish. When the first cutaway is completed, the plate is printed a number of times. The second cutaway is then made on the same plate. This makes the process quicker as there is no need to repeat the first cutaway, but there is, of course, no going back to the first plate as it no longer exists in its original form once the second cutaway has been added. The full print run has therefore to be generated from the modified plate printed over the previous print run. If a further cutaway is required it is also added to the same plate and so forth. What this means is that the reductive technique does not offer you any chance to try things out, to make errors and then start again. The full plan of steps and colours to generate the final print has to be composed at the outset, and adhered to carefully. Picasso sometimes used as many as seven colours in the linocuts and Arnera said that there were no preparatory drawings.[150] He may have worked

on related themes and ideas in terms of content in other media, and for these he may have produced sketches and preparatory drawings, but for the execution of the reductive technique in the linocuts he did not develop drawings or a written plan of the stages of execution. He worked out and kept track of the steps of this complex process in his head.

This kind of complex planning, involving multiple steps is controlled by the prefrontal areas of the brain lying at the front of the frontal lobes, the most highly evolved zones of the brain. One laboratory task that is similar in requiring multiple steps is known as the *subject-ordered pointing task*,[151] the SOP. In the SOP, there is a series of pages, each containing abstract pictures that cannot easily be named. The same set of pictures appears page after page in a different arrangement. The task is to point on each page to a different picture, until every picture in the set has been selected. In the SOP, you cannot use your memory for spatial location to help, or go along the rows or columns, as the pictures change position, so you have to keep track of what has already happened, where you are in the picture set, and what is still to come. This means that there is a temporal quality to planning that requires keeping track both backwards and forwards in time. Patients with frontal lobe injuries find this task very difficult, as the frontal lobes underpin complex temporal planning activity.

Our frontal lobes are also critically engaged with problem solving and in generating the sequence of steps needed to achieve a distant target. In another laboratory-based task called the *Tower of London*, there are three vertical pegs of different heights, on each of which one, two or three coloured balls are placed (see plate section). When the balls are placed on the

pegs in an initial arrangement, the child or adult being studied is challenged to move the balls into a different position shown in a goal picture, by only moving one ball at a time and never having more than one ball off a peg at a time. Logically, the only way to solve this problem is to construct a plan with a series of component steps and then to keep track of how far the steps have gone. Functional imaging studies of the brain have confirmed the linkage between performance on this task and frontal lobe activity.[152]

Picasso's reductive technique involved similar cognitive demands and a set of mental processes to the Tower of London and SOP tasks combined, because the final print had to be decomposed backwards from a mental image into a series of planned steps that had to be carried out in precise sequential order. The artist had to keep track of where in the process they were, and what was still to come, with only an abstract linoleum cutaway to work from. The reductive technique therefore demands heavy frontal lobe input in terms of planning, sequencing and execution.

In chess, similarly, heavy forward planning that requires an individual to keep track of where they are in terms of a sequence of moves and relative spatial positions is involved. Here the complex plan may also have to be adapted in response to the opponents' actions and ongoing changes in the spatial array. Expert chess players must have very well-developed frontal lobes. For grandmasters, they must be exceptional.

Korean chess, Janggi, places even greater demands upon the frontal lobes than Western chess. This game, derived from the Chinese game Xiangqi, is a strategy game involving complex planning and multiple spatial moves. The pieces of Janggi relate

to those in Western chess but some of their potential moves are more complex. For example, the Horse is similar to the Knight in its combined sideways and diagonal movement but it can be blocked, creating an additional complication. The Elephant of Janggi resembles the Bishop of Western chess but it has a combined move that is first forwards or backwards and then diagonal, whereas a Bishop moves only diagonally. This means that the spatial demands of planning the moves of the Horse and Elephant are more complicated than the moves of the Knight and Bishop. My favourite piece is the Janggi Cannon, for which there is no Western equivalent. It can only move frog-like by jumping over things and cannot move at all unless there is an obstacle to jump over, much as in the board game of draughts, though with capture working differently. Other Janggi pieces, Generals, Chariots and Foot Soldiers, are closer to the Kings, Rooks and Pawns of Western chess.

Perhaps surprisingly, age and experience do not seem to be critical in mastering these complex strategy games with their heavy frontal lobe demands. By mid-teenage years, brain development is sufficient to allow the substrate for these skills. For example, in 2012, Vaibhav Suri became an Indian grandmaster at the age of only fifteen. Even younger, the Norwegian Magnus Carlsen, who was the world No. 1 player in 2013, became a chess grandmaster at the age of thirteen. Similarly, Fabiano Caruana, an American of Italian ancestry, became a chess grandmaster at the age of fourteen, going on to become world No. 3 in 2013.

Given the common underlying brain processes in aspects of the execution of Picasso's art and chess, it is unsurprising to find that some artists are also enthusiastic chess players. One

of the most famous is probably Marcel Duchamp, the French-American artist whose early work was influenced by Cubism but who carved out his own distinctive and memorable place in the evolution of modern art. Duchamp learnt chess as a child and was obsessed with it all of his life. It was not simply that similar brain processes may have been involved in chess and aspects of art: Duchamp even drew chess into the content of his work – for example, painting the Cubist-inspired work *Painting of Chess Players* in 1911.

Returning to Picasso's work, a further example of complex planning was the triptych on which Picasso started work in the early 1950s to decorate the deconsecrated castle chapel in Vallauris where he was living in the south of France. It was a medieval building with a barrel-vaulted nave. He wanted to turn it into a Temple of Peace and, for this, he made more than two hundred and fifty drawings of his plans. The work was called *La Guerre et la Paix* (War and Peace – see plate section). There were two large panels that would cover the side walls and the chapel vault, each of which was made up of several rectangles. Then a third panel would fill in the west end of the nave, and join the piece together. The work was designed to follow the rise and curve of the chapel walls and vault and then meet in the middle. For people who saw the work in progress it was difficult to see or imagine what it would look like, either in terms of the panels meeting up together or how the third piece would bind the whole.

Yet Picasso had been able to work through the full plan of execution so as to know how to achieve the distant integrated goal with a series of steps working on seemingly unrelated aspects. It was another example of Picasso's advanced, analytical planning

skills and capacity to construct and implement a complex multi-step plan of order and relative position, in this case with all three dimensions being critical. The initial response when people only saw the incomplete work was negative and critical, as the whole could not be imagined. As Patrick O'Brian notes,[153] 'There would have been far less adverse criticism if others had possessed Picasso's eye, enabling them to see *La Guerre et la Paix* as it can be seen now, in its own place, and lit by one uniform light from below.' The visitor is 'inside a picture' able to look at either 'War on one side or Peace on the other', while the 'brilliant third panel ... that links the two and closes the tunnel, making it a world of its own, is visible all the time'.

So Picasso was a technical master and innovator, who rapidly acquired established skills and then applied them in novel ways that the technical experts often thought would not work. It was not simply the content of his work that showed genius and the underpinning technical skills that demonstrated innovation; the way in which he executed his art also showed genius.

One of the curious contradictions in Picasso's abilities is that despite this capacity to engage with very complex multi-step creative spatial plans where the relationships and layout of things had to be finely worked out ahead of time and remembered step by step, he nevertheless had some difficulty with right–left discrimination and image reflection. Picasso 'was never good at telling the difference between the sides'.[154] In many of his self-portraits he did not reverse the image that he saw of himself in the mirror; thus paintings were generated in which his hair falls over his right eye, whereas in reality it fell over his left. Similarly, in many of the linocuts, he carved the date directly into the lino, not transposing it; when it was

printed, the dates emerged in mirror image. Interestingly, we know that right–left discrimination and the ability to reflect images engage quite different parts of the brain to those involved in complex spatial planning or in 3D perception. Right–left discrimination and image reflection involve the parietal lobes of the brain, whereas multi-step spatial planning involve the frontal lobes, particularly on the right.

Another facet of planning controlled by the frontal lobes is the ability to engage in more than one activity at once. It is common to joke in the West about the multi-tasking capabilities of women over men but in reality the human brain of both men and women should be capable of carrying out simultaneous tasks under the control of the frontal lobes. A very simple illustration of this is seen in Luria's hand-alternation task that we discussed earlier. Patients with frontal lobe injuries and planning difficulties often find this hand-alternation task very difficult. If you find it easy, you can add another task: try, as you perform the hand-alternation task, to subtract in threes down from thirty-five as fast as possible, and watch the speed and fluency of your hand alternation start to slip a little. Even healthy frontal lobes slip up if overloaded with simultaneous task demands, particularly if some of them are novel.

We know that the brain is capable of thinking and deciding about more than one thing at once. Some memorable examples are detailed in studies of the split-brain patients who famously had the major fibre tract of the brain that interconnects the two halves, the *corpus callosum*, sectioned for the treatment of intractable epilepsy. There are lots of laboratory experiments with split-brain patients that illustrate the separation of information and decision-making in the two halves of the brain.

These also highlight the intimate involvement of the left hemisphere with language, as well as the more visual and non-verbal conscious activity that is underpinned by the right hemisphere of the brain. These dichotomies have fascinated psychologists, linguists, philosophers and neurologists for several decades. There are also day-to-day anecdotes, including the split-brain patient whose two hands would compete in the cheesecake section of the supermarket freezer, with one hand keen to choose the flavour that she liked and the other keen to select the one that her husband preferred, competing loyalty arising from the failure of integration of the decision across the brain.

In general, our *corpus callosum* with its millions of fibres is actively operating and providing us with an integrated experience of life, including the integration of simultaneous components of planning. What we see, though, in some creative individuals is the capacity to engage in rather advanced simultaneous planning. Leonardo's sketch books show that he moved to and fro from sketching an arm to inventing a machine on the same sheet. Some of Picasso's sculptures were planned with the simultaneous incorporation of novel materials, juxtapositions, concepts, forms and memories. His reductive-technique linocuts incorporate complex planning steps but also simultaneous planning of overall structure and component feature design. He did not simply plan the fine-feature analysis that is so strong in the work of some autistic artists: he simultaneously considered the order of multiple steps he would have to work through for both the global structure and the feature components. This advanced planning ability was critical to the successful execution of his work. Picasso was aware of the multiple simultaneous demands of his work,

recommending, 'If you can handle three elements, handle only two. If you can handle ten, then handle only five. In that way the ones you do handle, you handle with more ease, more mastery, and you create a feeling of strength in reserve.'

Picasso, Mad Artists, Creativity and Disorder

'I managed to grope and find a way to live by tracing a thread that is art. However if it hadn't been for art, I would have killed myself a long time ago.'

Yayoi Kusama

PICASSO AND HALLUCINATIONS IN ART

Picasso hallucinated that he had invented photography,[155] had nothing left to learn and so might as well die. The hallucinations were the result of consuming opium, which Picasso and his friends indulged in two or three times a week during their early days in Paris. One component of opium is morphine, which binds with opiate receptors in the brain, sometimes inducing hallucinations.

This experience of opium may have influenced some of Picasso's work in the early 1900s during what was called his late Blue Period and early Rose Period because of the colour palette he was using then. John Richardson, Picasso's biographer, suggests that opium could account for the trancelike expression on the faces of the waifs that Picasso depicted, and also the faces in the two works called *Boy with a Pipe* and *Woman with a Fan*

136

(see plate section). Opium's impact may also be evident in some of the characters in haunting pictures of travellers and circus people called the *Saltimbanques*, in which Picasso sometimes put the faces of his friends.

These effects were transient and drugs were not a major feature in Picasso's life after this early phase of youthful experimentation, ending almost entirely after the suicide of Picasso's friend, the German painter G. Wiegels, who died after consuming a massive dose of drugs. In the hours before his death, Wiegels had been hallucinating that he had turned into a horse or an animal.[156] His body was discovered by the postman, who raised the alarm; Picasso rushed to Wiegels' studio and found him hanging in the window.[157] It was a profound shock and Picasso's use of opium subsequently became much rarer. There is no compelling evidence that drugs, alcohol or addiction enhance creativity. Quite the opposite; numerous early deaths linked to substance abuse indicate that it repeatedly cuts short creative potential.

Picasso's hallucinations arose from consuming a drug that altered the neurochemistry of his brain, and when he stopped taking the drug the hallucinations ceased too. Some people, however, experience hallucinations without taking any drugs. The delicate neurochemistry of their brains is already slanted in favour of abnormal perceptions and visual and auditory experiences that feel like reality but are generated without the normal external sensory stimulation. From the age of ten, Yayoi Kusama began to hallucinate dots, nets and violet flowers that covered everything she saw. Her parents ran a seed nursery and in her hallucinations, fields of their violet flowers started to talk to her, each with its own individual appearance.

When a psychiatrist suggested that she translate these visions into art, Kusama produced large canvases, completely covered in small, undulating loops of different colours that form the rhythmic landscape of compression, expansion and circular structures that she calls *Infinity Nets*. Thereafter, she produced paintings dominated by brightly coloured polka dots. She also became an innovator in multi-media installations, sometimes painting polka dots onto living people or decorating the outside of otherwise conventional houses with them, or filling the open spaces around buildings with polka-dot-covered sculptures. She also attracted a degree of infamy in the 1960s by producing sculptures completely covered with phallus-shaped structures.[158]

Kusama's interest is in the place of self within infinity. More simply, she sees herself as one dot of an infinite number and explores how individuality can exist in a universe with multiplicity. In this pursuit, she obsessively produces multiplicity of forms that overflow boundaries. Many of the proliferating images are of organic substances: some dots are seed-like; flowers, leaves and plants also pervade her more recent work, in both painting and sculpture. Unfettered growth abounds.

Yayoi Kusama is the only living female artist to have sold work for over $5 million, and her following continues to increase worldwide. Art, she believes, has been essential for her mental survival: 'I managed to grope and find a way to live by tracing a thread that is art. However if it hadn't been for art, I would have killed myself a long time ago from an inability to withstand the environment.' Living by choice in a Tokyo psychiatric hospital, she is Japan's most successful contemporary artist.

Articulating cause and effect in both directions, some have

argued that you have to be mentally ill to be creative, and others that a high level of creativity leads inevitably to mental illness of one form or another. Such discussions have also led to concerns that those with high levels of creativity may become stigmatised. Within the academic community, the idea that some highly creative colleagues may be both mad and brilliant is well established, and the literary world abounds with the stereotype of the mad and eccentric writer. In reality, of course, to win research grants, communicate discoveries, write papers and books and actually get them published the writer requires a variety of skills, needing to be organised, coherent and anything but mad, so the validity of these stereotypes is unclear. The concept of a misunderstood creator whose life ends in a premature death, poverty and madness was familiar to Picasso.[159]

HISTORICAL THOUGHTS

The above thoughts concerning creative genius are not modern ideas, but stem back to ancient Greece, where the Greek term for madness implied both inspiration and illumination, and was additionally considered a desirable state.[160] Aristotle said that 'no great genius has ever been without some divine madness', but is that really true? The Greek idea was that there was divine inspiration from the gods, with artists and poets being chosen and influenced by powerful unseen forces that breathed ideas into them, enabling them to be creative.

The Greek philosopher Plato argued that the power of madness was superior to a sane mind, as sanity was human but madness, so-called *theia mania* (literally madness from the gods), was of divine origin and an overpowering influence and gift from the deities. Madness was not seen as arising from inside a

person and conveying an element of sustained vulnerability, but as being imposed from outside, as something transient but also welcome. The particular impact of the madness was affected by the gods from whom it originated. From some it enabled the power of prophecy, from others the ability to engage in mystical rites, and from Aphrodite it engendered the divine madness of love and the ability to see the beauty of the world. When it came from the muses, divine madness provided the inspiration for poetry, rhetoric and songs. So beautiful poetry was neither human, nor did it come from humans; poets simply communicated the divine inspiration of the gods who possessed them.

Picasso would not necessarily have objected to elements of this view. As Patrick O'Brian notes, he told his friend of later years, Helen Parmelin, that a really good painting was good because it had something holy about it and had been 'touched by God',[161] even though Picasso's own religious conviction was not conspicuous throughout his life.

In 1895, Cesare Lombroso, an Italian criminologist from Verona, best known for his erroneous belief that criminality was identifiable by physical anomalies, argued in *Man of Genius*[162] not only for the physical inferiority of talented individuals but also for their general state of misery. Lombroso believed that some people were born with lifelong criminal dispositions and that anatomical stigmata (signs) marked them out from normal, socially adjusted individuals, saying that 'pathological individuals manifest rudimentary physical and mental attributes of primitive man'. He rigorously measured the physical dimensions of the skull, face and limbs in criminals, arguing that they were atavistic throw-backs to more primitive man.

Lombroso has had rather a bad press but his work also included many ideas that were ahead of their time. Although incorrect in linking criminal predisposition and anatomy, Lombroso had started discussing biological predispositions to behaviour and personality in an era when the science of genetics was still very much in its infancy. We take genes and biology so much for granted nowadays that it is hard to imagine the context of earlier debates. By recognising the possibility of biological influences, Lombroso laid the foundations for biological theories of crime and indeed contemporary debates about inherited predispositions in personality and behaviour.

Lombroso was also very systematic in his studies and engendered a much more scientific and less intuitive approach to investigations. While his atavistic ideas are rightly dismissed now, in his discussions he raised concepts of evolution when Darwinian ideas were just emerging. He also laid the foundations for more contemporary criminology, with an increasing interest as he became older in the influence of society and environment in the emergence of criminal behaviour. So Lombroso himself was a highly creative thinker and he also thought creatively about genius.

Just as the criminal was seen as a throw-back, the genius was also seen as an exceptional oddity, even if a more effective one. Lombroso argued that 'genius is one of the many forms of insanity' but he emphasised its exceptional qualities. 'The appearance of a single great genius is more than equivalent to the birth of a hundred mediocrities ... Good sense travels on the well-worn paths; genius, never. And that is why the crowd, not altogether without reason, is so ready to treat great men as lunatics.'[163]

Lombroso also linked epilepsy with both criminality and genius, suggesting that genius was a special kind of epilepsy, and that the unconscious creation of a genius reflected an unusual epileptic effect of epileptic madness. Genius, criminality and epilepsy were all seen as resulting from something that went wrong during embryological development and that affected the superior nerve centres which control ethics and behaviour. According to Lombroso, genius and epilepsy shared not only a biological basis but also the tendency to suicide, religious fervour and mental ramblings.[164, 165] Just as people have done more recently, he studied the lives of geniuses from different ages and fields, and looked for signs of disorder, in this case that they might have suffered from epilepsy.[166] To support his hypothesis he talked about Napoleon, Molière, Peter the Great, Handel, Dostoevsky and Tolstoy, among others. Lombroso made accurate observations in many areas but he was wrong about a linkage between genius and epilepsy and madness, just as he was wrong in his conclusions concerning the anatomy of criminals.

Lombroso's use of contemporary experimental designs and theory-testing marked him out. His imaginative explorations and dedication in pursuing issues over decades showed that he himself combined creativity, perseverance and innovation. Unfortunately, the limited scientific understanding of the time, and emerging ideas of the era, influenced his approach, meaning that his final deductions and interpretations were frequently completely incorrect.[167, 168, 169]

We now know that epilepsy is a very common disorder that results from the coordination of cells in the brain firing their electrical messages simultaneously in one area. This

simultaneous activation of electrical activity causes a spike in electrical activity across the brain, which disrupts its normal functioning, leading to a seizure. In most cases, epilepsy is treated easily with medication that dampens down the potential for electrical surges. In terms of behaviour, a seizure may cause anything from a twitch of an arm to complete loss of consciousness. In relatively rare cases of epilepsy, among a small subset of those where the seizures are focused in the temporal lobes of the brain, it is possible for the electrical anomaly to generate the experience of hallucinations or religious visions. It may be this rare association that contributed historically to misplaced ideas about epilepsy.

PICASSO AND MENTAL ILLNESS

Ideas about a connection between genius and insanity have persisted, and high-profile cases such as Van Gogh's dramatic suicide and the severing of his ear have reinforced such an association. So did Picasso have any form of mental illness? Before discussing this, let us just tie down a bit of terminology.

Madness and insanity are rather loaded and general terms, so let us think more explicitly about what we mean by mental disorders. Broadly speaking, psychiatric disorders are divided into two groups: *neuroses* and *psychoses*. *Neuroses* are milder and most of them are associated with some kind of anxiety. They include phobias and anxiety disorders, depression, obsessions, compulsions and hypochondrias. Many are amenable to treatment by psychologists or with medication and they are often of short duration.

The cut-off point between what is normal and what is a neurotic disorder is vague and can be affected by the degree of

support you have around you, the attitude of the culture you are in and whether you actually seek help or not. Generally, people identify a neurotic condition as a disorder when it starts to impact upon day-to-day life and spill over into wider areas. Diagnosis is rarely clear-cut. This is especially so when looking at a slightly unusual creative genius. Identification, or otherwise, of mental disorder in such cases is definitely not straightforward.

The more serious group of psychiatric disorders is that of *psychoses*. These are all disorders in which the individual in some way loses contact with reality and exhibits irrational behaviour, with impaired insight and disordered thought. Hallucinations and delusions can be characteristics of psychoses. The psychoses include *schizophrenia*, *affective disorders* (encompassing severe depression) and *manic depression* (which is also called *bipolar disorder*). The impact of these tends to be more long lasting and the symptoms tend to be more conspicuous, so diagnosis in principle is more straightforward, except that many of the characteristics of the symptoms can appear in diluted form. So, without exhibiting schizophrenia itself, people may have schizotypal personality traits. Likewise, many may have gloomy traits or mood swings but not necessarily have depression or bipolar disorder. There may also be occasions, such as bereavement, when very low mood for a moderately extended duration is quite normal and does not signify clinical depression. Diagnosing mental disorders is not an exact science, such as with diagnosing measles. With these caveats in mind, it is nonetheless interesting to examine what people have tried to find out about mental disorders and creative genius, and how far they have succeeded.

In recent years, the question about the relationship between creativity and mental disorder has been explored in three different ways. One way, just as Lombroso attempted, is to look at highly creative people and see whether they have high levels of mental disorder. An alternative is to monitor people with mental disorders and see if they are highly creative. A third way would be to start with a group of people who may or may not be creative and look to see whether their levels of creativity and their levels and symptoms of mental disorder, if any, appear to be related. Each of these approaches answers a slightly different question and so the outcome may not be identical.

Let's start with the first approach, which takes highly creative people and looks to see whether they have a mental disorder. If we look at Picasso, a highly creative individual, is there any evidence that he suffered from any form of mental illness? Well, Picasso is sometimes described as being depressed, but people can be considered depressed without actually having clinical depression. We all feel low, indeed very low at times. One of the critical things in clinical depression is that it may strike without any external event producing a trigger, or to a degree that is quite disproportionate to an external event. Also, the impact is generally such that it interferes with normal day-to-day life.

When and how, then, was Picasso said to be depressed? Broadly, three things made him feel down: being separated from works that he had created and to which he was attached; ending close relationships that he had enjoyed with women; and the death of people to whom he had been close.

Picasso was deeply attached to his works. He often had several unfinished paintings in his studio, and would go from

one to the other, hating to finish any of them, saying, 'To finish a work? To finish a picture? What nonsense! To finish it means to be through with it, to kill it, to rid it of its soul, to give it its final blow; the most unfortunate one for the painter as well as for the picture ... A finished work is dead work, killed.'[170] Even when his paintings were finally complete, he did not like to part from them. So, although artists are supposed to be delighted by sales, Picasso often felt a sense of loss along with the pleasure of a sale. Given the length of time, emotion and energy that he invested in his creations and the fact that, once sold, a painting or work of art might never be seen by him again, it is not extraordinary that he felt a sense of loss at their disappearance from his life.

Picasso felt that he put some essence of himself into his work: 'People don't realize what they have when they own a picture by me. Each picture is a phial with my blood. That is what has gone into it.' Picasso's lover Fernande Olivier said that she 'always saw Picasso depressed when he had to sell a painting'.[171] During the days after a sale, he had difficulty in extracting himself from his state of melancholy and this state of gloom after a sale was one of the few things that sometimes stopped him from working.[172, 173] This interruption of the normal flow of his life would be consistent with a diagnosis of depression, but one would expect there to be other things that drove Picasso into a melancholic state, and there are few. Furthermore, Picasso gave away many works of art to friends, without any documented sense of gloom, so perhaps it was when he was forced to sell that it became difficult, or perhaps the sense of separation was not so absolute when work went to friends, given that he might see them, and thus his paintings, again.

Dealers found it hard to comprehend Picasso's dislike of selling paintings and his reluctance to celebrate when an exhibition had gone well or a new buyer appeared and lots of pictures were sold, but to Picasso money was never a motivator in itself and so the financial outcome of the sale was less salient than to some artists.

Moving on to relationships with women, Picasso is described as having gone through a protracted period of wretchedness and unhappiness as his marriage to Olga Khokhlova, the Russian ballet dancer, fell apart prior to the birth of his daughter Maya, whose mother was his young lover, Marie-Thérèse. By all accounts, the conflict with Olga, and the unpleasantness this resulted in were intense. Wretchedness and unhappiness in such circumstances is understandable, and does not in itself indicate any form of atypical emotional reaction or response. The pressures of the dispute with Olga affected Picasso's work and he was either unable or felt no inclination to paint for some months in 1935. It was not all misery though, as he enjoyed spending quite a lot of time then with Marie-Thérèse and the baby Maya, to whom he was deeply attached. Then, in 1936, he met Dora Maar, a beautiful and intelligent photographer who, having lived in the Argentine, was also a Spanish speaker; the seeds of a new and powerful relationship were sown, which lifted Picasso's spirits.

Dora was herself not the most stable of individuals. When Picasso first saw her, she had her hand spread out and was stabbing between her fingers with a sharp knife, sporadically cutting herself – not a look that would appeal to everyone, but, of course, Picasso was intrigued. Dora could engage with Picasso at an intellectual level but was also emotionally intense,

being the model for the many weeping women paintings and drawings that followed. She was also the muse who recorded his production of the political work *Guernica*, a masterpiece in which Picasso 'expressed his loathing for the military caste that has plunged Spain into a sea of suffering and death'.[174] Dora herself disintegrated at the end of her relationship with Picasso, developing what seems to have been a psychosis.

Picasso later became very dispirited towards the end of his relationship with Françoise Gilot, the mother of his two children, Claude and Paloma. 'Sadness so overcame Picasso that his production dwindled, almost ceased entirely.'[175] 'Depression was always lying in wait under his gaiety, and since he was extremely sensitive to atmosphere the one thing he could not cope with was domestic gloom.'[176] He justified to friends the focus on a new lover, Genevieve Laporte, whom he had known for many years, saying, 'I was ready to kill myself. She made me laugh. Laugh, you understand me? Laugh . . .'[177]

From our discussions thus far, then, there is evidence that Picasso felt depressed when he sold paintings to which he was attached, and when he was under intense emotional pressure, at the end of a relationship. There are no records, though, of depression striking unexpectedly, or of incapacitation except at times when many of us would have similarly struggled to cope, so the evidence for a truly clinical level of depression is not strong.

Picasso was sensitive and could feel very down when those around him were unhappy. Sometimes such feelings overwhelmed him but they tended not to last very long. We cannot, *post hoc*, be certain of how intense such low spirits were, but we can say that the degree of unhappiness seems to have been commensurate with the circumstances. Any depression was

always reactive and never chronic. Human contact, new relationships and the company of friends lifted his mood with time. In Picasso's case, at least, high creativity does not seem to have been linked to any chronic mental disorder.

For other creative individuals, there is more explicit evidence of mental disorder. At the start of this chapter, I mentioned Yayoi Kusama, an enormously successful contemporary artist who actually develops art from her hallucinations. In Kusama's case, without the hallucinations it is hard to imagine that her art could have developed in the way that it has, and we know that her hallucinations predated the start of her art. For Kusama, the mental disorder that created the hallucinations must have been a precursor for the form of the creativity of her art. Her initial work tried to chart what she was hallucinating and then she developed from there.

Several studies have looked at groups of creative and successful people to see whether they have high levels of mental disorder. An early work called *A Study of British Genius*,[178] written in 1926 by Havelock Ellis, looked at 1,020 eminent Englishmen. From their entries in the *Dictionary of National Biography*, Ellis decided that 4.2 per cent of them were 'insane'. However, as Judith Schlesinger[179] from San Bernadino in California, has pointed out, Ellis's diagnosis of insanity was broader than most, for example including the development of dementia in later life. Nevertheless, even with this questionable breadth of diagnosis, Ellis concluded that genius does not seem to be a form of insanity at all.[180]

In contrast, a few years later, in 1931, also using retrospective analyses of over eight hundred biographies, Wilhelm Lange-Eichbaum[181] argued that the greatest geniuses were found

among those who had both exceptional gifts and also concomitant mental disorder; he cited Luther, Napoleon and Beethoven as examples.

In a later oft-quoted study, Nancy Andreasen[182] interviewed writers and their families at a writers' workshop and asked them to describe their own difficulties and disorders and those of people in their families. She claimed that 80 per cent of the writers had mood disorders compared to only 30 per cent of a comparison group who worked in law, administration and social work. These rates seem extraordinarily high and the results have received considerable attention over subsequent years. Judith Schlesinger is unconvinced,[183] arguing that the interview used in the study was developed and judged by Nancy Andreasen alone. It was therefore neither validated nor objective. Also, the criteria used to classify the disorders were not clear, with episodes of severe depression or mania lumped in with people who had vague experiences at some point in their lives. Judith Schlesinger also points out that the study took fifteen years to carry out, yet included only thirty writers, which raises questions about the selection of cases and the sample size.

Another study on the same theme was carried out by Kay Jamison, who interviewed forty-seven British poets, writers and artists about their moods and psychiatric history.[184] Jamison reported that 38 per cent of them had been treated for affective illness, with a rate of 50 per cent in the poets. Again Judith Schlesinger[185] is unconvinced. She argues that too much has been made of the results of a study that involved just one person classifying a small number of cases; for example, the 50 per cent rate in the poets comes from a sample of just nine poets, and a 12.5 per cent rate for depression in artists reflects a single case.

A later study by Jamison, this time based on deceased individuals, inevitably suffers from even more questionable and speculative diagnoses. Similar critiques can be applied to another much quoted analysis of biographies, which looked at thirty-five poets and twenty-four playwrights, claiming that 80 per cent of the poets and 87 per cent of the playwrights had an affective disorder.[186]

In such studies, issues concerning how people were selected and how they were diagnosed occur repeatedly. Opponents argue that cases have been selected in a way that is unrepresentative of the population as a whole and also that diagnosis was often made retrospectively, on the basis of scant information. Nevertheless, the numbers remain surprising and at least suggest the need for further investigation.

A better and certainly more extensive interview-based study – conducted by Albert Rothenberg[187] of Harvard University, Boston, and covering three decades and two thousand hours of interviews with creative people – concluded that there was no association at all between creativity and mental instability. The one characteristic that Rothenberg did identify across the board in the creative people was that they all had a strong drive and motivation to be creative and did not simply want to be effective or competent. Drive was the distinguishing characteristic.

Overall, there is not much reliable evidence that if you look at groups of creative people you find significantly higher levels of mental disorder than in the rest of the population. However, these studies fail to provide sufficiently robust evidence to refute the possibility entirely, so the jury is still out.

MENTAL ILLNESS AND CREATIVITY: SCHIZOPHRENIA AND BIPOLAR DISORDER

As I mentioned above, another way to approach the issue of mental illness and creativity is to start not with creative people themselves like Picasso, Kusama, writers or poets, but instead to start with those who have mental disorders, and then look and see if there are higher than expected rates of creativity among these people. Another helpful tack would be to look at explicit types of mental disorder that have received a clear diagnosis. Some studies have suggested increased levels of creativity linked to bipolar disorder.[188] Other studies have suggested higher levels of creativity in the relatives of those with mental disorders, and this has argued for some kind of genetic linkage between creativity and mental disorder.

One reason for the persistent belief that there must be something advantageous about mental illness is that, despite genetic influences, it has not evolved out of the population. Indeed, mental illness is found in every population across the globe ever studied. This persistence throughout evolution has led to the idea that there is a selective advantage linked to mental disorder that sustains it in the population. A candidate for the advantage is increased creativity, either in those who have a mental disorder or in their relatives; the idea being that a moderate biological dose of the relevant genes may be advantageous but that too many of such genes can lead to the emergence of mental illness.

An early study of the children of mothers with schizophrenia, back in 1966, found that about half of the children showed some kind of psychosocial difficulties but the other half went on to become highly successful adults, many of whom

showed exceptional creative traits.[189] Similarly, a study of seven generations of relatives of schizophrenics, in an Icelandic family, found high numbers of creative people.[190] These effects could simply be a result of the experience of living in a family with someone with schizophrenia, but another early study showed that levels of creativity in adopted children are also significantly related to the incidence of mental illness in their biological parents.[191] This type of study supports genetic linkage rather than environmental family impact. More recently, children who have a parent with bipolar disorder have been found to score more highly on a test of creativity than children of healthy parents.[192]

A recent study that has looked at the issue on a large scale has been carried out in Sweden.[193] The scientists there took a huge sample of three hundred thousand people with severe mental disorders from the Swedish registers and then looked at how many of them worked in creative occupations. They considered a thirty-year period from 1973 to 2003, and assessed cases of schizophrenia, bipolar disorder (where individuals swing between depression and mania) or unipolar depression (where the patient only has the low mood swings but not the highs) that were sufficiently severe for the individuals to receive in-patient treatment. Additionally, the scientists also looked at relatives of these individuals who did not have any diagnoses of mental disorder and they also compared their results to a matched control sample. This was a robust study, in terms of design, with lots of cases reliably diagnosed and recorded. Swedish records are so good that they have often been incredibly helpful to science in answering questions.

The results from the Swedish study were very clear. People

with schizophrenia did not work more often in creative jobs over-all, but they did work more often in visual artistic occupations, and their healthy parents and siblings were over-represented in the creative professions overall. The children of those with schizophrenia did not show increased employment in the cre-ative professions overall but were over-represented in visual artistic occupations. So those with schizophrenia and their children show increased employment in visual artistic occu-pations, whereas the substantial dash of overlapping genes in the siblings and parents of those with schizophrenia conveys a wider creative advantage across creative professions.

In the Swedish study, there were also increased levels of jobs across the creative professions for both the relatives of those with bipolar disorder, and those with the disorder. For the relatives, this was more likely to be in a scientific creative area; for those with the disorder, it was more likely to be in an artistic area. So, having bipolar disorder or a sibling with bipolar disorder, with whom there is a substantial dash of overlapping genes, is linked to increased levels of creative employment.

The results could not be explained by intelligence. Although family influences and environment might be thought to have an impact, the scientists also compared the effects upon maternal and paternal half-siblings, as when there are environmental effects there is usually greater impact from maternal half-siblings, but there was no difference; the explanation, then, is likely to be genetic rather than environmental.

This large study finally shows that certain types of men-tal disorder really do convey a creative advantage, and that widespread advantage comes from having a sibling with either schizophrenia or bipolar disorder. Creativity apparently peaks

in the close relatives of those with mental disorder rather than in those who actually have the disorder. The effects are limited to schizophrenia and bipolar disorder. Neither those with uni-polar depression nor their siblings were over-represented in the creative professions, so depression without the upbeat coun-ter-swing does not confer a creative advantage.

In these discussions it is important to remember that just because there may be evidence for an association between bipolar disorder and creativity and also between schizophrenia and creativity, this does not mean that all creative individuals have one or the other of these mental disorders, or relatives with them. For example, we have already discussed how there is no robust evidence of clinical depression for Picasso, let alone of bipolar disorder or schizophrenia. Although Picasso sometimes had mood swings and a temper, these were not sufficiently incapacitating to reach a level that would invoke any clinical diagnosis. He did not have bipolar disorder or schizophrenia. There is also no evidence of mental illness in his family.

Most highly gifted and creative individuals do not have any form of mental disorder at all. What the studies show is that if you have some of the genes that circulate in the families of those with bipolar disorder or schizophrenia, you are a bit more likely to become involved in creative activity yourself, but you don't have to have these particular genes in order to be creative. There are probably lots of other genes that have absolutely nothing to do with mental disorder but that also convey creative advantage.

Even among those who do not have bipolar disorder, creative bursts of activity can have echoes of the euphoric state of mania. When I am very active writing, or working on a new

science project, or thinking about the possibilities of developing something new, I feel enthusiasm, energy, drive and a sense of excitement, concentration and flow. Artists and writers talk of feeling slightly euphoric in some creative moments, when they may be able to work fast, producing ideas rapidly and fluently. This does not however mean that they are mentally ill.

DEPRESSION AND CREATIVITY

Depression was not found to be associated with increased creativity in the large Swedish study but there have been studies that have looked at anxiety and depression using a different approach. Paul Silvia and Nathan Kimbrel,[194] from the University of North Carolina, point out that for most mental disorders only a few people actually meet all the clinical criteria for diagnosis but far more people show some milder symptoms. So, for example, schizophrenia itself is relatively rare but people occasionally having odd thoughts or sensory experiences is much more common. So, rather than looking at people diagnosed with clinical depression or anxiety, Paul Silvia and Nathan Kimbrel looked at symptoms of anxiety or depression.

Narrow definitions of creativity may miss creative output, so Silvia and Kimbrel measured creativity in several different ways, including giving tasks to measure what is called *divergent thinking* (e.g. how many uses can you think of for a brick?), to measure creative thought, and to test creative behaviours (like writing a story or designing a costume) and creative accomplishments. The results were unexciting but clear. Neither depression nor anxiety symptoms have much to do with any facet of creativity. This result agrees with the Swedish study, and confirms that depression is not related to creativity and neither is anxiety.

How then do we account for the popular perception that depression is linked to creativity? Famously depressive, creative people who have committed suicide spring to mind like Sylvia Plath, Virginia Woolf, Vincent van Gogh and Ernest Hemingway. In these cases, though, there is often evidence that there were also upbeat swings in mood, so the underlying disorders may have been more bipolar than unipolar depression; remember that the Swedish study found a link to bipolar disorder but not unipolar disorder. There were also phases of remission during which much of the creative endeavour occurred. In a recent Polish study of forty patients with bipolar disorder, their degree of creativity reflected in levels of inventiveness was found to be much higher than controls when they were in remission but significantly lower than controls when they were depressed.[195]

It is also, of course, true that just because depression may not be related to creativity, it does not mean that you actually cannot have depression if you are creative. Group studies look for effects that come out when averaging over large numbers. There may be no direct link between depression and creativity but it is still possible for the two to occur coincidentally in the same individual.

Although periods of remission or active euphoric moods may be associated with creative innovation and the depressive side with withdrawal and internal preoccupation, nevertheless for some writers like Virginia Woolf and Sylvia Plath some creativity appears to have coincided with phases of depression, though perhaps not the most disabling phases. In the case of Sylvia Plath, it led to the generation of some very moving though deeply dispiriting poetry and her semi-autobiographical book *The Bell Jar*.[196]

The Bell Jar had quite a profound effect on me, as one of my brothers gave it to me as a teenager when I was feeling a bit down. He handed it to me, saying, 'Here, read this. It will cheer you up.' Such is the wit of Scottish siblings. Sylvia wrote the *Bell Jar* in 1961, based upon a very unhappy earlier period of her life. The following year, in September 1962, she separated from her husband, the gifted poet Ted Hughes, after disagreement over an affair he was having with Assia Wevill, who became pregnant. Sylvia found it difficult to come to terms with the separation and although she wrote some extraordinary and wonderful poetry that autumn, there followed a miserable and unusually cold winter, during which Sylvia was shut up painting a chilly, new flat, isolated with her two young children, who also became sick.

Finally, in February 1963, after several failed suicide attempts, Sylvia gassed herself in her oven. She'd left a note for her downstairs neighbour to call the doctor, but the gas seeped through the floor and knocked him out for several hours. It is possible that had he got the note on time, Sylvia would have been saved, and it is unclear, given the timing, whether she actually intended to kill herself or whether it was an attempt that she had expected to be interrupted. She was only thirty-two when she died. A highly intelligent and sensitive child, she had struggled with mental disorder from a relatively early age and was particularly disturbed by the death of her father, a university professor, from diabetes when she was eight years old; she published her first poem that year. Struggling with depression, she made her first unsuccessful suicide attempt as a teenager, and further unsuccessful attempts while at college. Plath noted that she was at her most productive when she was least disturbed.

She said, 'When you are insane, you are busy being insane all the time . . . When I was crazy, that was all I was.'[197] Like Yayoi Kusama, Sylvia Plath felt that writing poetry helped to keep her sane, saying in her journal, 'I justified the mess I made of life by saying I'd give it order, form, beauty, writing about it.'[198] Sylvia also believed that confidence and self-belief were important for creativity, saying, 'And by the way, everything in life is writable about if you have the outgoing guts to do it, and the imagination to improvise. The worst enemy to creativity is self-doubt.'

After her death, several further books of Plath's extremely beautiful and intense poetry were published to great acclaim, selected and edited by Ted Hughes. Things though did not run smoothly for Ted Hughes and Assia Wevill. Six years after Sylvia's death, Assia herself committed suicide by the same method, gassing herself in an oven, and she also killed her four-year-old child Shura, whom she had had with Ted Hughes. So Ted Hughes lost three of his great loves to suicide. But although one may pluck these examples of suffering, depression and creativity from the statistics, we should remember that the larger-scale studies do not point overall to any unusual level of association between depression and creativity.

The Dutch artist, Vincent van Gogh, despite phases of depression and mental disorder, was focused and coherent during his phases of artistic productivity. His use of a colour palette vastly surpassed that of Picasso and in his own way he was a revolutionary, but he started late as an artist and his artistic life was very short, the work for which he is famous principally having been produced over a single decade: 1880–1890. Picasso had over eight times that period to develop his

work. Who knows what Van Gogh would have produced given the same timescale?

ORDERED AND DISORDERED THOUGHTS

What the Swedish study discussed earlier does show is a clear association between schizophrenia and raised levels of visual artistic creativity, and in the case of the relatives of those with schizophrenia raised levels of creativity more broadly. If this is an effect that results from some kind of genetic influence, what is it that is happening in terms of thought? Why is there increased creativity? One theory proposes that those who rate highly as psychotic are creative, partly by virtue of the way that psychosis often induces its sufferers to make unusual associations between seemingly unrelated things (e.g. John Nash, physicist and mathematician; Edgar Allan Poe, writer; Yayoi Kusama and Ralph Albert Blakelock, artists). This could relate to lower levels of the latent inhibition that I discussed in the first chapter.[199] Maybe the genes that underlie affective disorders and schizophrenia also induce a reduction in the latent inhibition that might normally lead to thinking in an unimaginative, structured way. Reduction in latent inhibition might lead to more open associations and cross-linkage between ideas and concepts. When channelled appropriately, these would enable successful creative endeavours, but when loose associations are also linked to loss of contact with reality, thought disorder and poor insight, they may become part of a psychotic disorder.

There may be a biological link between certain mental disorders – like bipolar disorder and schizophrenia – and creativity that suggest they share a related genetic origin, but

there may also be cognitive mechanisms, like ease of forming loose associations, that are common between them. For effective creativity, the thought processes have to be successfully controlled and channelled. In contrast, psychotic thinking is often quite chaotic and does not make sense. Creative thinking, although original and distinctive, is largely rational, purposive and targeted towards a specific constructive outcome.

The success of artists and creative individuals who do not have any psychopathology or relatives with psychopathology shows that reduction in latent inhibition, novel associations and cross-linkage of ideas can also feature as part of a mind that is not pathological. Indeed such cognitive processes are likely to work best when the creator is entirely sane. The Spanish artist Salvador Dali, whose thought productions generated art that might sometimes have seemed slightly mad, summed up this concept when he noted that: 'There is only one difference between a madman and me. I am not mad. There is more to the nightmarish world than people think.'[200] Dali could make creative and novel linkages and associations but within a framework that was sane, structured and effective. This framework appears to be absent in the disordered thoughts of those with schizophrenia or affective disorder.

GENETIC FOUNDATIONS

In terms of the neuroscience, connections between creativity and schizophrenia have been linked to ideas related to dopamine imbalance as a precursor for creativity. Dopamine is one of the chemical messengers in the brain that enable one cell to communicate with another. Evidence from a variety of sources has supported the idea that dopamine plays a role in creative

thought and behaviour and we know that in some psychotic disorders such as schizophrenia the balance of dopamine is distorted, with elevation of its activity. Drugs that mop up dopamine reduce some of the florid symptoms of schizophrenia. In contrast, cocaine – which damages so-called D2 *dopamine receptors* – impairs performance on tasks that require flexible inhibition.

Individuals with a particular genetic signature (which has the technical label *DRD2 TAQ 1A polymorphism*) have a 30–40 per cent reduction in D2 dopamine receptor density. This means that they have a reduced ability to mop up dopamine in the system, so the dopamine sits around for longer. These people show significantly better performance on creativity tasks.[201, 202] However, the neurochemical elements of the dopamine theory are complicated by dopamine's many brain functions, multiple sites and circuits of action in the brain, and its complex interactions with other, poorly understood, neurochemical systems. Creativity does involve uninhibited novel associations and divergent thought but it also involves structured convergent thought and targeted inhibition. This means that a one-dimensional idea of excessive dopamine activity increasing creativity is too simple.

Another gene that has been linked to a greater risk of both schizophrenia and bipolar disorder is called *Neuroregulin 1* gene. Szabolcs Kéri in Hungary wondered whether this gene might also be relevant to creativity. He asked for volunteers, via newspaper ads and web contacts, who thought that they were particularly creative or had significant scientific or artistic success in their lives. Then he tested their intelligence, assessed their creative achievements and measured their creative thinking with

a standard test[203] that asked, 'Just suppose clouds had strings attached to them which hang down to earth. What would happen? List your ideas and guesses.'

The results showed that people with a double dose of the Neuroregulin 1 gene scored significantly more highly on the *creative cloud test* than those who had no dose of the gene.[204] So Kéri argued that this had a significant impact upon creativity. Interestingly, in this sample of intelligent people, there was no connection between the gene and any schizotypal features. Kéri suggested that the mechanism of action of the gene might be to reduce cognitive inhibition, thereby increasing creativity, and noted that there is evidence that the site of action for the gene is the prefrontal cortex. These ideas would fit with the theory that some genes that predispose to mental disorder in some individuals may actually convey creative advantage without disorder in others, and this may be why such genes are sustained within the population.

PICASSO AND DYSLEXIA

Other disorders, besides schizophrenia and bipolar disorder, have been linked to creativity and exceptional skills. One of these, dyslexia, may be relevant to Picasso. A number of exceptionally creative individuals have had dyslexia. For example, Leonardo da Vinci and Einstein were both dyslexic, and some argue that dyslexia sometimes leads to complementary enhancements of specific brain functions. Biological theories link constraints in the development of the systems that underpin reading in the brain to enhanced development of other areas. The notion that genius can combine with dyslexia has attained a high profile, and in assessing children with dyslexia, I have sometimes

been asked by parents to identify such talents. Unfortunately, however, dyslexia does not automatically confer exceptional talent. Sometimes strong skills are indeed evident in less verbal domains, but not always. It is also worth remembering that although people with dyslexia do often become successful architects, engineers and scientists, suggesting high 3D abilities, they can also become successful editors, writers, poets and journalists, professions that are more dominated by language.

Picasso's biographers differ in their judgement of whether he was dyslexic. Picasso loathed school from the outset and found it difficult to settle, having tearful tantrums, faking illness, and trying to distract attention away from the classroom. No explanation is given for this sustained distress but it would certainly be consistent with experiencing intense difficulties with initial mastery of literacy. He is described as having been 'an exceptionally dull scholar'[205] and made limited progress in the subjects taught at school, despite the fact that all the later evidence points to his being highly intelligent. Roland Penrose[206] notes that Picasso always hated school, where even the rudiments of reading, writing and sums gave him a great deal of trouble. The problem was sufficiently bad that the family hired a private tutor.[207]

Patrick O'Brian notes[208] that Don José, Picasso's father, was aware of the limitations in the literacy of his son, and when he moved post to La Coruña he sought the assistance of a friend in attaining certificates that would enable Picasso to enter school there. O'Brian points to early spelling errors Picasso made in Coruña, with *entonces* (meaning *then* or *in that case*) written as *entonses*, and *azul* (blue) as *asul*. He comments, 'These mistakes, together with those that have nothing to do with phonetics,

also show that Picasso remained impervious to printed shape, which is strange when one considers his astonishingly accurate recall of other forms, even then.'[209] We know now that the way the brain is organised means that it is not so surprising that there can be poor memory for letter forms and written words when there is good memory for other visual shapes, as written language uses different systems from those that underpin memory for other abstract forms.

John Richardson[210] concluded, however, that Picasso was not dyslexic, basing that view upon the following three arguments. First, if you look at an examination script that Picasso completed at the age of nine and a half, you find that he writes correctly. Second, Picasso was so talented in other areas that he must have been talented in reading too, for 'someone as mimetic and intuitive, as visually and mentally alert as Picasso would have learned to read and write as effortlessly as he mastered any other mental endeavour'. Third, according to Richardson, the idea Picasso had dyslexia represents a deliberate mythology.

Look back at the examination script in question, however, and what you find is that the dictation passage consists of about twenty words. Even if superficially 'passable', Richardson offers no analysis of the degree of literacy that would have been necessary to perform the task adequately. By the age of nine and a half, even if dyslexic, Picasso would have been expected to be able to write some things. The script itself is insufficient.

Nor is the view that if Picasso was good at other things, he must have found learning to read and write easy, consistent with our current understanding that developmental dyslexia is entirely compatible with high intelligence, verbal fluency, good memory, excellent visuo-spatial and perceptual skills,

and strength in visual processes that do not involve the written word. It would therefore be perfectly feasible for someone as 'mimetic and intuitive, as visually and mentally alert' (to echo Richardson's words) as Picasso to be dyslexic.

One person who is likely to have been well aware of Picasso's written literacy skills is Jaime Sabartés, a writer and sculptor who was Picasso's long-time friend. They met in 1899, when Picasso was age eighteen, and later, from 1935, Sabartés worked as Picasso's secretary for many years. Jaime is very explicit on the issue, claiming that Picasso could not read well before the age of ten years. He was clear that Picasso consistently spoke of having struggled with reading and writing, and had ultimately learnt them late. Even if these tales are exaggerated, it is highly unlikely that Picasso would invent something of this sort when he was always so keen to be seen as talented and able. Patrick O'Brian agrees, saying, 'To the end of his life he was not at home with the alphabet . . . his spelling remained highly personal.'[211] Similarly, Roland Penrose notes[212] that 'Picasso has confessed to me that he can never remember the sequence of the alphabet.'

As a boy, Picasso developed a technique in La Caruna of sending to his relatives in Malaga an illustrated news-sheet comprised largely of drawings, rather than writing to them in traditional format.[213] 'At no time in his life was Picasso a willing writer of letters.'[214] Gertrude Stein, Picasso's American friend, collector and ally, also discussed Picasso's ongoing reluctance to write letters even in adulthood and his preference for communication via sketches.[215]

Organising fluent writing was a considerable challenge to Picasso. He could sketch and draw at speed but when it came to writing a letter, 'Hesitant notes in sketchbooks reveal that

Pablo could not write the simplest letter without a preliminary draft.'[216] Patrick O'Brian notes that his handwriting was also very poor: 'except for some early laboured inscriptions he always wrote like a cat'.[217] Picasso was therefore unsurprisingly a poor correspondent and Max Jacob complained that he never wrote, though this was an exaggeration.[218] Picasso himself recognised his lack of enthusiasm for writing, saying in an interview in response to a difficult question (about why he had joined the Communist Party), 'I should much rather answer with a picture for I am not a writer.'[219]

Although Picasso did learn to read, like many adults who have been dyslexic as children he never read for pleasure or with enthusiasm as an adult. Fernande Olivier[220] notes that 'Picasso was not a great reader.' And Patrick O'Brian comments that although some have asserted that Picasso was a reader, 'they admit that they never saw him with a book in his hands'.[221] Nor have any of his companions ever spoken of him reading in bed.[222] Picasso owned a considerable number of books but, as Patrick O'Brian notes, 'he did not read a great many', though 'he illustrated books magnificently'.[223]

We cannot sit Picasso down and test his literacy, so we have to go by what those who knew him noticed and our knowledge of his life. We know that he did not settle at school and experienced sufficient difficulty to need additional tutoring despite evident high intelligence. He had idiosyncratic aspects to spelling that ignored the phonics and sound patterns of words in childhood, and he remained unenthusiastic about writing throughout his life, exhibiting difficulties in the organisation of a letter without a plan and a draft. There is no record from any of those who knew him of his reading a book for pleasure and fun, except

where he was planning to illustrate it. His secretary reports his late reading development and his difficulties. Perhaps most critically, Picasso himself recognised and was sensitive about his weakness in this area, sometimes laughing and exaggerating about it to turn it into a joke, a common behaviour for those who have suffered from dyslexia. In my view as a neuropsychologist, the balance of probabilities is that he was dyslexic.

Picasso also struggled with some aspects of arithmetic. 'Counting came hard, so did telling the time.' In certain critical school tests a friend is said to have given him the answers to the questions that were being asked.[224] Later, though, Picasso did master some measure of calculation and certainly became accomplished at financial negotiations with dealers, with whom he could drive a hard bargain.

PICASSO AND LANGUAGE

Despite his reluctance both to write and to read, Picasso became a lover of poetry, and his coterie of close friends generally included poets who later became distinguished, their identity varying through the different phases of his life: Max Jacob, Guillaume Apollinaire, Jean Cocteau, André Breton and Paul Eluard. Max Jacob not only wrote his own poetry but also loved to read the poetry of other French poets to Picasso, and Max also introduced him to French literature. In the early days, he was very disparaging about Picasso's awful French and gave Picasso tuition to improve it.[225]

Picasso continued to be 'no good at languages: in 1911 after years and years of Paris, a monoglot French mistress, and the perpetual company of French friends, his written French remained awkward'.[226] We know that those with dyslexia often

have written difficulties that are even more marked in second or third languages.

Picasso was self-conscious about his heavy Spanish accent in French – which he was unable to lose throughout his life – along with his individualistic approach to the French language.[227] His lack of confidence in his mastery of other languages meant that he dreaded making a mistake in French. Many of us are familiar with the sense of horror and surprise when we first hear recordings of our own voices, as they sound so different from the way they sound inside our own heads. Picasso also had this experience and did not like the sound of his voice at all. He never wanted to be recorded by stalking journalists, and he was keenly aware that things he said might be taken out of context and misinterpreted, usually for the worse. The films he made were often without words.[228]

Picasso resisted verbal analysis of his work: 'he was easily irritated by people who tried to question him about his work; tried to make him explain what he was unable to explain'.[229] This contrasted with Matisse, who was fluent and articulate in discussions of his work and other issues, and, with 'an astonishing lucidity of mind, was precise, concise, and intelligent and impressed people'.[230]

While on the subject of language limitations, it is surprising that Picasso did not name his work. He was a highly creative artist but did not feel the drive to assign creative verbal labels or link titles to his work. He named very few of his paintings, an exception being his 1903 work *La Vie*, with nearly all the titles of his works having been invented by dealers, critics, or archivists and cataloguers. Picasso usually hated the titles that were selected, perhaps because they tend to be brief and descriptive

as one might expect of an archivist, but consequently also rather mundane, dull and uninspiring, unlike the works to which they are linked. So, unlike the German artist, Paul Klee, whose titles are often either witty or perceptive, adding to the effect of the work, Picasso's art was created without any motivation to link them to even a brief verbal label. A further consequence of people other than Picasso himself giving titles to his work is that the titles can be inconsistent and also inaccurate.

Picasso did engage in some creative writing. He wrote poetry, for example, which certain people, such as Paul Eluard, claimed to like, but it was not universally admired and has certainly not stood the test of time. It comes across as unconnected rambling, though it may be that in the context of the ideas of his day, it had greater significance when it was created. It has also almost certainly lost quality, flow and subtlety in the process of translation. Here is an example: 'the hastened thrust of the sword in the quince's flesh opens the hand and like a cache-sexe lets out its secret prime the emerald so that it will let itself be eaten dressed up as a watercress salad with pieces of gross good eating whispering in your ear behind the lane damn beforehand happy to go to the stake try to be clever and make a bag of nuts . . .'[231] and so it goes on. Enough said, perhaps. Given the written efforts that have survived, I would say he was a pretty awful poet, though no doubt there will always be those who disagree. Picasso also wrote some plays, which his friends performed, but again they seem to have been fairly unexceptional.

LEONARDO AND DYSLEXIA

Another genius who struggled with written literacy was Leonardo da Vinci. Whereas Picasso eventually achieved competency if

not enthusiasm in writing, Leonardo had persistent difficulties throughout his life. His writing was unusual and striking, as he wrote from right to left in what we now call mirror-writing. This is rare, though occasionally seen in left-handers – and Leonardo was left-handed. Even if you take Leonardo's writing and read in a mirror, it still looks a bit odd, and not just because it is in Renaissance Italian. The strange appearance arises, first, because Leonardo made lots of spelling mistakes and, second, because he did some odd things when writing strings of words.

The patterns of his spelling and writing have been scored and analysed in relation to more contemporary ideas about literacy by the Italian academic, Professor Giuseppe Sartori of the University of Padua.[232] The analysis of spelling errors shows that Leonardo would double consonants at the beginning of words: e.g. 'casa (house)' à *ccasa*; substitute letters: e.g. 'ipocrito (hypocrite)' à *ipoclito*; and delete letters: e.g. 'contrastare (to oppose)' à *contastare*. He would also blend words together: e.g. 'sicurarsi da triboli (save oneself from three-point nails)' à *sicurarsidatriboli*; or segment words in a stream at places that were not the word boundaries: e.g. 'veduto da ciasum movente (seen from everyone who moves)' à *ve dutto daciascu n movente*. Other examples of this are 'a levante' (east) à *allevan te*; 'con equal (with equal)' à *cone qual*; 'natura (nature)' à *na tura*. So, Leonardo generated these non-words that look like words; they are in some ways logical spellings, but they are just wrong.

When Leonardo's written words are blended, the final blend sounds the same as the original words, if spoken aloud. Similarly, where the word boundaries were written in the wrong place, the sounds of the stream of words would still be the same as the correct version if read aloud. Because the incorrect spellings

preserve the correct sounds of the words, we call them *homophones*. Homophones are easier to spot in English than in Italian because there are different spellings for vowels that sound the same; so, for example, we have *meat* and *meet*, which are homophones, as are *sale* and *sail*. There are also pairs of words in English that are homophones, where one has irregular spelling patterns, e.g. *rain* and *reign*. In Italian, the language is so regular that you do not get these word-pair homophones but homophones do appear, as Giuseppe Sartori[233] has shown in the sequences of words blended or segmented incorrectly by Leonardo.

Leonardo's problems in writing cannot be attributed, though some have tried, to his writing from right to left, rather than left to right. His pattern of performance is no different when he does on rare occasions write, as in most Western scripts, from left to right, for some formal letters. So, for example, there is a surviving letter that he wrote to the Duke of Milan when he was trying to get a job as an engineer, and it has spelling errors in it that are similar to those we see in his mirror-writing. Leonardo's spelling errors are also not specific to Italian, as they also appear in his copying Latin, and indeed their very appearance in copying tasks for both Latin and Italian is unusual. Normal spellers make very few errors in copying but Leonardo made the same errors that you see in his spontaneous writing.

We all make spelling mistakes at times, and when we are rushing or stressed they may appear more frequently, but these mistakes with the boundaries of words – either blending them together or chopping the words up in the wrong places – are not mistakes that most people make. This kind of error made by Leonardo was really unusual and yet 44 per cent of his spelling mistakes were of this type.

Leonardo did sometimes notice when he had missed out or added a letter, and his corrections are marked in some of his writing. But there are no signs of him correcting the homophone strings of words. Homophones are interesting to neuropsychologists and neurolinguists, because there are thought to be two different systems involved in spelling, both of which we normally rely on, yet homophones look as though they come from using one system without the other. One of our spelling systems uses the sounds of words to work out their spelling. This is called the *phonological spelling system.* It is the one you can almost hear yourself using when you are trying to write down a long, and not very familiar word —you virtually sound it out loud as you are going, segment by segment. It is also the system we would use if we were asked to write a sensible spelling for a nonsense word, like *gip* or *wole.*

In contrast, the second spelling system takes account of *word-specific information* and the meanings of words. In English, this system is needed to write words like *reign* and *yacht* that you cannot write by sound alone, as they break sound rules. This second system also enables us to write homophones that have different spellings, and put the right one in the right place, so that we know that a *sale* indicates low prices whereas a *sail* is on a boat, and that there is a *right* way to *write* but not a *write* way to *right.* This second system that gives information about the meaning of words and enables us to distinguish between homophones is known technically by psychologists as the *lexico-semantic route.* Leonardo's spelling suggests that he has not properly developed this lexico-semantic spelling system, but his preservation of the sounds of words in his spelling errors shows that he does have a well-developed *phonological spelling system.*

There are children today who have similar spelling difficulties whose spelling problem is called *surface dysgraphia*. Leonardo da Vinci, as Giuseppe Sartori has successfully demonstrated, also had surface dysgraphia. This would come as no great shock to Leonardo himself, who was well aware of the limitations of his writing, saying, 'They will say that, being without letters, I cannot say properly what I want to treat of . . .' Leonardo also said, 'you should prefer a good scientist without literacy abilities than a literate without scientific skills', though some of those working in the arts might disagree. It is a pity that Leonardo is not accessible five hundred years later to discuss the issue.

Chris McManus and his colleagues in London[234] explored the relationship between drawing ability in art students and non-artists and the incidence of dyslexia, wondering whether dyslexia might be linked to a particular pattern of drawing skill, bad or good. They found no relationship between drawing ability and dyslexia, or drawing ability and spelling ability, or drawing ability and stuttering or stammering. The only proviso to this was that there was a small subgroup of those with dyslexia who also had mathematical difficulties, which correlated with weak visual memory, and this group were particularly poor at drawing. In general, though, dyslexia conferred neither a weakness nor a talent in drawing but was unrelated to it.

The McManus study also successfully eliminated a whole series of other possible theories about drawing skill. Drawing skill did not correlate with handedness, educational achievement, sex, personality factors or aesthetic behaviours in general. The only significant relationships to drawing that they found were with visual memory and with the ability to draw angles. So, the McManus study shows that there is no general

relationship between drawing skill and dyslexia. If you are an art student, having dyslexia does not routinely convey any advantage or indeed any disadvantage in drawing.

In the arena of genius, though, we might be seeking a very tiny and specialised subset of those with dyslexia. It remains possible that certain individuals with dyslexia who are at the end of some spectrum do have compensating special talents in non-verbal intelligence or visuo-spatial ability. It could be individuals who have unusually strong visual memories or 3D skills and it might even be a subset of individuals to whom Picasso belonged. However, the evidence for such a possibility is limited at present.

Genetic studies of related ideas are ongoing. So, for example, a family has been identified with six members, all of whom have significantly higher non-verbal intelligence than verbal intelligence, suggesting that this facet may be under genetic control.[235] Three of the six family members had dyslexia, so this could be a candidate family for artistic and creative strength, but in reality none of the family members had exceptional visual memory, and so there was no evidence of strength in skills relevant to drawing or indeed any creative skills being implicated; rather, any genetic driver appeared to influence the overall balance of verbal and non-verbal strength, and that may have related to underlying anatomy.

Discussions continue about the strength of visuo-spatial skills in dyslexia.[236, 237] That strength in visuo-spatial skills may co-occur with dyslexia is evident, but this is not the same thing as there being a causal connection. Some of the discussions follow earlier ideas that hormonal influences during foetal development affect the growth of the brain in ways that have

implications for later skills and abilities.[238] Going back to my own study of Oxford academics[239] that I mentioned earlier, I also looked at the incidence of dyslexia or stuttering in this test group. Only 2 per cent of the verbal academics had dyslexia or stuttering as children but 7.5 per cent of the mathematical academics had experienced such problems. Does this suggest an association of mathematical talents with dyslexia and stuttering, or does it simply indicate that if you have experienced dyslexia or stuttering you are less likely to pursue a verbal academic career? The debate about dyslexia and talents is one that will continue to roll until we have stronger evidence.

CHAPTER 6

Picasso in Love and in Life: Personality, Drive and Emotion

'Love is the greatest refreshment in life.'

Picasso

OPENNESS TO EXPERIENCE

Personality is not a particularly easy thing to measure but one popular theory has identified five different dimensions of personality, the so-called Big Five theory. The Big Five dimensions are *Extraversion, Neuroticism, Agreeableness, Conscientiousness* and *Openness to Experience*. The last of these, *openness to experience,* is the trait that has been most frequently linked to creativity. Picasso's sustained playfulness in adulthood is seen as an expression of this personality trait that enables open exploration of the world, encouraging creativity.

While many studies have demonstrated this link between openness to experience and creativity, Sophie von Stumm[240] and colleagues have tried to go further and tease apart the process of creativity itself and work out which part of it is linked to openness to experience and whether other personality traits are also important. They divide creativity into three parts. First, there is fundamental, underlying *creative ability*. Second, there is the tendency to think creatively about ideas – they call this

creative ideation. Third, there is actual *creative achievement*. So, there is creative ability, ideation and achievement.

In Picasso's case, there is strength in all three parts: his fundamental ability is evident from the content of his work; his exceptional creative ideation is also evident from the composition and novelty of his work, and from the linkages between different ideas it expresses, reflecting ideas that must have occurred before or during its production; and his achievement is evident in the vast volume of work he produced and its lasting appeal.

Sophie von Stumm's study found that the personality trait openness to experience related to both creative ability and creative ideation. So for Picasso, his openness to experience personality trait was linked to both fundamental creative ability and creative thinking. Creative achievement itself may be linked to different personality traits.

Sophie von Stumm points out that openness to experience actually overlaps with intelligence, as both have common aspects of mental speed and flexibility. This may help to explain the association between *divergent thinking* that is a form of intelligence and *creative ideation*. In most intelligence tests, there is a single correct answer and you have to try to work out what it is. These are *convergent thinking* tests. In contrast, in *divergent thinking* tests, there is no single correct answer as the questions are open-ended, with the classic example, 'How many uses can you think of for a brick?' There is no single correct answer here, and imagination and innovation will help to strengthen the number of ideas generated. One can see why divergent thinking like this would be linked to creative ideation, and therefore why this measure of intelligence and creativity is related.

HYPOMANIA AND SCHIZOTYPY

The Sophie von Stumm study identified two other personality traits that were linked to creativity: *hypomania* and *schizotypy*. Hypomania is characterised by racing thoughts, decreased need for sleep, euphoria, irritability, risk-taking and an excessive drive for success.[241] Hypomania was advantageous in the study, for both creative ideation and creative achievement, though it showed no relationship to underlying creative ability. Hypomania, then, seems to get you thinking creatively and spurs you into actually achieving creative work, but it does not affect the underlying talent that is the core creative ability.

Descriptions of Picasso do not neatly fit hypomania. While he was a risk-taker in art, he was not a general risk-taker in life or his other interests. In terms of decreased need for sleep, Picasso did often work late into the night but then he often did not get up before mid-day, so the cycle of his day was not typical, yet there is no evidence of altered sleep requirements. Racing thoughts and euphoria do not leap from the pages of his autobiographies. Similarly, while he could have a temper, general irritability was not a consistent personality trait. So while there is clear evidence for Picasso being strong in the personality trait of openness to experience, there is no robust evidence of hypomania as a personality trait. What of schizotypy?

UNUSUAL EXPERIENCES AND MATING SUCCESS

Schizotypy sounds a bit worse than it is. It refers to a mixed bag of elements: first, being rather impulsive and nonconformist in a way that involves reckless behaviour; second, being somewhat disorganised in thinking about the world, sometimes with poor concentration and attention; third, having a tendency towards

unusual experiences, that could include magical thinking or even visions or hallucinations; and fourth, not always responding emotionally in the way one would expect, and not always deriving much pleasure from normal day-to-day activities, being a bit withdrawn emotionally and socially. So there are four different dimensions to the schizotypy personality trait[242]: recklessness, disorganised thinking, unusual experiences and emotional detachment.

Evidence of these four schizotypy traits in Picasso is limited; only the merest dashes are evident. Picasso was a non-conformist and could be impulsive occasionally but he was not particularly reckless. He may have been disorganised in terms of managing the clutter in his homes but there is no evidence that he thought about the world in a disorganised way and he certainly did not exhibit poor concentration and attention, except when his concentration and attention were focused elsewhere. He derived lots of pleasure from normal day-to-day activities, was sociable with wide circles of friends and was withdrawn only in the sense of often working in a solitary way. So in these facets, there is very little evidence of schizotypy in Picasso.

There is more of a case, though, for some manifestations of unusual experiences. Though there are no reports of visions or hallucinations, Picasso did have a tendency towards superstitious behaviour that may have stretched to magical thinking. For example, he had a habit of reciting a litany of friends' names each day in a bizarrely superstitious effort to ward off their death. By what most of us would think of as an extremely unfortunate coincidence, on the day that his friend Maurice Raynal died, Picasso had forgotten Maurice's name on the list

and failed to utter his name. Picasso agonised over the omission. A friend pointed out to him that this did not mean that he had actually killed Maurice, but Picasso replied, 'To be forgotten is worse than to be dead.'[243] He definitely had a superstitious streak. Picasso's friend Max Jacob also loved the occult, mysticism, horoscopes and Tarot cards, and it may have been Max's influence that led to some of Picasso's fascination with this too.

So of the four dimensions of schizotypy, three seem not to apply to Picasso, there being evidence only of unusual experiences. Of interest, the Sophie von Stumm study referred to above also looked at these different dimensions of schizotypy and found that it was the single schizotypy trait, unusual experiences, that was significant and positively related to the quantity of ideas and originality in creative people.

While those with full-blown schizophrenia score highly on all four dimensions of the schizotypy trait, other people who do not have schizophrenia can nevertheless (like Picasso) have dashes of these traits, in a way that may actually be very positive. The evolutionary conundrum of schizophrenia is that it is substantially heritable and associated with sharply reduced fitness and drastically reduced probability of reproduction, yet it is sustained in all populations across the world. The idea that some of the personality traits that in more extreme form lead to schizophrenia might in milder form have positive benefit for creativity[244] is supported by studies that show that people who work in the creative arts do indeed have elevated levels of some schizotypal traits. As we discussed in the last chapter, there is also evidence for elevated involvement in creative professions in those who have close relatives with schizophrenia and who therefore share some genetic overlap.[245, 246]

But if certain schizotypal traits do facilitate creativity, would this answer the evolutionary question; in other words, does artistic creativity actually convey an evolutionary advantage? If schizotypal traits are sustained in the population, because of their impact upon creativity, these traits and artistic creativity would also need to convey some form of reproductive advantage.

To test this, Daniel Nettle and Helen Clegg, from the University of Newcastle and the Open University, UK, looked at mating success in a sample of 425 British poets, visual artists and other adults.[247] For each of the adults, they looked at the four dimensions of the schizotypy personality trait, *impulsive non-conformity*, *disorganisation*, *unusual experiences*, and *emotional and social withdrawal*. They also looked at the level of creativity in the production of poetry and visual art, as well as information about life history, and mating success. Mating success was based on time spent in steady relationships as well as absolute number of partners.

What they found was that higher levels of two of the dimensions of schizotypy were associated with a higher number of partners. Perhaps unsurprisingly, a higher level of impulsive non-conformity and recklessness was related to a higher number of sexual partners but a tendency to unusual experiences was also related to a higher number of sexual partners. This was not simply related to the lifestyle of the poets and artists in the sample, as when these individuals were removed from the group, the same pattern of results emerged in a further analysis of all the other adults. So the links between both impulsive non-conformity and unusual experiences and number of sexual partners is a feature of the general population as well as of

artists and poets. There was no link between schizotypy and the time spent in a steady relationship.

The prediction of the study was that if schizotypy increased mating success, it would do so at least partly through enhancing creative behaviour. Daniel Nettle and Helen Clegg therefore also looked at the level of creativity as reflected in degree of activity in the production of art and poetry and compared this with the number of partners. They found that serious and professional producers of art and poetry have a larger number of sexual partners than non-producers and hobby producers, and this result is unaffected by whether you are a man or a woman. Level of creativity did not affect time spent in a steady relationship.

Doing some rather fancy statistics called *path analysis*, Daniel Nettle and Helen Clegg were able to drill down even further. They showed that having unusual experiences has a significant positive effect on creative activity, which in turn then had a significant positive effect on number of partners. Impulsive non-conformity in contrast simply had a direct effect on number of partners that was not actually mediated by creative activity at all. So of particular significance in terms of our interests in creativity, Nettle and Clegg show that part of the reproductive success of the schizotypal traits is mediated through enhanced creativity. This fits in with the ideas of Geoffrey Miller,[248, 249] from the University of New Mexico, that artistic creativity in humans functions as a mating display.

One possibility would be that schizotypy has a beneficial effect upon mating up to a certain point, beyond which dis-organising effects reduce mating success, but Daniel Nettle and Helen Clegg argue otherwise. They say that actually the

levels of impulsive non-conformity and unusual experiences are about the same in poets and artists and actual patients with schizophrenia; where people differ is in their levels of *social withdrawal* and their general condition otherwise. Maybe those in good condition, with social engagement, can channel these personality traits into creative output and achievement, but those in poorer condition succumb to the disorganising effects and develop psychiatric disorders.

CONFIDENCE

Another personality trait that is associated with creative people is confidence.[250] Yet Picasso was not so confident. Patrick O'Brian notes, 'for one like Picasso, half of whose mind was filled with doubt, moderate success was essential'.[251] In spite of his strong drive to almost continually produce new creative works, plus his determination and his strong and sometimes dominating personality, he remained tormented by doubt and was sometimes a lonely spirit. Whereas Georges Braque, his fellow artist and explorer in Cubism, was sure of himself, Picasso continued to be plagued by self-doubt. His drive to be creative did not arise from confidence in his abilities and his work.

These doubts may have contributed to his extreme sensitivity to approval, even as an old man, when he would still watch intently for the facial reactions of those to whom he showed his work.[252] Given his innovations, feedback to his work was not always positive. His Blue Period was initially intensely disliked by dealers, who thought that it would be hard to sell. *Les Demoiselles d'Avignon*, the painting that is now seen as the iconic start of Cubism, was barely noticed by his lover

and queried dubiously by his friends. Cubism more widely was greeted with horror by many and castigated harshly, along with Picasso's talents, by critics. The initial ballet *Parade*, on which Picasso worked on the stage sets and costumes, was not successful, though it did have some notable admirers, for example the writer, Proust. Perhaps it was this sustained flickering self-doubt that contributed to the jealousy Picasso is said to have always felt for the artist Juan Gris and to have developed over time for Braque.

DRIVES: ENERGY AND MOTIVATION

One of the behaviours that characterises Picasso and many successful creative people is relentless drive. As Patrick O'Brian comments, 'Picasso was one of the hardest-working painters, sculptors, draughtsmen, etchers that ever lived... Picasso drew to himself as some men talk to themselves, and he drew incessantly.'[253] He had prodigious energy and managed to be very active socially in terms of dining with friends, as well as being ferociously productive in creating art.

Picasso himself said, 'Where do I get this power of creating and forming? I don't know. I have only one thought: work. I paint just as I breathe. When I work I relax: doing nothing and entertaining visitors makes me tired. It's still often three in the morning before I switch my light off.'[254] Picasso always found it hard to get up, but he would begin to paint after lunch around 2 o'clock and then, except for a brief stop for dinner, would indeed continue to work until the early hours of the morning.[255]

His drive to create was relentless, each day, each year and each decade. He said, 'Everybody has the same energy potential. The average person wastes his in a dozen little ways. I bring

mine to bear on one thing only: my paintings, and everything else is sacrificed to it . . . myself included.'[256] Only once or twice did he stop – more of that later in the chapter.

Despite his energy and sustained drive to create, Picasso hated to work to order. He was relentless but it had to be in the pursuit of creative endeavours that he chose himself. When not working to order, Picasso's self-motivation to be creative was intense and incessant; he did not believe in procrastination, saying, 'Only put off until tomorrow what you are willing to die having left undone.'

Surprisingly, an intense drive to create can actually be triggered by brain injury or disease. Bruce Miller and colleagues in San Francisco studied people suffering from *semantic dementia*, a condition that involves deterioration of memory and loss of the knowledge of words, resulting predominantly from left-hemisphere damage to the brain. Along with the loss of memory, they found five cases who had also developed a compulsive desire to express themselves artistically, despite having no prior interest in art.[257] In a further two cases, one patient developed the strong urge to compose while another took to constant singing and whistling. Both showed reduced activity in the left hemisphere of the brain.[258] Bruce Miller and the San Francisco group concluded that the left hemisphere's deterioration reduces its normal inhibitory processes over the right hemisphere, freeing up the right hemisphere to be more creative. The brain damage had switched off the brake on the right hemisphere.

A further example of emerging obsessional creativity is seen in the case of a former builder and heroin addict with a history of violence, who had no previous interest in the arts or art,

Tower of London

(2 moves) (4 moves) (5 moves)

Initial position Goal position (no. 2) Goal position (no. 6) Goal position (no. 10)

e Tower of London Experiment.

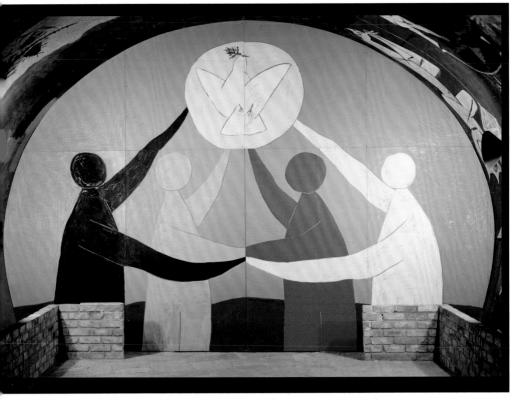

d panel of Picasso's *La Guerre et la Paix* triptych in Vallauris.

Boy with a Pipe and *Woman with a Fan* from Picasso's late Blue Period and early Rose Period.

Science and Charity by Picasso.

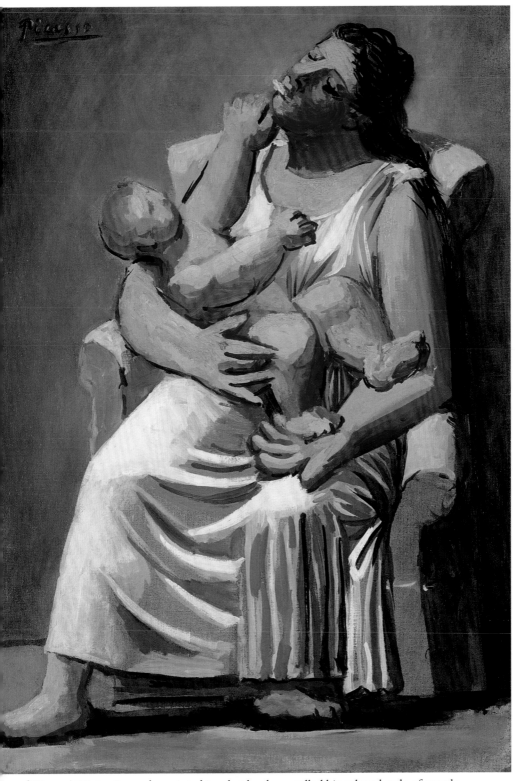

ne of Picasso's *Maternity* works, painted in what has been called his colossal style of people.

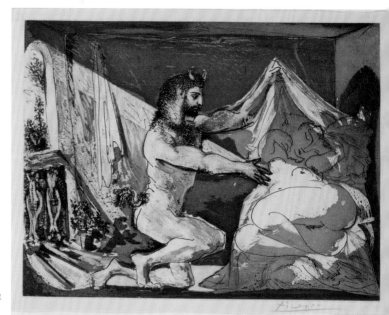

Picasso's *Faun Revealing a Sleeping Woman*.

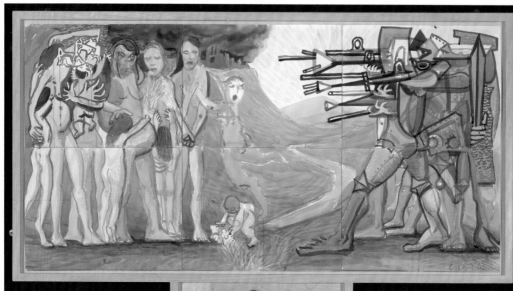

David Hockney's version of Picasso's 1951 picture *The Massacre and the Problems of Depiction*.

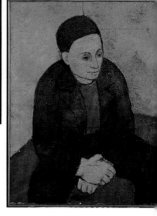

Untitled (Portrait of a Man), 1943 by Roy Lichtenstein.

yet after a brain haemorrhage became obsessed with creating paintings and sculptures.[259] However, it is worth noting that while the drive to create was strong, the quality of the artistic output in all of these cases was not that of genius. Some of it was competent, at best. The brain damage induced the drive to be artistic and creative but it did not induce brilliant underlying creative ability. The drive to create may be essential for creative achievement.

Other cases of brain injury or disease lead to intense shifts in interest, for example in the drive to listen to music but without the drive to actually create it. Cases have been described in which sudden and intense preferences develop for either pop music, polka music or classical music. One of these cases was a lawyer who had previously preferred classical music but after the onset of fronto-temporal dementia, a neurodegenerative disease that affects primarily the frontal lobes, developed a new enthusiasm for pop music, which he had thought of as 'mere noise' before.[260] In another case, a man developed fronto-temporal dementia in which parts of the temporal lobe and the right amygdala had also atrophied. He developed a passion for polka music that led him to sit in his car listening to the radio or cassettes for 12–18 hours at a time.[261] The right amygdala is tied to emotional response and is also involved in working out which things in the environment are significant and should provoke a response. It is possible that the deterioration in the amygdala caused a shift in this decision process about which things in the outside world are significant, leading to a distorted fixation.

A similar onset of enthusiasm for music has been described following drug treatment for epilepsy that had a right temporal

lobe focus,[262] meaning that the seizures in the brain started in this area and then spread out from there. Before treatment, the patient was indifferent to music, never listening to it for pleasure and shutting the door to avoid hearing her husband playing the piano. Yet, after medication controlled the seizures, the patient listened enthusiastically to classical music stations on the radio, asked to be taken to classical concerts and was transfixed by going to the opera *La Traviata*. She now found classical music pleasant and emotion-charged, though in other ways she was quite unchanged in tastes. Here, the intense drive does not seem to be linked to creativity, but the pleasure of music itself and the area of abnormality in the brain was right temporal, not left hemisphere as seen in cases of people driven to be creative composers, artists or sculptors. So, new drives and preferences may arise after brain injury or disease that in some cases involve new pleasure in experiencing the arts, and in other cases involve new motivation actually to engage in artistic creativity.

These cases show that the obsessional component that sometimes appears with fronto-temporal dementia is not necessarily linked to the drive to create but may be linked to a new intense preoccupation or interest. Other areas like the amygdala may also alter the emotional charge that affects preferences. In those cases where the drive is focused on actually creating things, it may be that a brake on the frontal lobes has been switched off.

It is not of course enough to feel a drive to start working on something; there needs to be the perseverance to see it through to the end. Picasso showed intense perseverance with most of his projects. When he did occasionally put things to one side,

he sometimes came back to work on them again after several years and had another stab. In his later work, when he typically dated everything, you can sometimes see more than one date on the same work, and the gaps in time between these dates can be quite long. No-one who produced the thousands of works that he produced could be accused of failing to deliver.

Picasso was aware of his intense drive to work under any circumstances, observing, 'We artists are indestructible; even in a prison, or in a concentration camp, I would be almighty in my own world of art, even if I had to paint my pictures with my wet tongue on the dusty floor of my cell.'[263] He felt the drive to work was beyond his control: 'I paint the way someone bites his fingernails; for me, painting is a bad habit because I don't know nor can I do anything else.' He also recognised the generality of the human drive to work: 'Work is a necessity for man. Man invented the alarm clock.'[264]

Emotion, then, may contribute to the drive to create or to cease creating, but the drive to create also has to be intensively sustained. This means that when engaged, the creator – whether artist, composer, inventor or writer – has to be able to sustain attention and ignore distraction over extended periods of time. Functional imaging studies have demonstrated that the *right prefrontal* area of the brain controls such sustained attention. This combination of obsessive and sustained attention, when allied to reduced inhibition, may be critical for the expression of creativity.[265]

For some brilliant artists, delivery was an issue. For all his fame, Leonardo da Vinci only left us about fifteen paintings, a Spartan cultural inheritance and yet one that has had an incredible impact, paintings such as the *Mona Lisa* gaining

iconic status. Leonardo started lots of projects that he did not finish. He seems to have started them well enough, got part of the way through, and then just stopped. So, if you regularly fail to finish something, you can comfort yourself with the thought that even genius sometimes works that way.

THE DRIVE TO CREATIVITY OF LOSS

We all know that our feelings affect our thoughts. Grief, love, anger and fear all influence the way we think. The emerging research field of *emotional cognition* examines the way in which our emotions influence such cognitive processes in the brain as language, memory, thinking, reasoning and, of course, creativity. Although we have yet to understand all the underlying processes, it is clear that unhappy life events can trigger innovation and creativity. Picasso experienced intense loss as a teenager. His adored sister Conchita died of diphtheria at the age of seven, when Picasso himself was aged fourteen, and the family records imply that a younger brother called José may also have died.[266] Picasso retained an obsessive tenderness for the memory of Conchita throughout his life.[267, 268]

After Conchita's death, the first of Picasso's autobiographical works, driven by emotion, was elicited. In this early mode, the style was *social realism*, very different from his later, more famous styles. He produced paintings of bedside invalid scenes which display an unusual maturity. For example, *Science and Charity*, painted in 1897, when Picasso was sixteen, shows a doctor, modelled on Picasso's father, taking the pulse of a dying woman, while a nun who holds a child in her arms, looks down from the other side of the bed (see plate section). Painting realistic scenes of domestic activity in this way broke the more

common convention of depicting work related to religion, history or literature.

The origins of Picasso's Blue Period, so called because of the palette employed in his new paintings, are generally attributed to the emotional grief and inspirational guilt that resulted from the suicide of one of Picasso's closest friends, Carlos Casagemas (Picasso himself told his friend Pierre Daix, who later catalogued much of his work, 'It was thinking about Casagemas's death that started me painting in blue'[269]). Contemporary studies of emotional cognition demonstrate that when a person's mood and feelings are low, they experience a cognitive bias that leads them to notice negative information and unhappy events more, which reinforces their original mood. That is what the Blue Period represents, with Picasso himself unhappy, focusing upon the unhappiness of others in the world around him.

Shifting such a biased mindset to a more positive outlook able to focus instead on more upbeat things and reinforce good feelings is one objective of current *cognitive behavioural therapy*, known as CBT, and *mindfulness-based cognitive therapy*, MBCT, widespread treatments for depression and unhappiness. Studies in neuroscience suggest that these therapies may actually alter the degree of activation of differing circuits in the brain, changing the way in which the brain responds to external events. Without such contemporary developments on offer, Picasso had to find his own way through and, given the work that he generated during this era, we are lucky that it took him some time, only changing as he emerged into his more cheerful Rose Period, helped by the cheerful presence of a new lover Fernande Olivier.

THE DRIVE TO CREATIVITY OF LOVE

Much has been written about Picasso's negative treatment of women, to the extent that he is sometimes brushed off as misogynistic, cruel, philandering and a bit of a beast. Yet looking at his work, this image of a harsh Picasso contrasts intensely with the very beautiful, emotive and spine-tingling paintings that he produced of the women he loved. Picasso himself recognised the autobiographical nature of his work and his paintings reflect the intensity of the love that he felt for a number of different women during his life. As some of these relationships deteriorated, the paintings of the women became less filled with love and more with angst, but in the deterioration of many relationships over time, such transitions are not uncommon.

Picasso did clearly love with great passion, and these great loves motivated and drove some of his most productive and beautiful works. He also supported and cared for some of his lovers throughout his life and did not cast them all off, as sometimes depicted. The way in which love drove Picasso to represent his women in art interacted with their personalities and the form of his own attachment to them. There is another book to be written about his eight key loves (see Table 6.1 below for a summary of who they are); here I will just highlight aspects of the drive and how love impacted upon Picasso's brain and emergent creative work.

Picasso recognised that love was a strong motivator in his drive to work: 'In the end there is only love.'[270] Each new love triggered an intense outpouring of new work and as a relationship ebbed the volume of work produced would sometimes tail off too. Other great artists also recognised the powerful motivation

that a partner generates, though some expressed it with greater emphasis on sex than love. Renoir, when asked if painting came from the head or the heart, said, 'From the balls', and Cézanne is thought to have shared these sentiments.[271]

Table 6.1: Picasso's wives and lovers

Wife/lover	Era of Picasso's life	Picasso's age	Principal period of art	Comments
Fernande Olivier b.1881 (real name Amelia Lange)	1904–12	23–30 years	Rose. African-influenced. Analytical Cubism.	Artist and model. Lived in Bateau Lavoir. Unable to have children. Relationship ends when Fernande falls in love with Umbaldo Oppi, the Italian Futurist artist, and Picasso falls in love with Eva Gouel.
Eva Gouel b.1885 (real name Marcele Humbert)	1912–15	30–34 years	Analytical Cubism. Synthetic Cubism.	Appears more often as a Cubist guitar than in facially recognisable form. Eva died of cancer, aged thirty, on 14 December 1915.
Olga Khokhlova b.1891	1917–35	35–53 years	Colossal. Synthetic Cubism. Neoclassical.	Russian ballerina. Married 12 July 1918, Paulo born 4 February 1921. Separated 1935. Never divorce. Olga dies Feb 1955.
Marie-Thérèse Walter b.1909	1927–44	45–63 years	Synthetic Cubism. Neoclassical. Curved Graphism. Surrealism.	Maya born 5 September 1935. Remained close 1944–54. (Suicide 1977, four years after Picasso's death.)

Dora Maar b.1907	1936–44	54–61 years	Cubist with classical.	Yugoslavian. Photographer. Records Picasso painting . Multi-lingual, including Spanish. Has 'depressive' breakdown in 1944.
Françoise Gilot b.1921	1943–53	61–72 years	Cubist. Ceramics. Sculptures. Old Master reinterpretation.	Artist. Claude born 15 May 1947 and Paloma born 19 April 1949. Françoise leaves with children, 1953, and subsequently marries Luc Simon, and later Jonas Salk.
Jacqueline Roque b.1926	1954–73	73–91 years	Ceramics. Linocuts. Old Master reinterpretation. Neo-expressionist.	Married 2 March 1961. Picasso dies, 8 April 1973. (Suicide 1986.)
Genevieve Laporte b.1927	1945–53	62–73 years		Writer and poet. Intermittent relationship, principally 1951–53.

Picasso's feelings for Marie-Thérèse, although initially hidden in some of his paintings, eventually emerged in the development of Curved Graphism, the innovative style that has had sustained popularity and engendered eye-watering prices at auction. No-one who knows about Picasso could look at these works and doubt that he was in love with Marie-Thérèse. They are sensual but also warm and tender. Curved Graphism is much more immediately accessible than Cubism, and accessibility and ease of understanding make paintings more widely popular. The combination of simplicity yet complexity,

accessibility yet novelty, in Curved Graphism contributes to their enduring popularity. Picasso in love was a genius.

Although the presence of and involvement with his muses and lovers was a critical driver in generating many of Picasso's paintings, their mental engagement with the work that he produced did not appear to be critical to this process. Thus, Fernande in the early days was said to have been quite disinterested in the iconic *Les Demoiselles D'Avignon* and Picasso's evolving Cubist work. Olga also demonstrated no particular liking for his work, and even Marie-Thérèse was more interested in sport than painting or sculpture, had never heard of Picasso when she met him, and was never particularly interested in his work, preferring to be a sanctuary of escape and simply enjoying being with him.

Dora Maar was an exception and one of the most intelligent of Picasso's partners, photographing his work and creative enterprise. Some of Picasso's most complex work was created in the Dora Maar era, Picasso finding in Dora an absorbing, intellectual, political woman with whom to argue and discuss. He brought together facets of previous styles during his time with her, but they evolved into something even more substantial. Unfortunately Dora was also unstable, and as she became more disintegrative and estranged from him, the pictures of her weeping and anguished proliferated, reflecting not only the agony of Spain but also her own agony and perpetual tears.

As Dora Maar deteriorated mentally, Picasso became captivated by a young, intelligent artist called Françoise Gilot. Picasso and Françoise fell in love, another era of fabulous paintings and drawings began, and with their move to live in the South of France a new colour palette developed, work with

ceramics began and the era of linocuts also took root. The births of Claude and Paloma also evoked many wonderful paintings.

Picasso's love for eight women provided the emotive driver in the brain to inspire and produce great works of creative genius. Love has a particular signature in the brain. Andreas Bartels and Semir Zeki have shown in a study using fMRI scanners that when people look at partners with whom they are in love, compared to other friends, a unique network of several areas is activated.[272] It seems that this network stimulates the network that underpins creative genius.

THE DRIVE TO CREATIVITY OF FULFILMENT

For Picasso, part of the drive to paint was the joy and pleasure involved. When Ambroise Vollard, one of his dealers, asked him to produce a copy of the work, *Child with Pigeon*, as it was so popular, he said, 'But, it wouldn't give me any pleasure to copy my own painting: how do you think I could paint without joy?'[273]

Picasso had an intense need to fulfil himself. He understood that following one's drives could lead to deep fulfilment, and he wanted others to achieve fulfilment as well. 'The essential is to do that which one wants to do',[274] he said. Jean Leymarie, an art historian who knew and wrote about Picasso, said:

> Picasso was extremely generous, that is to say, he wanted everyone to be fulfilled in his endeavours. Consequently, if you are an art dealer, you must make money. You must do your work seriously, and you must reap the harvest. To me, an art critic, he gave all the means for understanding him. Later, as he knew that I refused paintings as a museum curator, he made

several drawings for me, on books, but he also said to me on several occasions, 'If you need money, anything, let me know.'[275]

André Villers, the French photographer, also benefited from Picasso's generosity. In his early days, before he was known or established, he broke his camera and Picasso, when he heard, said, 'That is as if somebody had stolen your eyes' and sent him a professional Rolleiflex camera the following day.[276]

Picasso had a late phase in 1966 when his drive declined, fulfilment seemed impossible and he stopped working. For a whole year, he did not paint a picture. This was even worse than the period after the break-up of his marriage to Olga. It followed his prostate operation in the American Hospital at Neuilly in Paris, which is said to have left him subsequently impotent. Legal battles had also dragged on over Françoise Gilot's book about their relationship. The emotional impact of these two elements thwarted his usual productivity. However, he did still draw and etch, so he was not without artistic expression.

Early in 1967, Picasso telephoned a friend to say that he would not be phoning again as it was too difficult to make out what she was saying. His eyesight was starting to be affected and his hearing was failing. Fortunately, though, he soon cheered up and started to paint again, beginning a prolific series of painter-musketeer works, as well as returning to the theme of circus people and the Harlequin. He also worked on some of his most sexually explicit work that some have subsequently deemed pornographic and that is seldom reproduced. This perhaps was his way of reacting to the reduction of his own sexual capacities. If he could no longer express himself in reality, he could at least express himself in art.

PICASSO'S FANTASIES AND CREATIVITY

In Picasso's work, we see the conflict he was experiencing at the time of the break-up of his marriage to the former ballerina Olga, when the pregnancy of his young and loved mistress Marie-Thérèse became known. As noted earlier, in drawings and paintings of rich fantasy scenes, he depicts himself as a blinded Minotaur, being led by Marie-Thérèse, who clutches a candle.

Children, of course, use fantasy in their games and play, unless they have autism, a core feature of which is an absence of imaginative play. Children who play imaginatively early in life are both happier generally and able to function more effectively, possibly because they use play to make sense of and explore the world around them.[277]

Sigmund Freud[278] argued that fantasy play was a precursor of the daydreams that are part of adult life. With age, increased inhibition, and more formal structures like schooling, imaginative play reduces and daydreaming develops. Freud thought that daydreaming was significant in relation to creativity, as it is not only important in order to appreciate works of literature but is the basis for creative writing too. He also thought of daydreaming as a kind of release valve that stops less acceptable impulsive overt behaviours. These internal creative thoughts were in his view critical to sustain appropriate social behaviours. Like many of Freud's ideas, this remains a bit contentious. Although theories abound, contemporary scientists still cannot yet agree upon what dreaming at night is actually for, let alone daydreaming.

Yet daydreaming is a normal and widespread human activity. We may also often find ourselves thinking about

matters that are not really directly related to a task in hand. Researchers use the term TUIT (task-unrelated images and thoughts) for these thoughts.[279] They can be more fragmentary than daydreams but just as persistent. People who daydream more are also thought to produce more TUITs. Current concerns and unresolved conflicts can feed into TUITs and daydreams as well as into dreams at night. Fantasy and dreams also feed into creative literature and poetry, from Coleridge to Shakespeare.

One emotional trait relevant to fantasy and related to personality that has been explored in artists is *alexithymia*, which is a difficulty in identifying and describing emotions. Although one might imagine that this would be associated with some reduction in sensitivity, and some studies have suggested that it is linked to lower levels of creativity, others argue quite the reverse, namely that alexithymia reduces the constraints in the way in which emotions are thought about, enabling unusual associations, a richer fantasy life and increased creativity. Consistent with this idea, creative art students have higher levels of alexithymia, with greater difficulty verbalising, identifying and analysing emotions than normal, but they also seem to feel emotions more intensely and have a richer fantasy life.[280]

Daydreaming, fantasy and thought that is independent of any specific stimulus becomes active when the brain is at rest. It has been called the *Brain Default Network*.[281] It reduces again when a demanding or new task appears. Brain-imaging studies describe this network as involving two areas. The *medial temporal lobes* provide the memories and associations from which imagery and mental constructions may derive.

The *medial prefrontal system* facilitates the dynamic and flexible use of this information to construct mental simulations.[282] The two areas appear to start to interact when children are toddlers and pretend play emerges. Autism, schizophrenia or dementia may disrupt these processes. For artists like Picasso and those with rich daydreams and fantasy, the activity of the Brain Default Network and the medial prefrontal system may be particularly strong.

There are numerous examples of creative individuals solving apparently intractable problems through the use of fantasy or dreams. Famously, the German chemist, Friedrich Kekulé (1829–1896), who preferred to be known as August, said that he solved the problem of the structure and carbon bonding of benzene rings after having a daydream about a snake biting its own tail. He also spoke about another daydream of dancing atoms and molecules that made him develop his theory of chemical structure. Similarly, the German physicist Albert Einstein (1879–1955) had a vision of a man falling off a roof and realised that acceleration and gravitation were just two different ways of describing the same thing. The Danish physicist Neils Bohr (1885–1962), who won the Nobel Prize for Physics in 1922, worked out the structure of the atom after having a dream in which he saw the nucleus of an atom with lots of electrons spinning around it, similar in appearance to the solar system. The dream gave him his answer when he was asleep.

In each of these cases, the Brain Default Network became active when the mind was notionally at rest, and not focused upon a specific task. Insights may emerge during such periods of relaxation.[283] The network appears to involve activation

of memories and associations that are generated from the medial temporal lobes, but the dynamic construction that enables a solution to an explicit problem involves the medial prefrontal system.[284]

CHAPTER 7

Picasso's Frontal Lobes: A Triumph of Evolution

'The meaning of life is to find your gift. The purpose of life is to give it away.'

unknown

THREADS ALL LEADING TO THE FRONTAL LOBES

Drawing together the threads of previous chapters, Picasso's creative genius is repeatedly linked to the prefrontal and right frontal areas of his brain. As our frontal lobes mature in childhood, the expression of creative play reduces with age. Behaviour is more inhibited, more goal-oriented, and there is less mental flexibility. Yet Picasso's retention of play in both life and within his art, combined with his mental flexibility and exploration, and his very effective development of goal-oriented behaviour, enabling the production of large numbers of works, points to something unusual about the impact of his frontal lobe maturation, the degree and modulation of inhibitory control and mental flexibility.

Exceptional single-exposure visual memory contributes to artistic talent in some adults with autism. Studies of other exceptional mnemonists indicate that it is the strategies used

when encoding and recalling memory that are critical, rather than the size of the stores themselves. Prefrontal activity is implicated in the use of such mnemonic devices. For Picasso, intense concentration, deep processing and repeated exposure to relevant paintings or sitters enabled his over-learning of visual memories and deep encoding of them. The novel associations made from these memories, such as his integration of images of Iberian sculpture into the portrait of Gertrude Stein, distinguished much of his work. So, it was not simply his visual memory per se that was exceptional but the way in which that visual memory was used and adapted. The temporal lobes and the structures that lie under them, including the horse-shaped hippocampi, are known to be important in the laying down and storing of memories. They underpin memory capacity and performance in most standard clinical tests of our ability to remember stories, facts or pictures, but it is the prefrontal cortex that is implicated in using these memories in real-life situations,[285] and integrating different memories and multiple sources of knowledge to develop something new.

In exploring portraiture, experiments showed that artists are better than normal at extracting the signature features of faces. This skill uses top-down visual perception involving the brain in extracting important elements from what it perceives. Such top-down perceptual processes depend upon direction from the frontal lobes. In direct confirmation, brain imaging of an expert portrait artist at work showed an enhanced activation of the right-middle frontal cortex.[286] Picasso also demonstrated a marked sensitivity to the use of alternative perspectives within his work, predating more recent developments in psychology with his ideas. This capacity to flip from one perspective to

another, as with the reversing Necker cube, is also underpinned by the frontal lobes, with patients with frontal lobe injuries experiencing a reduced number of Necker cube switches in perspective.[287] So the frontal lobes are also implicated in Picasso's visuo-perceptual skills.

In the development of skills, Picasso used a sophisticated reductive technique to generate multi-coloured linocuts from a single plate. This required complex planning and keeping track of an ordered sequence of actions that are executed over time, using skills that are the core components of two classical tests of prefrontal lobe activity. Picasso also continued to explore new techniques and go beyond previous established skills. This exploration of novelty also has frontal lobe underpinnings.

Some creative artists have psychiatric disorders either themselves or in their families, such as bipolar disorder or schizophrenia, both of which link to functions of the frontal lobes. Picasso did not have schizophrenia or bipolar disorder and nor was it evident in his relatives. However, obsessional behaviour is also linked to frontal lobe function, as is the capacity for intense attentional focus and an ability to ignore distraction. Picasso had strands of obsessional behaviour manifest in his hoarding behaviour and he also had an intense work focus, with extreme drive. The obsessional focus of many geniuses and capacity to operate with intense concentration, and to sustain attention without distraction, reflect high levels of prefrontal engagement. We also know that in some special cases of dementia, where the frontal lobes are essentially freed up, there are people who have never been interested in creative artistic expression but who begin to be driven to create. The prefrontal lobes, with their strong connections to more

primitive emotional systems in the *limbic system* and *midbrain*, are also important in the modulation and response to emotion that is a key driver in the impetus and content of creative work.

This means that in a whole series of areas, Picasso's brain and those of other geniuses demonstrate advanced development of the prefrontal areas of the brain. Strong development of any of these individual elements would contribute to talent. Genius may arise when they combine.

As you go up the animal kingdom, the volume of the outer covering of the brain – the so-called cortex – increases, but as you progress through the primates to man, the area that proportionately increases the most is the cortex around the frontal lobes. So it is not a surprise that the frontal lobes are involved in the most highly evolved of our human activities, including the creative process. Animals may also be skilled and adapt to their surroundings but they do not engage in the creative aesthetics, artistic endeavour, invention and innovation that are such a fundamental part of human society. Creative genius is uniquely human, however beautiful you may consider the dance of bees or the song of the whale. This does not mean that animals cannot show novel problem-solving capacity but this is not equivalent to the depth of endeavour and achievement that constitutes creative genius.

Neurological patients with frontal lobe damage may have difficulty in sustaining focused attention and have a tendency to display inappropriate emotional reactions.[288] They also show alterations in the levels of inhibition known to be controlled by the frontal lobes. When I worked with adults who had frontal lobe injuries in Oxford, those with left prefrontal injuries could sometimes be uncommunicative and

depressed, although fortunately not always. The right frontals were generally a gregarious set, and a few of them stand out for having been incredibly enthusiastic participants. They loved the experiments and they loved engaging with our research. They also loved the hospital furniture, the slightly run-down rooms and the food in the hospital canteen, and they would tell doctors or strangers they passed in the corridor how great everything was. Walking through the hospital with them consequently felt rather un-English, but also rather uplifting. They were disinhibited, enthusiastic and driven, but they were also socially unpredictable and slightly out of control. In laboratory assessment, they had difficulty with *executive tasks*: tasks that include complex planning for a distant goal, sustaining attention and ignoring distraction, thinking flexibly, switching strategies and learning from mistakes. More recent studies also demonstrated their difficulties with multitasking, with integrating diverse sources of information, and their fundamental difficulty in addressing new situations and the unexpected.

If we are correct that the frontal lobes and particularly the prefrontal areas, at the front of the frontal lobes, are critically involved in creativity, and that this is where all the exciting stuff is happening, then there should also be other evidence of links between the frontal lobes and creativity, and indeed there is.

DIVERGENT THINKING, NOVEL EXLORATION, MULTI-TASKING AND THE FRONTAL LOBES

Oliver Zangwill, who was Professor of Psychology at the University of Cambridge for thirty years in the twentieth century, was one of the first people to suggest that abnormal

functioning of the frontal lobes could disrupt *divergent thinking*, an important element of creative thought. Although nowadays we often think of divergent thinking as a single thing, exemplified, as I've mentioned before, by the classic 'How many uses can you think of for a brick?' test, Zangwill talked about two different components to divergent thinking. The first involved stopping and disengaging from whatever the current solution was, so this would be the bit of thinking that for the brick question would reject the answer 'for building a house' or 'for building a wall'. The second element to divergent thinking was then to find alternative solutions. It is this second aspect that tends to be discussed today when people talk about divergent thinking, but the first disengaging aspect is also really important to allow the new ideas in creative thought to happen. Zangwill's idea about disengaging is actually very similar to the idea that people talk about nowadays of *suppression of latent inhibition*, where the routine way of doing something has to be suppressed, so that thinking is more open to new associations. I have talked about how Picasso liked to explore new ideas and do things differently, continuing to be playful in his explorations, and this aspect of disengaging from the usual way of doing things and finding alternative solutions can be seen throughout the preceding chapters, whether it is in his use of memory, alternative perceptual perspectives, techniques, or expression of emotional ardour.

Evidence that the frontal lobes are important for disengaging from the current way of doing something and shifting to new strategies comes from several different sources. One is that people who have injuries to the frontal lobes have difficulty in tasks that involve disengaging and shifting strategy. This

was shown in early studies of patients with missile injuries to the brain,[289] resulting from gunshot or shrapnel wounds from the World Wars, as well as in neuropsychological studies of patents who had part of their frontal lobe surgically removed as a treatment for intractable epilepsy that could not be controlled by drugs, and later studies of people who have had strokes or other brain injuries that impact on the frontal lobes.

In healthy people, evidence of the linkage between the frontal lobes and divergent thinking comes from studies with novel tasks involving divergent thinking, where both the synchronisation of electrical activity and the level of blood flow to the frontal lobes increases.[290] Increased blood flow is taken as a measure of extra activity and work being done by the frontal lobes, with increased need for the oxygen and glucose that the blood brings as the brain works harder and burns up lots of calories.

People with Parkinson's disease have difficulty with divergent thinking tasks that involve disengaging and shifting strategy. Parkinson's disease results from degeneration of the *substantia nigra* (literally 'black body') that is a part deep in the brain responsible for making the neurochemical, *dopamine*, one of the uses of which is in brain messages that are involved in the control of movement. Dopamine appeared in the discussion of over-activity in dopamine circuits linked to schizophrenia. Dopamine circuits are particularly active in the frontal lobes of the brain, and patients with Parkinson's disease, who have reduced levels of dopamine, experience difficulty not only with initiating and controlling movements but also with other processes that are controlled by the frontal lobes. So, when they have difficulty with divergent thinking tasks, it is a result of

problems in their frontal lobe circuits in a similar way to the effects of more direct injuries like gunshot wounds, surgery or strokes.

Recently, scientists in the USA and Italy have been looking at the impact of Parkinson's disease on creativity itself. The rationale is that if people with Parkinson's disease have frontal lobe problems that cause difficulties with divergent thinking, and if divergent thinking is critical for creativity, then Parkinson's patients should also have difficulties with creativity. This is what the scientists wanted to test.[291] The patients were asked a standard question from a verbal creativity test called the ATTA: 'Just suppose you could walk on air or fly without being in an aeroplane or similar vehicle. What problems might this create? List as many ideas as you can.'

Sometimes the symptoms of Parkinson's disease start on one side of the body before the other. The scientists compared those whose symptoms had started on the left with those whose symptoms had started on the right. The way the brain is wired up means that those whose symptoms start on the left-hand side of the body actually have problems with circuits on the right-hand side of the brain, and those whose symptoms start on the right-hand side of the body actually have problems that have started on the left-hand side of the brain. The research team compared the right-side onset patients and the left-side onset patients on this verbal creativity test.

They found that it was only the patients with onset on the right-hand side of the body who had difficulty with the creative tasks and showed a decrease in this test of verbal creative fluency. Other creative tasks with drawings did not show any interesting results. The researchers explained the results by the greater

involvement of the left hemisphere of the brain in language activities, and an implication of their study is that some creative processes may be tied to a particular type of material; in this case, words. If low levels of dopamine do indeed reduce brain creativity, as in Parkinson's disease, then the scientists also wondered whether increasing brain dopamine might increase creativity. This brings us back to the earlier suggestion that an association of schizophrenia or relatives with schizophrenia and creativity might arise from effects of dopamine circuits in the frontal lobes.

The authors of the Parkinson study also point out – and this again is an idea I have touched on earlier – that a moderate level of something like dopamine may be good.[292] Too little may create problems of reduced creativity but too much may not be effective either, possibly even tipping over into disorder. There may a level in the middle that is ideal for creativity to be stimulated most effectively and we can assume that, for Picasso, the level was calibrated to maximum benefit. Our earlier discussion, though, also suggested that it might be the stability, organisational skill and social engagement that occur along with creative thought that differentiate the highly creative individual from cases of mental disorder.

I have talked about the strength of Picasso's openness to experience, his quest for new ways of doing things and his inhibition of routine behaviours. Yet another interesting aspect to the way in which Picasso worked was his use of completely different styles contemporaneously. Thus, he might have been working on a highly analytical Cubist painting yet working also on a precisely representational and classical drawing or portrait simultaneously. Similarly, he developed new styles

while simultaneously being involved in other styles. So, for example, immediately after the First World War, in 1918, he developed what has been called his *colossal style* of people, with giant bodies and giant limbs (though they were generally rather gentle-looking nevertheless – see plate section), yet while he was producing these he was simultaneously producing severe synthetic Cubist depictions. What becomes clear after reading at least some of the raft of Picasso biographies is that Picasso's innovation of new developments actually took place at the same time as he was refining previous developments. He was taking one set of ideas to their limits and fine-tuning their potential, while he was starting something that had never been seen before. This demonstrates highly developed skills in mental organisation, so that even when excited and driven by new creative conceptual innovations, he could still in the same week engage in controlled refined exploration of other modes of work. This level of operational planning and control reveals high-level sophisticated prefrontal lobe activation.[293]

Despite the evident innovations in his work, Picasso did not view his work as something that was progressing and evolving.

The several manners I have used in my art must not be considered an evolution, or as steps towards an unknown ideal of painting. All I ever made was for the present and with the hope that it will always remain in the present ... Different motives inevitably require different methods of expression. This does not imply either evolution or progress, but an adaptation of the idea one wants to express and the means to express that idea.[294]

FRONTAL LOBE INJURY OR DISEASE IN NON-ARTISTS

If the frontal lobes are critical for creativity and underpin Picasso's genius then it should follow that injury or disease of the frontal lobes affects creativity. The discussion of Parkinson's disease touches on this but there are other populations that also provide evidence. First, there are people who are not professional artists, just ordinary people who develop brain disease that particularly affects the frontal lobes. Does this affect their normal drawing and creative artistic skills? Another group to study, looking at what this does to their art, is that of professional creative artists who sustain injury or disease that affects the frontal lobes.

Starting with people who are not professional artists, an example of recent studies is one by Katherine Rankin and colleagues at the University of California, San Francisco, which compared the effects of three different kind of degenerative brain disease: Alzheimer's disease; fronto-temporal dementia (FTD); and semantic dementia.[295] FTD is the one that is of particular interest here as it is a progressive neurodegenerative disease that affects primarily the frontal lobes. In contrast, in semantic dementia it is the memory stores in the temporal lobes that are disproportionately affected, along with just a little bit of the bottom of the frontal lobes called the *orbitofrontal cortex*. Earlier, I talked about the unexpected drive to create that can sometimes arise from dementias, but in this study the drawings made by all three of these groups of patients with dementia were compared to the drawings of healthy people of the same age, who did not have dementia. The interest was in the quality of the work rather than the drive or motivation.

Katherine Rankin asked the patients to do four things. First, they had a vase of flowers put in front of them and were asked to draw it. Here, then, they had to make a real-life drawing based on immediate visual cues. For the second task, they had to imagine and visualise a room in their own home and draw a scene based on that. This task involved drawing from an internal image rather than directly from real-life visual cues. Third, a mirror was put in front of them and they had to try to draw a self-portrait; this time, then, they had visual cues to draw a real-life face. Finally, they were asked to visualise the emotion they were feeling at that moment and then to draw something that depicted that emotion. So here they had to try to draw something abstract and they had no environmental cues to help.

Katherine Rankin found that the different dementia groups had quite distinct styles of drawing. The interesting results for us were the characteristics of the drawings of those with FTD dementia, the ones whose disease primarily affected the frontal lobes. The first problem for these seemed to be the planning and organisation of their drawings, which were more disorganised. Whereas the drawings made by the healthy people tended to be placed centrally on the page and then fill it up, reflecting awareness of the edge of the page, the drawings by those with FTD tended to 'float' on the page and were placed haphazardly, without apparent awareness of the overall space and its boundaries.

Part of the planning and organisation of a drawing involves object placement, and the composition of space in visual art. This aspect is disrupted in people with FTD dementia, causing a failure of spatial planning and organisation. In dementia that

affects the frontal lobes, that key element of frontal lobe function involving planning and spatial organisation is disrupted in a way that directly affects the planning and organisation of drawing itself. Another example of difficulty in organising the composition of space is seen in a study of twenty-six professional artists with Parkinson's disease; a disease which, as I have discussed above, impacts on the frontal lobes. These had difficulty in vertical orientation on the page, so objects they drew appeared to tilt.[296]

In the Katherine Rankin study, a second problem for those with FTD was that instead of making explicit, realistic, representational drawings, they tended to make simplified, abstracted drawings. We know that their visual, perceptual and basic visuo-spatial skills are normal, so this was the not the result of problems in any of those areas. Instead their adherence to visual reality seemed to have loosened, no longer retaining a sense of what the drawing should look like, and this loosening of associations may have contributed to the bizarre look of many of their drawings, particularly their self-portraits.

In the case of Picasso, at first sight some of his work may create the impression that such loosening of associations has happened, without any frontal lobe injury or disease, but Picasso's abstracted drawings are actually very structured and planned. When he drew an abstracted bull, a highly representational bull drawing preceded it. Then, gradually, as the drawings were repeated or altered and evolved, the bull went through a series of stages to become more and more abstracted, as Picasso drilled down to the key perceptual and structural elements. The same was true of several other series of drawings. Picasso worked at creating the loosening of reality and the

abstraction, and though the end result may appear pared down, it is not bizarre or random. It continues to capture the essence of what he wanted to depict.

In contrast, the patients with FTD are unable to draw other than with loosened associations and reality and with an overall look that is 'bizarre'. The ability to extract key perceptual features, to depict in a portrait or cartoon, is dependent upon the frontal lobes; a conclusion supported by evidence from the blood-flow study of a portrait painter at work. The people with FTD dementia have lost this capacity to extract and drill down to the key features, so their simplified and abstracted drawings miss vital elements and appear odd.

The final problem for those with FTD in the study was that they included fewer details, were less vigorous in making marks, and stopped tasks earlier than necessary. Together, these seemed to reflect higher levels of apathy. These subtle and specific measures of effort indicated that the FTD patients were more passive and less actively engaged in the tasks, meaning that there was a reduction in the drive to draw.

Planning and organisation, extraction of key features, and the relentless drive to draw and generate art are all hallmarks of Picasso's work; all these aspects are particularly impaired in FTD dementia.

EFFECTS OF FRONTAL LOBE INJURY OR DISEASE IN ARTISTS

The case of a professional artist who went on to develop a form of early-onset FTD, known by the acronym NIFID (Neuronal Intermediate Filament Inclusion Disease), was described in 2007 by Valmantas Budrys and his colleagues from Lithuania.[297] The

artist, whose initials were VV, worked in several media and produced paintings, engravings, poetry and performances. She was also the art director of a puppet theatre. Repeated brain scans showed progressive atrophy of the frontal and temporal lobes but the other lobes of the brain remained intact.

Before any formal diagnosis was given, her colleagues had already noticed that she was having difficulty in coping with her usual artistic tasks in preparing for what was to be the last performance of the puppet theatre. She had difficulty in organising characters well enough to engage in performances, and these declining planning and organisational skills affected her artistic competency. Writing of poetry had stopped even earlier, the previous year, though here the atrophy of the *anterior temporal lobe*, which would have affected fundamental language skills, may also be relevant. VV also became apathetic, with a reduction in motivation and drive, and a consequent decline in her creative production. In short, then, declining organisational skills reduced competency to be creative in performance and declining drive reduced the volume of creative activity of any sort.

Painting and drawing were sustained for longer than poetry-writing or puppet performance but, from early in the course of deterioration, there were changes in the style of her painting and drawing. First, the professional quality is described as having deteriorated rapidly. This suggests that, fundamentally, her creative outputs were of declining quality. There was also a clear shift in style. VV had been an abstract artist, producing work that was intensively marked and detailed. She changed to produce work that was concrete and figurative, with alarmed-looking individuals drawn with

bold lines. There was also a *perseverative* (repetitive) element to some of the work, with the same figure being drawn again and again on long narrow strips of paper.

The drawings became increasingly simplistic and, while recognisable as people, they did not demonstrate any particular creative talent any more, although the content did convey some kind of agitation, so they were not without simple emotional expression. In spite of these changes, when VV was asked to copy pictures, even when her disease was quite advanced, she was very accurate, indicating that the deterioration of her art and drawing did not result from any fundamental deterioration in visual, perceptual or physical drawing skills. For VV the impact of the FTD was to eliminate the expression of abstract art, causing her to fall back into more simplified figurative work of limited evident creativity.

There was also a shift in VV's use of colours to those that were predominantly primary colours, where muted tones had been used previously. This change has also been noticed in other studies of those with FTD and might speculatively relate to the disruption of dopamine circuitry in the frontal lobes. We know that dopamine is fundamentally involved in transmission systems related to colour recognition, and the distinction between primary colours would be more easily processed in such a deteriorating system than the more muted subtleties of colour that had been evident in VV's work before she became ill.

Other cases of frontal lobe injury illustrate further elements of decline in artistic ability. To give another example, back in the 1930s an art student was described who had a sudden injury to the left frontal area that also extended back a bit into

the parietal lobe. In the first couple of weeks post-injury, the student appeared to lose the ability to draw altogether but then she recovered and tried drawing portraits, which she had been very good at before her injury. Although the portraits were recognisable, they distorted the relative size of the head in relation to the body.[298] This has echoes of the effects I talked about earlier in the drawings of non-artists who develop FTD and then have problems with organising the composition of space, though it is also possible, in the 1930s student's case, that the way the injury extended into the parietal lobe also contributed to this defect.

EARLIER THEORIES

We have identified a number of elements involved in Picasso's creative genius, many of which have a frontal lobe basis. How do these elements link up with earlier theories and ideas about creativity? Well, in general, earlier theories tend to have looked at a narrower range of aspects. So, for example, papers interested in personality and creativity have focused on just that and, while identifying the common theme of the importance of openness to experience, have not really then cross-integrated this aspect with other facets of cognition and drive.

There has been quite a lot of interest in creativity and problem solving. The classical model here involves *preparation, incubation, illumination* and *verification*. The *preparation* aspect relates to the idea that you need to have established stores of knowledge about the area in which you will be creative and developed expertise to the level that any problem would be evident to you. The *incubation* largely relates to a gap of time for thought but then *illumination* involves innovative cross-linkage

of previous knowledge and something new, to create a novel perspective or solution that is then checked in the *verification* process. This theory fits with the ideas we've discussed and is compatible with the elements we have talked about. Our discussion has been broader in range, recognising facets like the importance of drive, personality, analytic skill to drill down and extract the key elements of things, and the organisational and planning skill relevant to preparation.

The key part of the classical creative problem-solving model is that 'aha' illumination moment of insight or idea, when the novel linkage and development occurs. This is a critical moment in the creative process. Carol Aldous at Flinders University in Australia argues that some kind of interaction between conscious and unconscious reasoning or structured thought and defocused attention is important both for *incubation* and *illumination*.[299] The capacity to form novel linkage and association from established knowledge and change, to modify or develop it into something, is the fundamental element for creative success. Arthur I. Miller, not the playwright but the Professor of History and Philosophy of Science at University College, London, has discussed how 'wondering' about the outcomes of things can feed into this process.[300] Albert Einstein, in the process of developing his theory of relativity, is reported to have spent time wondering about what the consequences would be of running beside and then catching up with a point on a light wave. Wondering and phases of unconstrained thought allow creativity.

There have been lots of psychology studies in the last couple of decades that discuss the bits of thinking and cognition that are *explicit* and clearly known and those that are more

implicit and felt, and the way in which these two interact. Antonio Damasio[301] has emphasised the importance of feeling in deciding upon rational outcomes in solving problems. He referred to a patient with lesions in a small area of the frontal lobe who seemed to lose that sense of whether something was right or wrong. The patient was logical and sensible but was unable to reach a final conclusion, having no inner feeling of what was right. Damasio argues for the importance of feelings in understanding cognitive thought. I have talked about feeling affecting drive, the motivation to be creative and the content of creative expression, but Damasio's ideas emphasise that feeling and emotion is also important in decisions about when a creative work is complete,[302] though we know that Picasso was reluctant to ever reach this point.

Perhaps one difference between creativity in problem solving, and creativity more widely, is that any 'aha' moment of insight may stretch into a more extended phase of novel creation and reflection as creative work develops over time in other domains. Picasso said, 'A picture is not thought out and settled beforehand. While it is being done it changes as one's thoughts change.' Problem solving does not have quite the same temporal development component after the 'aha' moment, as once the problem is solved it is solved, though, as with preparatory sketches of painting, there may be many iterations of attempts at problem solving before the correct solution is achieved.

The issue of how established knowledge and later associations and thought link together to generate creative ideas has also been discussed by Kenneth Heilman and colleagues in Florida.[303] They talk about the specialist knowledge in the temporal and parietal lobes, and then the divergent thinking of the

frontal lobes, but they also suggest that to find a uniting thread may require communication between zones that do not generally link up. They suggest that low levels of arousal may reduce the focus of the brain's activity and allow broader associations, and that the mediation of this might happen via modulation of the neurotransmitter system that involves the chemical messenger *noradrenalin* (*norepinephrine* in the US) as this underpins arousal, so that creative people not only have knowledge and divergent thought but can moderate arousal to enable creative threads to emerge. This idea takes us back to the ideas of varying levels of inhibition, and being able to either switch off inhibition or flick it on and off, as well as to the Brain Default Mechanism, active in states of low arousal allowing broader associations.

The linkage to noradrenalin now means that all three major neurotransmitter systems have been linked to creativity. Dopamine has appeared in discussions of the frontal lobes. Serotonin has been implicated in bipolar disorder and creativity and now noradrenalin links to levels of more generalised levels of arousal. The chemical cocktail linked to creativity appears to involve multiple circuits, and again this may not be surprising given the evolutionary stage of the prefrontal cortex and that creative genius such as that of Picasso exemplifies a triumph in evolution. It is hardly likely that a single neurotransmitter system ratcheted up or down would explain such complex higher-level activities of the brain.

TIE-UP

So what does all this mean for creative genius? Well, if I extrapolate from Picasso and the other people of genius who have been talked about, the recipe seems to be as follows:

◆ Predisposing genes and environmental encouragement as essential biological and social underpinnings.

◆ The retention of an exploratory and playful perspective beyond childhood to sustain openness to new experiences.

◆ A capacity for focused and sustained attention, but also a capacity to moderate normal inhibition, disengage from the expected and switch ways of thinking to embrace novelty.

◆ Strong memory and exceptionally intense concentration when exposed to new material, so that it is encoded deeply, with strong associations and linkage to other knowledge.

◆ Strong visuo-perceptual skills if an artist, enabling extraction and distillation of key elements.

◆ Hard work and relentless experimentation to really perfect techniques and skills, and that extra capacity, interest in novelty and appetite for risk to go beyond these into untried waters.

◆ Highly developed organisation, planning and thought, not necessarily in all domains of life but in the zone where creativity is being expressed. This includes the ability to judge multiple aspects simultaneously and keep track of complexity, in time, sequence and place.

◆ To be slightly mad is fine but not necessary or essential. If a psychiatric disorder is to be in evidence for peak creative genius it is probably best for it to be bipolar disorder, and the most creative output is likely when the condition is not

at its peak in terms of disabling effects, but rather in the more gentle intermediate zones, or affects only a sibling.

- In addition to an open personality, intense, almost obsessive drive is absolutely essential, and the resilience to persevere with sustained effort.

- Life tragedies are not critical but can spur on new waves of activity after recovery, and strong emotions like love or bereavement can also help to trigger subsequent creativity.

- And underpinning almost all of these aspects, extremely well-formed and interconnected frontal lobes, particularly prefrontal, are vital.

So creativity is not some random phenomenon. Nor is it the result of some kind of free association. Nor can it be distilled down to a single unique factor or brushed away as a consequence of hours of practice. The creative genius brings together a biological predisposition and a set of exceptional skills, abilities and drive, reliant on frontal lobe circuitry, that in combination enable exploration of the truly novel and the evolution and expression of genius.

Picasso's Legacy and Impact on the World

'A picture . . . is not there to explain . . . but to awaken feeling in the heart of the person looking at it.'

Picasso

SOCIAL NETWORKS

Watching people sleeping is a recurrent theme in Picasso's work. In his early twenties, he portrayed his lover Fernande asleep, with either himself or a man with shaggy hair, thought to be Fernande's violent husband, watching her. Later, Picasso depicts himself as a faun watching over the sleeping Marie-Thérèse, trying to read her thoughts (see plate section). Picasso had mixed views about sleeping observation, saying, 'When a man watches a woman asleep, he tries to understand; when a woman watches a man asleep, she wonders what sauce she is going to eat him with.'[304]

Sometimes women watching men are not quite so cannibalistic though. I once had a wonderful boyfriend and lover who was a gifted, Oxford mathematician. Much of his work consisted of creating new mathematical equations to describe scientific phenomena or solving equations with other equations.

Yet sometimes he found himself so thwarted in his work that he would begin to dream about a problem at night and would sleep-talk, spouting equations. Dutiful girlfriend that I was, I would stagger out of bed to sit on the freezing-cold floor, writing down equations from the somniloquy of my mumbling lover, almost as though taking shorthand dictation. In the morning, he would wake well rested and revived while I, sleep-deprived but undaunted, would present the miraculous transcript. Occasionally, the transcript was complete nonsense. More usually, though, these morning transcripts contained an elusive and exciting solution.

Somewhere in the less constrained and inhibited thought of the sleeping mind, a solution had been born in a way that had eluded the conscious mind. I talked earlier about the activity of the Brain Default Mechanism in daydreaming, fantasy and dreams, and its role in creative solutions. In the case of my former boyfriend, though, the creative solution would not have been recorded without an associated scribe who enabled the creativity to be recorded, as he himself had no overt memory of the dreams. Most creative geniuses have not lived in isolation, and their capacity for expression may be critically affected by the constraints or support of their families, friends, work and social environment. For the entourage, there can be pleasure too, for while being creative is clearly satisfying to those engaged, enabling others to express their creativity is also satisfying, albeit in my case sometimes chilly and exhausting.

A popular image is that of a creative genius struggling in isolation, often in a garret but, more commonly, a creative genius will have a close friend, or a lover or family, whose role is critical in supporting the creative process. Picasso recognised

that he needed to be alone to work, saying, 'It is necessary that I live my work and that is impossible except in solitude.'[305] But in reality, although Picasso usually worked alone, his life was anything but solitary. He did not live in isolation. Friendship and the support of friends were very important to him. Through most of his working life he had a close female muse or companion who supported and encouraged him, and who was there whenever he needed her. Picasso hated to sleep alone. He also had strong circles of close friends, whom he saw regularly and with whom he talked, discussed, debated, argued and laughed. He surrounded himself with artists, writers, thinkers and creative intellectuals, many of whom admired and supported him. At various times his coterie reads like a who's who of international culture, innovation and creativity in early twentieth-century Paris. Picasso's friends were generally also lively and fun.

The First World War brought loneliness when friends went off to fight, or were captured or taken away, some dying, some returning injured and others psychologically so changed that the point of connection and contact was never the same again. Even Georges Braque, who had worked so closely with Picasso, never became close to him again after the war, with tensions exacerbated by differences in perspective and perhaps a little mutual jealousy. Picasso stayed on in Paris throughout, but like all those in Europe he could not but be affected by the events that were ongoing.

For the middle portion of Picasso's life he was also close to his children, with whom he was actively and energetically involved, and he retained strong family contacts with his mother – while she was alive – and his siblings. His network of friends and his

female companions changed during different eras but until his last years of relative isolation living with Jacqueline Roche, he had a substantial crowd of people, including poets, philosophers and other artists in his core social network.

Not only did Picasso like to surround himself with people; he also liked the company of animals. Not long after he first moved to Paris, he acquired a pet mouse, which lived in the table drawer, safe from cats. Throughout his life he almost always had a dog and at various other times he also had cats and a goat. He even had a little ape in the early days of his relationship with Fernande. Animals were recurrent themes in his work and constant companions in his life.[306]

Picasso's mind was lively to the end and he enjoyed argument and discussion in his conversations with friends. But in the very last years of his life Picasso refused many visitors. Jacqueline Roche, his final partner and second wife, was blamed for these exclusions, but according to his grandson Olivier,[307] they were Picasso's decisions; it was just that Jacqueline was the one who had to implement the instructions and take the rap. Given that the exclusion of others extended beyond Picasso's death to his funeral, it is not clear whether this is the whole story.

Of course it is not simply that Picasso or any artist has friends who provide support and companionship; the friends also benefit. Picasso was reputed to have a considerable impact on people, even at first meeting, partly because of his attentive stare and large, dark and piercing eyes. Fernande noted the 'immense vitality that flowed from him'.[308] Leo Stein also commented: 'He spoke little and seemed neither remote nor intimate – just completely there . . . he seemed more real than most people while doing nothing about it.'[309] This vitality, combined with

wit, humour, intelligence and a sense of exploration, meant that Picasso was very good company.

Social support and the environment within which a creative individual works is important to enable them to fulfil their creative activities. Szabolcs Kéri[310] looked at the social networks of creative people using two different kinds of contacts. First he used an interview to work out the number of people who were in a core social network of close friends and relatives, who were personally contacted by each other. He also looked at the size of a broader social network based on the number of Christmas cards that a person sent, either by conventional or electronic mail. He excluded people counted in the core social network in the count of the broader social network, so that the two different counts did not overlap. He found that the size of the core social network was significantly related to the degree of creativity achieved but the size of the broader social network was not relevant. So, the size of that core group of individuals who were known and contacted by each other strongly predicted creative success. This social context is important in providing support.

While not all creative individuals are great company, many have an openness and originality that makes them absorbing company. The creative genius may be dependent upon companions and supporters, but they too are enriched and develop from the link. As the population increases across the globe, with an increasing drive for efficient, stream-lined processes, one challenge will be to preserve the social and work environments that will enable the creative geniuses of tomorrow to make their vital contributions to new inventions, discoveries and the aesthetics of society, and through a creative chain to influence innovative progress in other spheres.

CREATIVITY STRANDS

In this exploration of Picasso's genius, several strands of understanding about how creative genius works have emerged. Let's draw these together and then think more about the creative chain they generate. I have shown how the creative genius retains a playful mindset and an openness to new experiences that is unconstrained by rules, and may even incorporate fantasy. Yet at the same time, they are capable of intense focus and of ignoring irrelevant distraction in a combination that is sometimes considered a paradox.[311] Another aspect of their approach is that they are capable of single-minded engagement, of an obsessional and stoical drive that enables them to persevere, even if initially thwarted. This combination of curiosity, focus and drive enables what I think of as *bounded creativity*, which generates innovation but also sustains activity to deliver an explicit outcome, by which I mean that something is actually created.

Our exploration has highlighted three strong cognitive strands. First, the creative genius has *perception*, which is strong and analytical, enabling him or her to extract key signature features from the world, which are then reflected and manipulated. Second, *associations* are made, taking established memories and knowledge and then linking them in new ways, thinking divergently to create something novel. Third, they have *skills*, both highly developed executive and problem-solving skills, so that organisational facility is high, with multi-tasking capabilities and also skills that are technical and have been practised, developed and refined. These combine with an approach where *inhibition* is controlled flexibly, suppressing routine and distraction but not inhibiting exploration, and where there is

curiosity and *obsession* with drive. These strands and the linkages between them are sometimes facilitated by daydreaming or reflection, which, by definition, involves *solitude*, enabling high levels of creativity. Strong development of any one of these individual strands may contribute to talent. Creativity arises when many exist in combination. Genius may arise when each strand is developed strongly, and the combination of approach and abilities enables the creation and expression of the truly exceptional. The synthesis of strands then becomes greater than a simple additive combination.

Creativity is not passive. It involves: *curiosity* – openness to experience and active exploration of novelty; *inhibition* that is actively sustained, both in inhibiting the usual way of doing things and in inhibiting outside distraction, so that attention is focused; *associations* from previous memory and knowledge that is taken and actively manipulated in new ways; *perception* that involves accurate analysis and thought; *skills* that involve active and detailed planning and juggling of multiple simultaneous components, as well as in techniques that have to be practised, repeated and developed; drive, which has *obsession*, is relentless, and continues even when thwarted, so that even emotion, which may cause set-backs, then spurs new activity. So Picasso's creativity is dynamic, positive and involves engagement and yet *solitude* is also necessary, as in states of relaxation, when the brain is not preoccupied with day-to-day issues and short-term targets and activities, the new creative ideas can find the mental space to formulate. We could use Picasso's name as an acronym or mnemonic to bind these strands together: *Perception, Inhibition, Curiosity, Associations, Skill, Solitude, and Obsession.*

In contrast to these critical strands, there are also several strands that are neither essential nor sufficient for creative genius to emerge. The creative genius may, for example, be mentally ill, but many people who are mentally ill are not creative geniuses, and vice versa. That said, particular mental illnesses may foster the creative process through hallucinations or unusual associations, and although this is neither essential nor usually effective, Yayoi Kusama provides a notable exception. Predisposing genes may include those that are common to relatives of those with certain mental illnesses, particularly bipolar disorder and schizophrenia. In such cases, genes linked to mental illness may facilitate the mental *solitude* and *associations* from knowledge that are part of this active process of creativity.

Extended and intensive practice is not sufficient for creative genius. Many people who practise extensively do not succeed in becoming exceptionally creative and some, like the sculptor Simon Bacon, demonstrate immediate talent and unusual creativity despite the absence of previous practice. Skills have to move beyond those derived from practice to be honed and refined, creating new techniques, and complex executive skills are also fundamental. Again, you need an approach with *perception*, *inhibition* of routine or distraction, *curiosity*, *associations* from knowledge and memory, *skills* both in organisation and techniques, *solitude* to enable reflective thought; and *obsession* that drives the pursuit of creativity relentlessly: PICASSO.

In terms of the underpinning biology, there is evidence of a genetic contribution, but multiple genes are most likely involved, and it may be their combination that enables genius. At the neurochemical level, some have also speculated about roles for dopamine, serotonin and noradrenalin (norepinephrine). Yet our

understanding of the interaction of these major brain neurotransmitters, let alone the modulating effect of lesser neurochemical influences, remains in its infancy. There is more success in thinking about anatomical areas, as the component behaviours and abilities that combine for the creative approach and the relevant cognitive strengths implicate the prefrontal areas of the brain as the biological substrate for creativity, with neuroimaging supporting that perspective. Picasso's brain and those of other geniuses demonstrate advanced development of these prefrontal areas, which may also be reflected in their increased connectivity.

AESTHETIC CHILLS AND UNDERSTANDING

Let's look further at what happens *after* a work of genius is created. For creativity does not end with the creative achievement and expression of a genius, or indeed with his or her death. Picasso may have been preoccupied with his own mortality, as evidenced by the large, fearful eyes and emaciated cheeks of his 1972 self-portrait painted the year before his death, but the products of creative genius, be they paintings, music, inventions, mathematical proofs, buildings or clothes create a legacy after death that has a subsequent impact upon the thoughts and work of others. So society and the environmental context will influence the creative, but then the work itself impacts upon other individuals and society.

Picasso's work had an intense impact on others, as he intended. He said:

> I am proud to say that I have never looked upon painting as an art intended for mere pleasure or amusement . . . A picture . . . is not there to explain . . . but to awaken feeling in the heart of the

person looking at it. A work of art must not be something that leaves a man unmoved, something he passes by with a casual glance. It has to make him react, feel strongly, start creating too, if only in his imagination . . . he has to be made aware of the world he's living in, and for that he must first be jolted out of it.[312]

The impact of a painting is often felt most by those who are not creative professionals. Studies highlight individual differences in aesthetic responses. Occasionally, if I hear of a friend's serious illness or reports of a traumatic war event or learn that something beautiful and irreplaceable has been destroyed, I feel goose bumps or shivers down my spine. These shivers happen when there is bad news that touches me in some way. It can also happen when I am at the theatre or watching a film when something very emotive arises. It's an automatic response that I can't control and sometimes it surprises me and actually makes me realise that I have been more affected by something than I had consciously recognised. For some people, shivers or chills like this are provoked by good news or something that touches them in a really positive way. I once talked to an architect who said that when he looked at a building he really liked he felt shivers down his spine. Now, I love lots of buildings but they have never had this effect on me. Once, standing in front of St Paul's Cathedral in London, which I love, I did try to feel as deeply and emotionally as possible about the architecture to see if I could invoke goose bumps but nothing happened, even though the building did look great. You can't deliberately make yourself experience these shivers, as they are a result of action by the autonomic nervous system, which is triggered without explicit will.

The chills that the architect experienced are called *aesthetic chills*. Some people also experience them when they look at paintings or in response to other arts. It can happen when listening to music, perhaps when it has unexpected harmonies, or even when reading or listening to an emotive tale, and these aesthetic chills contribute to intense aesthetic experiences.

Analysis of personality traits shows that aesthetic chills are most correlated with openness to experience, the personality trait that has been discussed several times before; this trait is linked to creative expression, but here it is linked to the aesthetic pleasure derived from creative work. Experiencing aesthetic chills extends across cultures, so much so that it has been suggested that they are actually a universal marker of openness to experience.[313] People who experience aesthetic chills also often have a tendency to feel touched and to become extremely absorbed or immersed in something, so that they can feel detached from their surroundings.[314] These three elements – chills, feeling touched and absorption – all enhance aesthetic experiences of the arts. The extent to which someone has an aesthetic response to a particular painting, though, can also be affected by more concrete phenomena; for instance, a preference for abstract modern art or more ancient representational art depends upon the viewer, and whether he or she seeks pleasure (an emotional objective) or cultural enrichment (a cognitive objective).[315] Modern art lovers tend towards the former.

Part of the aesthetic pleasure that comes from looking at a painting is thought to result from actually being able to understand it in some way or, in psychological speak, to cognitively process it successfully. This does not necessarily mean that the understanding has to be in any way sophisticated

or based on detailed knowledge of art history, technique or the message that the artist was actually trying to convey, assuming that there was one. But if we perceive some kind of meaning to a painting, then we like it better. A simple illustration of this is that adding a title or brief description to a painting increases the degree to which the painting is rated as pleasant.[316] It is therefore particularly exasperating that Picasso did not title any of his work and left it to others to generate dull, short, repetitive titles, as needed or desired. The titles therefore often add little to his work.

In contrast, Paul Klee, who possesses verbal wit as well as exceptional artistic talent, often added titles that bring out a new perception in a painting, and of course, in the case of more abstract art, the title may help to provide a clue as to the content of the painting, sculpture or construction.

Helmut Leder and his team in Vienna have shown that the effect of titles is influenced by the time spent looking at a painting.[317] Descriptive titles increase understanding even if a painting is viewed very briefly, but more elaborate titles lead to better understanding if a painting is looked at for at least ten seconds. However, although elaborate titles increased the understanding of abstract art, they did not increase liking. Leder thinks this may be because the works become less interesting and so have reduced aesthetic meaning.[318] So the aesthetic pleasure that comes from understanding, that is evident in the preference for less abstract art, is spoilt if verbal information is too elaborate.

The degree, then, to which it is easy to process and understand a work of art affects how much we like it, as well as its familiarity. Cubist paintings, one era of Picasso's work, vary

in their degree of abstraction and thereby the ease with which their content is recognisable. The easiest to recognise generate the strongest pupil dilation and are therefore liked the most.[319] Easy-to-process pictures also generate electrical responses from the face. They generate stronger electrical response above the *zygomaticus major* muscle, which is responsible for drawing the angle of the mouth into a smile.[320]

When you look at something that makes you feel good that smiley muscle blips out an electrical response; this can be measured in people to see how they feel. That circuitry from emotion to smiley muscle also seems to work in reverse: if you smile you actually feel better. I am not aware though of any experiment in which someone is encouraged to smile in front of a painting that they hate to see if it makes them like it more. That might be asking too much of our primitive electrical circuits.

PRIMITIVE BRAIN CIRCUITS

Clearly, lots of people love Picasso's paintings, drawings, sculptures and prints and some are prepared to pay extraordinarily high prices for them. But what is it that attracts people to his work? Why is Picasso so appealing, and what is it about the aesthetics of his work that people find so pleasurable and interesting? How does this preference for Picasso's work emerge, and what contributes to the strength of the pull of the paintings?

It seems that the attraction to Picasso's work starts early. Researchers in Zurich have recently shown that this preference for Picasso appears in infants who are under a year old.[321] Lots of studies with infants take advantage of the fact that infants are always interested in new things and will choose to look

at them. Over time, if the same or similar things are shown again and again to infants they get bored and stop looking. This is called *habituation*, and is also a feature of adult behaviour. You may be able to go to sleep despite the noise of your creaky heating system in the winter as it is very familiar and you have habituated to it but your visitors will not find it so familiar and may lie awake all night. Failure to habituate keeps us awake in hotels, where the background noises are unfamiliar too. In experiments with babies, researchers show the baby something again and again until they habituate to it, and then they show them something different. If the baby continues to be bored, then they have not noticed the difference, but if they start to look intently again, then we know that they have detected a change in content.

Going back to the infants and Picasso paintings, the Zurich researchers got nine-month-old babies to habituate to paintings by either Picasso or Monet.[322] So they showed half the babies lots of paintings by Picasso, and half lots of paintings by Monet. They used Cubist paintings by Picasso – still lives with bold vivid colours, sharp contrasts and figurative object-like elements. The Monet paintings were soft, subtle impressionist depictions of the countryside and trees. Would the babies be able to tell the difference between these artists?

The babies in each group habituated, as expected, and gradually started to look less and less at the paintings. They were then shown a pair of paintings; one was another painting by Monet and one was another painting by Picasso, neither of which they had seen before. The babies who had habituated to looking at the Monet paintings now preferred to look at the Picasso painting. Clearly, they noticed the difference between

the Monets and the Picassos, and their preference for novelty accorded with classic behaviour after habituating. What is fascinating, though, is that the babies who had habituated to looking at Picassos did not, as expected, now prefer to look at the new Monet painting but looked for longer at the Picasso painting. Even though they had habituated to Picasso, they wanted more of him. The strength of the preference for the Picasso painting overrode the usual novelty effect.

What was it about Picasso that the babies loved? The Zurich researchers wondered if it was the colour, so they repeated their study using black-and-white photos of paintings, but the effect was still there. All the babies, whether they had looked at the Monets or the Picassos before, preferred the black-and-white Picasso in the choice situation. Then the researchers wondered if it was the sharp contours that Picasso used and so they blurred all the pictures a bit to eliminate the sharply defined edges, but the babies still preferred the blurry Picasso to the blurry Monet. Finally, they wondered if it was object-like shapes in the Picassos that the babies liked. Perhaps these were more interesting than landscapes and flowers. So they took all the paintings and, using some clever computer techniques, broke them down into mosaic-like colour blobs that no longer had any figure-like shapes or objects. The paintings were no longer obviously recognisable as either a Picasso or a Monet to the casual adult observer, but the babies still preferred the Picasso mosaic blobs to the Monet mosaic blobs, regardless of which artist they had habituated to. So the preference for Picasso is highly robust and occurs even in the absence of very obvious artistic features like bold colours, sharp contrasts and object-like elements and figures.

One explanation that the Zurich researchers suggest is that there may be a biological basis to the preference in the visual system of the babies.[323] It is a simplification but there are two broad divisions in the visual system. The one that is older in evolutionary terms is the dorsal pathway, which is sometimes called the 'where-system'. It is not very sensitive to colour but can work well at low light levels and is particularly sensitive to movement, but also to space, position, depth and seeing an object against its background. Critically for this study, it is very sensitive to differences in luminance, which is the degree of lightness that an image has and reflects. Picasso paintings have lots of varied luminance and light reflection and therefore stimulate the dorsal visual stream intensely. Monet's paintings have very little variety in luminance. In paintings of poppy fields, Monet's poppies are almost the same luminance as the grass. They are both matched in brightness and reflection of light. This explanation has not yet been tested but, if true, it would mean that Picasso generates visual images that stimulate our primitive visual pathways more intensely than some other artists. In adult aesthetics, more complex emotional, cultural and educational aspects feed into our appreciation but this fundamental capacity of Picasso's work to stimulate the viewer's brain in a way that even babies cannot resist is amazing.

There has also been interest in whether any other automatic aesthetic processes play a role in art appreciation. One idea here is that there may be an initial rapid global view of a painting, in which one gets an overall impression of the painting's structure and meaning, which happens before a more detailed and structured organisation of the painting is made, able to lead us

to a deeper aesthetic appreciation based on pleasure or interest. The rapid initial impression is not a result of any conscious will or thought, but is one of range of automatic processes that psychologists call implicit. Generally, behaviour is classified as implicit when it happens so quickly that there has not been time to exert any conscious control; where the process is unintentional and happens without awareness.

One way that implicit processes are investigated is by looking at the time it takes someone to link two different things together. So, for example, Stefano Mastandrea and colleagues in Rome carried out an experiment in which they asked people to sort art pictures that were either figurative or abstract by pressing one of two keys.[324] They had to press, say, the right key for the figurative work and the left key for the abstract work; in other blocks of trials it would be the other way around. At the same time, they also had to sort words into either aesthetic positive words (e.g. attractive, beautiful, magnificent, wonderful) or aesthetic negative words (e.g. disgusting, dreadful, terrible, ugly). Again, some had to press the right key for positive words and the left for negative, while in other trials it was the other way round. So there were four different kinds of things to judge: two types of paintings and two types of words, but just two different keys to press in response.

What Stefano Mastandrea and his team found was that when the same key was to be used for figurative paintings/ aesthetic positive words and another for abstract paintings/ aesthetic negative words, the average response time was 684 milliseconds. But when the same key was used for figurative paintings/negative words and another for abstract /positive words, this increased to 840 milliseconds. So blocks of trials

where there was a pairing of figurative/positive and abstract/ negative were significantly faster than blocks of trials where there was a pairing of figurative/negative and abstract/positive.

We know from previous studies that people have a general preference for figurative over abstract art. The Stefano Mastandrea study shows that this preference is automatic and implicit, involving no explicit judgements about the paintings.

In a parallel experiment, Stefano Mastandrea found the same results when architectural stimuli had to be classified as classical or contemporary and aesthetic words had to be judged as before. The classical style/positive word pairing and contemporary style/negative word pairing were the fastest. So for architectural stimuli, aesthetic evaluations could also be activated automatically.

Mastandrea argues that these preferences are based on three elements: their reduced complexity so that they are easier to understand, the fact that they are more typical of what people expect, and the increased familiarity of figurative art and classical architecture. Although it is said that familiarity breeds contempt, Mastandrea's study suggests quite the opposite. This is of interest in relation to Picasso, as many of his works are now very familiar.

FAMILIARITY

Although habituation in the study with babies related to the idea that repeated exposure leads to boredom, declining interest or declining attention as the significance of novelty fades, there are also studies (including that of Stefano Mastandrea) that show a longer-term positive effect of familiarity in judging the pleasantness of a painting. Just seeing the same painting again

and again will make you like it a bit more, though obviously there are exceptions to this general rule.

Many of Picasso's iconic works are experienced by the general public repeatedly. His images appear in posters, magazine and book covers, advertisements, mugs, plates, notebooks, key-rings, scarves, t-shirts, and numerous other items. The familiarity of some of these images may heighten our appreciation of his work.

Certainly, there is long-standing evidence for our preference for familiarity. Back in the 1960s, Robert Zajonc wrote a classic paper in which he argued that simple exposure to something makes us like it.[325] He started his paper by talking about a story from the local press that told about a mysterious student who attended Oregon State University for two months covered in a big black bag, with only his bare feet visible. The professor who taught the class knew the identity of the student but none of the other students in the class did. The black bag attended the class three times a week and sat at a small table at the back of the classroom. The professor reported that initially there was hostility towards the bag but, as time passed, the students' attitude changed to curiosity and then in the end to friendship. Robert Zajonc used this as an example of how repeated exposure to a stimulus makes our attitude towards it more positive. It is this idea that much advertising is based upon.

Robert Zajonc also reported data that showed that we use words that relate to good, desired and preferred aspects of reality much more frequently than negative words. So, in one frequency rating that counts how often a word appears in long samples of text, the word *happy* occurred 1,449 times but *sad* only 202 times. *Laugh* occurred 2.4 times more often than *cry* and *love* 7 times more often than *hate*. To test the

mere exposure idea, Robert Zajonc asked people to rate a list of ten different countries and then ten different US cities in terms of how much they liked them. The same thing was done with fruits, vegetables and flowers. He then looked up the frequency of occurrence of the words in the lists and found that, in all cases, the order of preference people reported is highly related to the frequency in which they appear. Then, in the lab, Robert Zajonc gave students sets of nonsense 'foreign words' to look at. Later they had to say whether they thought the words referred to something good or bad. Again, the words were consistently rated positively if they had occurred more frequently in the experiment.

This idea that mere exposure can increase preference has also been tested with paintings. The Frenchman Gustave Caillebotte was both an impressionist painter and a collector of impressionist paintings. In a study by James Cutting,[326] of Cornell University, sixty-six images from Caillebotte's collection were chosen and each one was matched for both style and subject with another image of work by the same artist, so that sixty-six pairs of images were generated. Each pair of images was then shown to people, who had to decide which one of the pair they liked best. Cutting also laboriously counted how frequently each of the 132 images in the pairs occurred in a thousand books at Cornell's University Library. That's quite a lot of counting. What emerged was that in about 60 per cent of cases, the picture that people liked best in each pair was also the picture that occurred most often of the two in the Cornell books. Now, most people have clearly not looked at a thousand books in Cornell library, but the counts of the appearances of the pictures in the books were taken as evidence of how common in

general it was to see these particular paintings. In the majority of cases, the more commonly seen paintings were preferred over the less commonly seen paintings. Mere exposure affected liking of the paintings. So, mere exposure to Picasso's work will affect liking for it and increase his followers.

In order to study aesthetic appreciation, Helmut Leder and colleagues in Vienna have constructed a model of how it might work.[327] They spell out three different stages. In the first *perceptual stage*, features like colour, shape and contrast are analysed. Then there is a stage of *explicit classification*, which looks at the content and style of the painting; this stage strengthens with expertise. There is then a feedback system that tries to understand a work of art and evaluate it, involving what Leder calls *cognitive mastering*. The evaluation triggers feelings and thoughts that generate aesthetic experiences of pleasure and also aesthetic judgements.[328] Leder's work is an attempt to deconstruct what actually happens when you look at a painting and like it.

Interested in the neuroscience underpinnings of the pleasure that paintings can create, Ishuzu and Zeki in London have carried out fMRI studies that demonstrate major differences between the brain activity that occurs when judging the beauty of a painting and that when making a simple perceptual judgement about brightness. Judgements of aesthetic beauty in paintings are reflected in increased activity in both the *lateral* and *medial orbitofrontal* regions within the frontal lobes, as well as several small structures in the centre of the brain, including the amygdala.[329] The orbitofrontal cortex has also been implicated in other studies they conducted concerning the perception of beauty.

While writing this book, I went to a Picasso exhibition with a friend who, although aware of some of Picasso's work, did not like it very much – she did not mention this, though, until we were walking into the first room. As we worked our way around the exhibition and chatted about the different works, her knowledge about the paintings, their sitters and the context in which they were created increased, and this quite rapidly increased her pleasure in the works, to the extent that afterwards she said she had really enjoyed the exhibition. So, while some aesthetic appeal may be hard-wired – related to the sensitivity of our brains, the characteristics of our visual system, and the responsiveness of the autonomic nervous system in generating aesthetic chills – aesthetic appeal also increases with exposure, familiarity, increased knowledge and understanding.

CREATIVE CHAINS

Works of genius do not simply contribute to aesthetic effects on the viewer or listener, they also forge a creative chain through the minds and activities of others. Picasso's work leaves a legacy of impact not simply in aesthetic appeal but also in its effects upon later artists and creative individuals. Cubism is thought to have opened the way to many artistic movements that followed. Analytical Cubism and the way in which it led to the segmentation of images provided a background that was a necessary precursor of the art movements called *constructivism* and *minimalism*, whereas *Synthetic Cubism*, by assembling and creating images in a novel way, inspired the *Dadaists*, *surrealists* and *pop artists* to juxtapose images in new ways likewise, and spurred a new mode of expression with collage. Thus, John Richardson argues, 'Cubism engendered every major modern movement.'[330]

There are many examples of artists being influenced by Picasso's work. Take David Hockney, for instance, the contemporary British artist who admits to having been greatly influenced by Picasso. When Hockney was twenty-three and at a formative stage in his career, a major retrospective of Picasso was held at the Tate Gallery in London, and Hockney visited it several times. In 1985, Hockney designed a cover for *Vogue Magazine* in which he produced an image of Celia Birtwell, his then muse. He incorporated two alternative perspectives of Celia's face within the single image, with the influence of Picasso's alternative perspectives being obvious. In a similar act of creative homage, in 2003 Hockney produced a version of Picasso's 1951 picture *Massacre in Korea*, to which he added a viewer with a camera, to highlight the problems of such adaptation (see plate section). Just as Picasso had been fascinated by circus performers, acrobats and solitary harlequins, so Hockney also incorporated solitary harlequins in his work. Picasso also produced many drawings of an older and younger character in juxtaposition. Hockney copied this idea, placing himself as the younger artist opposite an older figure of Picasso, directly echoing the theme, but taking the characters forward in a further iteration of the creative chain.

The London 2012 exhibition of *Picasso and Modern British Art* at the Tate Britain, curated by Chris Stephens, traced Picasso influence on the Bloomsbury group of writers, artists and intellectuals, several of whom recognised his talent ahead of many conservative UK critics and media, and bought his work. The exhibition highlighted Picasso's impact upon Duncan Grant, Wyndham Lewis, Ben Nicholson, Francis Bacon and Graham Sutherland. Indeed, Sutherland actually

bought a house in the south of France not far from Picasso and also became his friend. Perhaps the most significant sculptor to be influenced by Picasso in the UK was Henry Moore, whose renditions of the human body, whether massive or tiny, are now scattered across the UK and internationally, and whose beautiful three-dimensional work has a timeless impact on the viewer.

Picasso also had an impact on many artists in other countries; for example, the American artist Roy Lichtenstein acknowledged Picasso as his most significant artistic influence: 'Picasso is the greatest artist of the twentieth century by far'.[331] One of Lichtenstein's first paintings, long predating his pop art fame, is *Portrait of a Man*, which is strongly influenced by Picasso's portrait of Gertrude Stein, with a similar pose and structure to the head and face (see plate section). He also made derivatives of Cubist work, all predating his relationship with dots. In 1961, Lichtenstein started to produce the works for which he is famous in his own unique style, but he then went on to apply this style to many derivatives of Picasso's work from his varied eras and styles.[332] Just as Picasso took the Grand Masters and reformulated their works in his own way, so Lichtenstein takes Picasso and applies his own unique style to reformulate them, even Picasso's Grand Master works, so that there are reformulations of the reformulations. The individual Picasso works that Lichtenstein has selected are explicitly recognisable but they are clearly Lichtenstein's in palette, style, form and message.

Picasso did not want to be looked back on as merely historical and no longer relevant. Similarly, he did not think that great art from the past should be relegated to history. He thought that great art, whenever it was produced, remained alive because of the impact and immediacy that such work continues to have

upon the viewer today: 'To me there is no past or future in art. If a work of art cannot live in the present it must not be considered at all. The art of the Greeks, of the Egyptians, of the great painters who lived in other times, is not an art of the past; perhaps it is more alive today than it ever was.'

CONCRETE LEGACY

In the autumn of 1972 Picasso developed bronchitis, and in the spring of 1973, he died. Because of his reluctance to face up to his eventual demise, he had not made a will, believing that to do so might bring bad luck or hasten his death. He left a concrete legacy in the works of art that survived him, some of which had already entered major collections before his death. Subsequently, an inventory of his works was compiled. One of the team working with Maurice Rheims on the project remembers entering La Californie, Picasso's last home: 'It was like Ali Baba's cave. I saw hundreds of paintings stacked against each other.'[333] The inventory of Picasso's estate after his death produced a listing of the vast amount of work left as inheritance: 1,885 paintings, 7,089 drawings, 1,228 sculptures, 6,112 lithographs, 2,800 ceramics, 18,095 engravings, 3,181 prints, 149 books containing 4,659 drawings and sketches, 8 carpets and 11 tapestries.[334] The total valuation in 1977 was 1,372,903,256 francs.

The value of Picasso's work has only increased since his death. Of the most expensive known sale prices for paintings, Picasso occupies the top slot, with Les Femmes d'Alger (Version O) selling in May 2015 for a record $179 million. While the vast sums of money paid for Picasso's work attract attention, it is not the value per se that is the most extraordinary and interesting thing

about his creativity legacy. Creativity in modern culture is also valued independently. Original and creative achievements are admired by many, whether in art, music, architecture, interior design, gardens, science, sustainability, investment, management, communication, dress or decoration. Western culture has a particular focus on individual expression at present, but individual innovation, discovery and creativity even in more socially cooperative eras or societies are admired and assigned status, partly because of their powerful capacity for legacy.

BIOLOGICAL LEGACY

In addition to the legacy of aesthetic impact and contribution to creative chains, Picasso also left a biological legacy in his offspring. His children share 50 per cent of his genes and his grandchildren 25 per cent. Picasso had four children – Paulo, Maya, Claude and Paloma – and several of his biological heirs have exhibited creative activity. Bernard, his grandson, the son of Paulo, has published poetry. Two of Picasso's grandchildren – Marina, Bernard's half-sister, and Olivier, the son of Maya – have published books about him. Diana, Maya's daughter, is an art historian, with a particular interest in her grandmother's powerful impact on Picasso that led to the creation of some of his most memorable paintings. Claude and Paloma, Picasso's children with Françoise Gilot, inherited a double dose of artistic genes, as their mother is also an accomplished artist. Claude worked as a photographer for *Vogue*, after an apprenticeship with the American photographer Richard Avedon, before establishing and running the Administration Picasso, which is now responsible for copyright and marketing issues, as well as verifications of authenticity. Paloma became a jewellery designer

for Yves St Laurent by the age of twenty, then launched her own brand; she also designed for Tiffany before expanding into accessories, fragrance, china and crystal. Of Picasso's children, she has had the career that has been the most creative.

Many of us, if we trace back our family trees, will eventually find a highly creative ancestor, whose DNA we harbour. All of us are also exposed to the creative endeavours of others, and we can all learn to be more open to experience, more dynamic, and to structure our lives so as to enable mental space for reflection and creative thought. It is within us all to enhance our contribution to the creative chain, either directly or indirectly, by supporting the work of others. Each of us can foster creativity and genius.

Picasso has achieved the timelessness in his art that he sought. His combination of acute *Perception*, sophisticated *Inhibition*, *Curiosity* and open-mindedness, *Associations* from knowledge and memory, *Skills* in organisation, planning, multi-tasking, and honing and evolving techniques, *Solitude* to reflect and think unhampered, and *Obsession* with work and the drive to express his ideas enabled his creative genius to work. His legacy in art and his contribution to the creative chain are unparalleled.

Notes

Chapter 1

1 Erskine, P. and Mattingly, R. (1998), *Drum Perspective*, 73.

2 O'Brian, P. (1976), *Picasso: A Biography*. London: William Collins Sons and Co.

3 O'Brian, *Picasso*.

4 Read, H. (1956), 'Picasso at 75', *The Times*, 27 October, 7.

5 Richardson, J. (1991), *A Life of Picasso*, Vol. 1. London: Pimlico.

6 Cox, N. (2010), *The Picasso Book*. London: Tate Publishing.

7 Read, 'Picasso at 75'.

8 O'Brian, *Picasso*.

9 Galton, F. (1869), *Hereditary Genius: An Inquiry into its Laws and Consequences*. London: Macmillan.

10 Terman, L.M. (1929–59), *Genetic Studies of Genius* (Volumes 1–5), Stanford, CA: Stanford University Press.

11 Terman, L.M. and Oden, M.H. (1959), *The Gifted Group at Midlife*. Stanford, CA: Stanford University Press.

12 Cox, C. (1926), *The Early Mental Traits of Three Hundred Geniuses*. Stanford, CA: Stanford University Press.

13 Simonton, D.K. and Song, A.V. (2009), 'Eminence, IQ, Physical and Mental Health, and Achievement Domain: Cox's 282 Geniuses Revisited', *Psychological Science*, 20, 429–434.

14 Simonton, D.K. (2006), 'Presidential IQ, Openness, Intellectual Brilliance, and Leadership: Estimates and Correlations for 42 US Chief Executives', *Political Psychology*, 27, 511–526.

15 Simonton, D.K. (2008), 'Childhood Giftedness and Adult Genius: A Historimetric Analysis of 291 African Americans', *Gifted Child Quarterly*, 52, 243–255.

16 Kéri, S. (2011), 'Solitary Minds and Social Capital: Latent Inhibition, General Intellectual Functions and Social Network Size Predict Creative Achievements', *Psychology of Aesthetics, Creativity, and the Arts*, 5, 215–221.

17 Clive Bell's piece 'A genius who worked magic' from 'Virginia Woolf', *Old Friends: Personal Recollections* (London: Chatto & Windus, 1956; New York: Harcourt, Brace, 1957), 92-118.

18 Cox, *The Picasso Book*.

19 Richardson, *A Life of Picasso*.

20 O'Brian, *Picasso*.

21 Temple, C.M. (2002), 'Oral Fluency and Narrative Production in Children with Turner syndrome', *Neuropsychologia*, 40, 1419–1427.

22 Temple, C.M. and Carney, R.C. (1996), 'Reading Skills in Children with Turner syndrome: An Analysis of Hyperlexia', *Cortex*, 32, 335–345.

23 Temple, 'Oral Fluency and Narrative Production'.

24 Temple, C.M. and Shephard, E. (2012), 'Exceptional Lexical Skills but Executive Language Deficits in School Starters and Young Adults with Turner syndrome: Implications for X Chromosome Effects on Brain Function', *Brain and Language*, 120, 345–359.

25 Temple and Shephard, 'Exceptional Lexical Skills'.

26 Temple and Shephard, 'Exceptional Lexical Skills'.

27 Burgess, P.W. and Shallice, T. (1997), *The Hayling and Brixton Tests*. Bury St Edmunds, UK: Thames Valley Test Company.

28 Temple, C.M. and Martin Sanfilippo, P. (2003), 'Executive Skills in Klinefelter's Syndrome', *Neuropsychologia*, 41, 1547–1559.

29 O'Brian, *Picasso*.

30 O'Brian, *Picasso*.

31 O'Brian, *Picasso*.

32 O'Brian, *Picasso*.

33 Penrose, A. (2010), *The Boy Who Bit Picasso*. London: Thames and Hudson.

34 O'Brian, *Picasso*.

35 Penrose, *The Boy who Bit Picasso*.

36 Gardner, H. (1982), 'Giftedness: Speculations from a Biological Perspective', *New Directions for Child Development*, 17, 47–60.

37 Langer, E.J. (1989), *Mindfulness*. Reading, MA: Addison-Wesley.

38 Plucker, J.A., Beghetto, R.A. and Dow, G.T. (2004), 'Why isn't Creativity More Important to Educational Psychologists? Potentials, Pitfalls, and Future Directions in Creativity Research', *Educational Psychologist*, 39, 83–96.

39 Gardner, H. (1982), 'Giftedness: Speculations from a Biological Perspective', *New Directions for Child Development*, 17, 47–60.

40 Parrot, L. (1948), 'Picasso at Work', *Masses and Mainstream*, March, 1948.

41 Widely attributed to Picasso, and used as an epigraph in *Time* (4 October 1976), 'Modern Living: Ozmosis in Central Park'.

42 Carson, S.H., Peterson, J.B. and Higgins, D.M. (2003), 'Decreased Latent Inhibition is Associated with Increased Creative Achievement in High-functioning Individuals', *Journal of Personality and Social Psychology*, 85, 499–506.

43 Kéri, S. (2011), 'Solitary Minds and Social Capital: Latent Inhibition, General Intellectual Functions and Social Network Size Predict Creative Achievements', *Psychology of Aesthetics, Creativity and the Arts*, 5, 215–221.

44 Burgess and Shallice, *The Hayling and Brixton Tests*.

45 Zabelina, D.L. and Robinson, M.D. (2010), 'Child's Play: Facilitating the Originality of Creative Output by a Priming Manipulation', *Psychology of Aesthetics, Creativity, and the Arts*, 4, 57–65.

46 Goff, K. and Torrance, E.P. (2002), *Abbreviated Torrance Test for Adults Manual*. Bensenville, IL. Scholastic Testing Service.

47 McCrae, R.R. and Costa, P.T. (1999), 'A Five-factor Theory of Personality', in L.A. Pervin and O.P. John (eds), *Handbook of Personality: Theory & Research*. New York: Guildford Press.

Chapter 2

48 O'Brian, P. (1976), *Picasso: A Biography*. London: William Collins Sons and Co.

49 O'Brian, *Picasso*.

50 Rosenblatt, E. and Winner, E. (1988), 'Is Superior Visual Memory a Component of Superior Drawing Ability?', in L.K. Obler and D. Fein (eds), *The Exceptional Brain: Neuropsychology of Talents and Special Abilities*. New York: Guilford Press, 341–363.

51 Winner, E. and Casey, M.B. (1992), 'Cognitive Profiles of Artists', in G. Gupchik and J. Laszlo (eds), *Emerging Visions of the Aesthetic Process*. New York: Cambridge University Press, 48.

52 Jones, E.E. (1922), 'The Correlation of Visual Memory and Perception of Perspective with Drawing Ability, *School and Society*, 15, 174–176.

53 Rosenblatt and Winner, 'Is Superior Visual Memory a Component of Superior Drawing Ability?'

54 McManus, I.A., Chamberlain, R., Loo, P.-W., Rankin, Q., Riley, H. and Brunswick, N. (2010), 'Art Students Who Cannot Draw: Exploring the Relations between Drawing Ability, Visual Memory, Accuracy of Copying and Dyslexia', *Psychology of Aesthetics, Creativity, and the Arts*, 4, 18–30.

55 McManus, I.A. et al., 'Art Students Who Cannot Draw'.

56 Richardson, J. (1996), *A Life of Picasso: 1907-1917*.

57 O'Brian, *Picasso*.

58 O'Brian, *Picasso*.

59 O'Brian, *Picasso*.

60 Richardson, J. (1996), *A Life of Picasso*, Vol. 2. London: Pimlico.

61 Richardson, *A Life of Picasso*, Vol. 2.

62 Richardson, J. (1991), *A Life of Picasso*, Vol. 1. London: Pimlico.

63 Happe, F. and Vital, P. (2009), 'What Aspects of Autism Predispose to Talent?', *Philosophical Transactions of the Royal Society of London – Series B: Biological Sciences*, 364 (1522), 1369–1375.

64 Arnheim, R. (1980), 'The Puzzle of Nadia's Drawings', *Arts in Psychotherapy*, 7, 79–85.

65 Mottron, L. and Belleville, S. (1995), 'Perspective Production in a Savant Autistic Draughtsman', *Psychological Medicine*, 25, 639–648.

66 Happe and Vital, 'What Aspects of Autism Predispose to Talent?'

67 Makuuchi, M., Kaminaga, T. and Sugishita, M. (2003), 'Both Parietal Lobes are Involved in Drawing: A Functional MRI Study and Implications for Constructional Apraxia', *Cognitive Brain Research*, 16, 338–347.

68 Snyder, A.W., Mulcahy, E., Taylor, J.L., Mitchell, D.J., Sachdev, P. and Gandevia, S.C. (2003), 'Savant-like Skills Exposed in Normal People by Suppressing the Left Fronto-temporal Lobe', *Journal of Integrative Neuroscience*, 2, 149–158.

69 Snyder, A.W. and Thomas, M. (1997), 'Autistic Artists Give Clues to Cognition', *Perception*, 26, 93–96.

70 Stein, G. (1938), *Picasso*. London: Batsford.

71 O'Brian, *Picasso*.

72 O'Brian, *Picasso*.

73 O'Brian, *Picasso*.

74 Cermak, L. and Craik, F. (1979), *Levels of Processing in Human Memory*. Hillsdale, NJ: Erlbaum.

75 Craik, F. and Lockhart, R. (1972), 'Levels of Processing: A Framework for Memory Research', *Journal of Verbal Learning and Verbal Behavior*, 11, 671–684.

76 Maguire, E.A., Valentine, E.R., Wilding, J.M. and Kapur, N. (2003), 'Routes to Remembering: The Brains Behind Superior Memory', *Nature Neuroscience*, 6, 90–95.

77 Maguire, E.A. et al. (2000), 'Navigation-related Structural Changes in the Hippocampi of Taxi Drivers', *Proceedings of the National Academy of Science, USA*, 97, 4398–4403.

78 Maguire, E.A. et al., 'Routes to Remembering'.

79 Bor, D., Billington, J. and Baron-Cohen, S. (2007), 'Savant Memory for Digits in a Case of Synaesthesia and Asperger Syndrome is Related to Hyperactivity in the Lateral Prefrontal Cortex', *Neurocase*, 13, 311–319.

80 Bor, Billington and Baron-Cohen, 'Savant Memory'.

81 Baron-Cohen, S., Burt, L., Smith-Laittan, F., Harrison, J. and Bolton, P. (1996), 'Synaesthesia: Prevalence and Familiality', *Perception*, 25, 1073–1079.

82 Luria, A.R. (1966), *The Mind of a Mnemonist*, Cambridge, MA: Harvard University Press.

83 Bor, Billington and Baron-Cohen, 'Savant Memory'.

84 Gilot, F. and Lake, C. (1964), *Life with Picasso*. New York: McGraw-Hill.

85 O'Brian, *Picasso*.

86 Stein, *Picasso*.

87 O'Brian, *Picasso*.

88 Rosenblatt, and Winner, 'Is Superior Visual Memory a Component of Superior Drawing Ability?'

89 Solso, R.L. (2001), 'Brain Activities in an Expert Versus a Novice Artist: An fMRI Study', *Leonardo*, 34, 31–34.

90 Temple, C.M. (1992), 'Developmental Memory Impairment: Faces and Patterns', in R. Campbell (ed.), *Mental Lives: Case Studies in Cognition*. Oxford, UK and Cambridge, MA: Blackwell.

91 Tombaugh, T.N., Kosak, J. and Rees, L. (1999), 'Normative Data Stratified by Measure of Verbal Fluency: FAS and Animal Naming', *Archives of Clinical Neuropsychology*, 14, 167–177.

92 O'Brian, *Picasso*.

93 Gilbert, S.J., Meuwese, J.D.I., Towgood, K.J., Frith, C.D. and Burgess, P. (2009), 'Abnormal Functional Specialization within Medial Prefrontal Cortex in High-functioning Autism: A Multi-voxel Similarity Analysis', *Brain*, 132, 869–878.

94 O'Brian, *Picasso*.

95 O'Brian, *Picasso*.

Chapter 3

96 Richardson, J. (1991), *A Life of Picasso*, Vol. 1. London: Pimlico.

97 O'Brian, P. (1976), *Picasso: A Biography*. London: William Collins Sons and Co. Ltd.

98 O'Brian, *Picasso*.

99 O'Brian, *Picasso*.

100 Stein, G. (1938), *Picasso*. Batsford: London.

101 Richardson, *A Life of Picasso*, Vol. 1.

102 Richardson, *A Life of Picasso*, Vol. 1.

103 Marr, D. and Nishihara, H.K. (1978), 'Representation and Recognition of the Spatial Organization of Three-dimensional Shapes', *Proceedings of the Royal Society of London B*, 200, 269–294.

104 Marr and Nishihara, 'Representation and Recognition'.

105 Hubel, D.H. and Wiesel, T.N. (1968), 'Receptive Fields and Functional Architecture of Monkey Striate Cortex', *Journal of Physiology* (London), 215–243.

106 Marr and Nishihara, 'Representation and Recognition'.

107 Ruskin, J. (1857), *The Elements of Drawing*. London: George Allen.

108 O'Brian, *Picasso*.

109 Richardson, J. (1996), *A Life of Picasso*, Vol. 2. London: Pimlico.

110 *Intransigeant* 15 June 1932, reprinted in *Picasso on Art* (1972) by Ashton, D.

111 O'Brian, *Picasso*.

112 From interview with Christian Zervos in: 'Conversation avec Picasso,' in *Cahiers d'Art*, Vol X, 7-10, (1935), p. 173-178. Translated in: Alfred H. Barr, Jr. *Picasso: Fifty Years of His Art*. 1946, and republished in: Herschel Browning, Chipp (1968), *Theories of Modern Art: A Source Book by Artists and Critics*. (1968), p. 266-273 ; Also quoted in: Richard Friedenthal, (translation Daphne Woodward) *Letters of the Great Artists – from Blake to Pollock* , London, Thames and Hudson.

113 O'Brian, *Picasso*.

114 Golding, J. (1959) *Cubism : A History and an Analysis 1907-1914*. London: William Collins.

115 O'Brian, *Picasso*.

116 'Picasso Speaks' in *The Arts*, New York, May 1923, 315-26; Reprinted in Barr Alfred: *Picasso* (1946). New York 270-1.

117 Richardson, *A Life of Picasso*, Vol. 2.

118 Richardson, *A Life of Picasso*, Vol. 2.

119 O'Brian, *Picasso*.

120 Silvia, P.J. and Barona, C.M. (2009), 'Do People Prefer Curved Objects? Angularity, Expertise and Aesthetic Preference', *Empirical Studies in the Arts*, 27, 25–42.

121 Richardson, *A Life of Picasso*, Vol. 1.

122 Kozbelt, A., Seidel, A., El Bassiouny, A., Mark, Y. and Owen, D.R. (2010), 'Visual Selection Contributes to Artists' Advantage in Realistic Drawing', *Psychology of Aesthetics, Creativity, and the Arts*, 4, 93–102.

123 Gilot, F. and Lake, C. (1964), *Life with Picasso*. New York: McGraw-Hill.

124 Widmaier Picasso, O. (2004), *Picasso: The Real Family Story*. London: Prestel.

125 Gilot and Lake, *Life with Picasso*.

126 Temple, C.M. (1990), 'Academic Discipline, Handedness and Immune Disorders', *Neuropsychologia*, 28, 303–308.

127 Temple, 'Academic Discipline'.

128 Temple, 'Academic Discipline'.

129 Richardson, *A Life of Picasso*, Vol. 1.

130 O'Brian, *Picasso*.

131 Richardson, *A Life of Picasso*, Vol. 1.

132 Richardson, *A Life of Picasso*, Vol. 1.

133 Richardson, *A Life of Picasso*, Vol. 1.

134 Hubel and Wiesel (1968), 'Receptive Fields'.

135 Richardson, *A Life of Picasso*, Vol. 1.

Chapter 4

136 Reprinted in Ashton, D. (1972), *Picasso on Art*.

137 Ericsson, K.A., Krampe, R.T. and Tesch-Romer, C. (1993), 'The Role of Deliberate Practice in the Acquisition of Expert Performance', *Psychological Review*, 100, 363–406.

138 Shenk, D. (2010), *The Genius in All of Us: Why Everything You've Been Told about Genetics, Talent and IQ is Wrong*. New York: Doubleday.

139 Protzko, J. and Kaufman, S.B. (2010), review of Shenk, *The Genius in All of Us: Why Everything You've Been Told about Genetics, Talent and IQ is Wrong, Psychology of Aesthetics, Creativity, and the Arts*, 4, 255–258.

140 Cox, N. (2010), *The Picasso Book*. London: Tate Publishing.

141 O'Brian, P. (1976), *Picasso: A Biography*. London: William Collins Sons and Co.

142 Richardson, J. (1996), *A Life of Picasso*, Vol. 2. London: Pimlico.

143 Cox, *The Picasso Book*.

144 O'Brian, *Picasso*.

145 Richardson, *A Life of Picasso*, Vol. 2.

146 Brassai, G. (1964), *Conversations avec Picasso*. Paris: Gallimard.

147 Gavanon, A.-F. (2004), Interview of Hidalgo Arnera. Appendix 1 of MA thesis. The Courtauld Institute, London.

148 Gavanon, Interview.

149 Gavanon, Interview.

150 Gavanon, Interview.

151 Petrides, M. and Milner, B. (1982), 'Deficits on Subject-ordered Tasks after Frontal- and Temporal-lobe Lesions in Man', *Neuropsychologia*, 20, 249–262.

152 Dagher, A., Owen, A.M., Boecker, H. and Brooks, D.J. (1999), 'Mapping the Network for Planning: A Correlational PET Activation Study with the Tower of London Task', *Brain*, 122, 1973–1987.

153 O'Brian, *Picasso*.

154 O'Brian, *Picasso*.

Chapter 5

155 Olivier, F. (2001), *Loving Picasso: The Private Journal of Fernande Olivier*. New York: Harry N. Abrams.

156 Richardson, J. (2009), *A Life of Picasso*, Vol. 1. London: Pimlico.

157 Richardson, *A Life of Picasso*, Vol. 1.

158 Morris, F. (ed.) (2012), *Yayoi Kusama*. London: Tate Publishing.

159 Widmaier Picasso, O. (2004), *Picasso: The Real Family Story*. London: Prestel.

160 Schlesinger, A. (2009), 'Creative Mythconceptions: A Closer Look at the Evidence for the "Mad Genius" Hypothesis', *Psychology of Aesthetics, Creativity, and the Arts*, 3, 62–72.

161 O'Brian, P. (1976), *Picasso: A Biography*. London: William Collins Sons and Co.

162 Lombroso, C. (1895), *The Man of Genius*. London: Walter Scott.

163 Lombroso, C. (1891), *The Man of Genius*.

164 Monaco, F. and Mula, M. (2011), 'Cesare Lombroso and Epilepsy 100 Years Later: An Unabridged Report of his Original Transactions', *Epilepsia*, 52, 679–688.

165 Lombroso, C. (1889), *L'uomo delinquente in rapporto all'antropologica, alla guirisprudenza ed alle discipline carcerarie*. Vol. II: *Delinquente epilettico, d'impeto, pazzo e criminaloide*. Torino, Italy: Bocca.

166 Monaco and Mula, 'Cesare Lombroso and Epilepsy'.

167 Monaco and Mula, 'Cesare Lombroso and Epilepsy'.

168 Lombroso, *L'uomo delinquent*.

169 Lombroso, C. (1894), *Genio e Follia*. Torino, Italy: Bocca.

170 O'Brian, *Picasso*.

171 Olivier, *Loving Picasso*.

172 Widmaier Picasso, *Picasso*.

173 O'Brian, *Picasso*.

174 O'Brian, *Picasso*.

175 O'Brian, *Picasso*.

176 O'Brian, *Picasso*.

177 O'Brian, *Picasso*.

178 Ellis, H. (1904), *A Study of British Genius*. London: Hurst & Blackett.

179 Schlesinger, 'Creative Mythconceptions'.

180 Ellis, *A Study of British Genius*.

181 Lange-Eichbaum, W. and Paul, M.E. (1931), *The Problem of Genius* (trans. Eden and Cedar Paul). London: Kegan Paul & Co.

182 Andreasen, N.C. (1987), 'Creativity and Mental Illness: Prevalence Rates in Writers and Their First-degree Relatives', *American Journal of Psychiatry*, 144, 1288–1292.

183 Schlesinger, 'Creative Mythconceptions'.

184 Jamison, K.R. (1989), 'Mood Disorders and Patterns of Creativity in British Writers and Artists', *Psychiatry*, 52, 125–134.

185 Schlesinger, 'Creative Mythconceptions'.

186 Post, F. (1996), 'Verbal Creativity, Depression and Alcoholism: An Investigation of One Hundred American and British Writers', *British Journal of Psychiatry*, 168, 545–555.

187 Rothenberg, A. (1990), *Creativity and Madness: New Findings and Old Stereotypes*. Baltimore: John Hopkins University Press.

188 Santosa, C.M., Strong, C.M., Nowakowska, C., Wang, P.W., Rennicke, C.M. and Ketter, T.A. (2007), 'Enhanced Creativity in Bipolar Disorder Patients: A Controlled Study', *Journal of Affective Disorders*, 100, 31–39.

189 Heston, L.L. (1966), 'Psychiatric Disorders in Foster Home Reared Children of Schizophrenic Mothers', *British Journal of Psychiatry*, 112, 819–825.

190 Karlsson, J.L. (1968), 'Genealogic Studies of Schizophrenia', in D. Rosenthal and S.S. Kety (eds), *The Transmission of Schizophrenia*. Oxford: Pergamon Press.

191 McNeil, T.F. (1971), 'Prebirth and Postbirth Influence on the Relationship between Creative Ability and Recorded Mental Illness', *Journal of Personality*, 39, 391–406.

192 Simeonova, D.I., Chang, K.D., Strong, C. and Ketter, T.A. (2005), 'Creativity in Familial Bipolar Disorder', *Journal of Psychiatry Research*, 39, 623–631.

193 Kyaga, S., Lichtenstein, P., Boman, M., Hultman, C., Langstrom, N. and Landen, M. (2011), 'Creativity and Mental Disorder: Family Study of 300,000 People with Severe Mental Disorder', *The British Journal of Psychiatry*, published online in advance of print.

194 Silvia, P.J. and Kimbrel, N.A. (2010), 'A Dimensional Analysis of Creativity and Mental Illness: Do Anxiety and Depression Symptoms Predict Creative Cognition, Creative Accomplishments and Creative Self-concepts', *Psychology of Creativity, Aesthetics and the Arts*, 4, 2–10.

195 Rybakowski, J.K. and Klonowska, P. (2011), 'Bipolar Mood Disorder, Creativity and Schizotypy: An Experimental Study', *Psychopathology*, 44, 296–302.

196 Plath, S. (published initially under the name Victoria Lucas) (1963), *The Bell Jar*. London: Heinemann.

197 Ludwig, A. (1995), *The Price of Greatness*.

198 Plath, S. (1998), *The Journals of Sylvia Plath*, ed. Ted Hughes. New York: Anchor Books, Random House.

199 Carson, S.H., Peterson, J.B. and Higgins, D.M. (2003), 'Decreased Latent Inhibition is Associated with Increased Creative Achievement in High-functioning Individuals', *Journal of Personality and Social Psychology*, 85, 499–506.

200 Salvador Dalí, as quoted in: La Cossitt, Henry (1956, July), Dalí is a dilly. *The American Magazine*, 162(1), 28–9, 107–9.

201 Akbari Chermahini, S. and Hommel, B. (2010), 'The (B)link between Creativity and Dopamine: Spontaneous Eye Blink Rates Predict and Dissociate Divergent and Convergent Thinking', *Cognition*, 115, 458–465.

202 Reuter, M., Roth, S., Holve, K. and Hennig, J. (2006), 'Identification of First Candidate Genes for Creativity: A Pilot Study', *Brain Research*, 1069, 190–197.

203 Goff, K. and Torrance, E.P. (2002), *Abbreviated Torrance Test for Adults Manual*. Bensenville, IL: Scholastic Testing Service.

204 Kéri, S. (2009), 'Genes for Psychosis and Creativity', *Psychological Science*, 20, 1070–1073.

205 O'Brian, *Picasso*.

206 Penrose, R. (1958), *Picasso: His Life and Work*. London: Victor Gollancz.

207 Richardson, *A Life of Picasso*, Vol. 1.

208 O'Brian, *Picasso*.

209 O'Brian, *Picasso*.

210 Richardson, *A Life of Picasso*, Vol. 1.

211 O'Brian, *Picasso*.

212 Penrose, *Picasso: His Life and Work*.

213 O'Brian, *Picasso*.

214 O'Brian, *Picasso*.

215 Stein, G. (1938), *Picasso*. London: Batsford.

216 Richardson, *A Life of Picasso*, Vol. 1.

217 O'Brian, *Picasso*.

218 O'Brian, *Picasso*.

219 From an interview with Pol Gaillard published in *New Masses* (New York), October 1944

220 Olivier, *Loving Picasso*.

221 O'Brian, *Picasso*.

222 O'Brian, *Picasso*.

223 O'Brian, *Picasso*.

224 O'Brian, *Picasso*.

225 Richardson, *A Life of Picasso*, Vol. 1.

226 O'Brian, *Picasso*.

227 O'Brian, *Picasso*.

228 Widmaier Picasso, *Picasso*.

229 Widmaier Picasso, *Picasso*.

230 Widmaier Picasso, *Picasso*.

231 O'Brian, *Picasso*.

232 Sartori, G. (1987), 'Leonardo da Vinci, omo sanza lettera: A Case of Surface Dysgraphia', *Cognitive Neuropsychology*, 4, 1–10.

233 Sartori, 'Leonardo da Vinci'.

234 McManus, I.A., Chamberlain, R., Loo, P.-W., Rankin, Q., Riley, H. and Brunswick, N. (2010), 'Art Students Who Cannot Draw: Exploring the Relations between Drawing Ability, Visual Memory, Accuracy of Copying and Dyslexia', *Psychology of Aesthetics, Creativity, and the Arts*, 4, 18–30.

235 Craggs, J.G., Sanchez, J., Kibby, M.Y., Gilger, J.W. and Hynd, G.W. (2008), 'Brain Morphology and Neuropsychological Profiles in a Family Displaying Dyslexia and Superior Nonverbal Intelligence', *Cortex*, 42, 1107–1118.

236 Von Karolyi, C. and Winner, E. (2004), 'Dyslexia and Visual Spatial Talents: Are They Connected?' in T.M. Newman and R.J. Sternberg (eds), *Students with Both Gifts and Learning Disabilities*. New York: Guilford Press, 95–118.

237 West, T. (1997), *In the Mind's Eye: Visual Thinkers, Gifted People with Dyslexia and Other Learning Difficulties, Computer Images and the Irony of Creativity*. New York: Prometheus Books.

238 Geschwind, N. and Galaburda, A.M. (1987), *Cerebral Lateralisation*. Cambridge, MA: MIT Press.

239 Temple, C.M. (1990), 'Academic Discipline, Handedness and Immune Disorders', *Neuropsychologia*, 28, 303–308.

Chapter 6

240 Von Stumm, S., Chung, A. and Furnham, A. (2011), 'Creative Ability, Creative Ideation and Latent Classes of Creative Achievement: What is the Role of Personality?' *Psychology of Aesthetics, Creativity, and the Arts*, 5, 107–114.

241 Eckland, M. and Chapman, L.J. (1986), 'Development and Validation of a Scale for Hypomanic Personality', *Journal of Abnormal Psychology*, 95, 214–222.18.

242 Mason, O., Claridge, G. and Jackson, M. (1995), 'New Scales for the Assessment of Schizotypy', *Personality and Individual Differences*, 18, 7–13.

243 Richardson, J. (2009), *A Life of Picasso*, Vol. 1. London: Pimlico.

244 Nettle, D. and Clegg, H. (2006), 'Schizotypy, Creativity and Mating Success in Humans', *Proceedings of the Royal Society B: Biological Science*, 273, 611–615.

245 Karlson, J.L. (1970), 'Genetic Association of Giftedness and Creativity with Schizophrenia', *Hereditas*, 66, 177–181.

246 Kyaga, S., Lichtenstein, P., Boman, M., Hultman, C., Langstrom, N. and Landen, M. (2011), 'Creativity and Mental Disorder: Family Study of 300,000 People with Severe Mental Disorder', *The British Journal of Psychiatry*, 199, 373–379.

247 Nettle and Clegg, 'Schizotypy'.

248 Miller, G.F. (2000), *The Mating Mind: How Mate Choice Shaped the Evolution of Human Nature*. Doubleday: New York.

249 Miller, G.F. (2001), 'Aesthetic Fitness: How Sexual Selection Shaped Artistic Virtuosity as a Fitness Indicator and Aesthetic Preference as Mate Choice Selection Criteria', *Bulletin of Psychology and the Arts*, 2, 20–25.

250 Feist, G.J. (1998), 'A Meta-Analysis of Personality in Scientific and Artistic Creativity', *Personality and Social Psychology Review*, 2, 290–309.27.

251 O'Brian, P. (1976), *Picasso: A Biography*. London: William Collins Sons and Co.

252 O'Brian, *Picasso*.

253 O'Brian, *Picasso*.

254 O'Brian, *Picasso*.

255 Gilot, F. and Lake, C. (1964), *Life with Picasso*. New York: McGraw-Hill.

256 Gilot, F.

257 Miller, B.L., Cummings, J., Mishkin, F., Boone, K., Prince, F., Ponton, M. and Cotman, C. (1998), 'Emergence of Artistic Talent in Frontotemporal Dementia', *Neurology*, 51, 978–982.

258 Miller, B.L., Boone, K., Cummings, J.L., Read, S.L. and Mishkin, F. (2000), 'Functional Correlates of Musical and Visual Ability in Frontotemporal Dementia', *British Journal of Psychiatry*, 176, 458–463.

259 Lythgoe, M.F.X., Pollak, T.A., Kalmus, B.A., De Haan, M. and Khean Chong, W. (2005), 'Obsessive, Prolific Artistic Output Following Subarachnoid Haemorrhage', *Neurology*, 64, 397–398.

260 Geroldi, C., Metitieri, T., Binetti, G., Zanetti, O., Trabucchi, M. and Frisoni, G.B. (2000), 'Pop Music and Frontotemporal Dementia', *Neurology*, 55, 1935–1936.

261 Boeve, B.F. and Geda, Y.S. (2001), 'Polka Music and Semantic Dementia', *Neurology*, 57, 1485.

262 Rohrer, J.D., Smith, S.J. and Warren, J.D. (2006), 'Craving for Music after Treatment for Partial Epilepsy', *Epilepsia*, 47, 939–940.

263 From *Der Monat* (Berlin, December 1949), reprinted in Ashton, Dore, *Picasso on Art* (1972).

264 From interview with Christian Zervos in 'Conversation avec Picasso,' in *Cahiers d'Art*, (1935) Vol X, 7-10, 173-178. Translated in: Barr, Jr, Alfred H. *Picasso: Fifty Years of His Art*, (1946), and republished in: Herschel Browning Chipp (1968) *Theories of Modern Art: A Source Book by Artists and Critics*. (1968), p. 266-273. Also quoted in: Friedenthal, Richard (translation Daphne Woodward) (1963), *Letters of the Great Artists – from Blake to Pollock*, Thames and Hudson, London.

265 Ranpura, A. and Lythgoe, M.F. (2010), 'The Paradoxes of Creativity', in Perry, E.K., Collerton, D., Le Beau, F.E.N. and Ashton, H. (eds), *New Horizons in the Neuroscience of Consciousness*. Amsterdam: John Benjamins.

266 Miller, et al., 'Emergence of Artistic Talent'.

267 Gilot and Lake, *Life with Picasso*.

268 Richardson, *A Life of Picasso*, Vol. 1.

269 Richardson, *A Life of Picasso*, Vol. 1.

270 O'Brian, *Picasso*.

271 O'Brian, *Picasso*.

272 Bartels, A. and Semir, Z. (2000), 'The Neural Basis of Romantic Love', *Neuroreport*, 11, 3829–3834.

273 Widmaier Picasso, O., *Picasso*.

274 Widmaier Picasso, O. (2002), *Picasso Portraits de famille*. Éditions Paris Ramsay, 29

275 Reprinted in Widmaier Picasso, *Picasso*.

276 Widmaier Picasso, *Picasso*.

277 Singer, J.L. (2009), 'Researching Imaginative Play and Adult Consciousness: Implications for Daily and Literary Creativity', *Psychology of Aesthetics, Creativity, and the Arts*, 3, 190–199.

278 Freud, S. (1962, original published in 1908), 'Creative Writers and Daydreaming', in Strachey, J. (ed. and trans.), *The Complete Psychological Works of Sigmund Freud* Vol. 9, 141–154. London: Hogarth Press.

279 Giambra, L.M. (1995), 'A Laboratory Method for Investigating Influences on Switching Attention to Task-Unrelated Imagery and Thought', *Consciousness and Cognition*, 4, 1–21.

280 Botella, M., Zanasni, F. and Lubart, T. (2011), 'Alexithymia and Affect Intensity of Art Students', *Psychology of Aesthetics, Creativity, and the Arts*, 5, 251–257.

281 Buckner, et al., R., Andrews-Hanna, J. and Schacter, D. (2008), 'The Brain's Default Network: Anatomy, Function and Relevance to Disease', *Annals of the New York Academy of Sciences*, 1124, 1–38.

282 Buckner, et al., 'The Brain's Default Network'.

283 Kounios, J., Fleck, J.L., Green, D.L., Payne, L., Stevenson, J.L., Bowden., et al. (2008), 'The Origins of Insight in Resting-state Brain Activity', *Neuropsychologia*, 46, 281–291.

284 Buckner, et al., 'The Brain's Default Network'.

Chapter 7

285 Damasio, A.R. and Anderson, S.W. (2003), 'The Frontal Lobes', in Heilman, K.M. and Valenstein, E. (eds), *Clinical Neuropsychology*. New York: Oxford University Press.

286 Solso, R.L. (2001), 'Brain Activities in an Expert Versus a Novice Artist: An fMRI Study', *Leonardo*, 34, 31–34.

287 Damasio and Anderson, 'The Frontal Lobes'.

288 Damasio and Anderson, 'The Frontal Lobes'.

289 Newcombe, F. (1969), *Missile Wounds of the Brain: A Study of Psychological Deficits*. Oxford: Oxford University Press.

290 Fink, A., Grabner, R.H., Benedek, M., Reishofer, G., Hauswirth, V., Fally, M. et al. (2009), 'The Creative Brain: Investigation of Brain Activity during Creative Problem Solving by Means of EEG and fMRI', *Human Brain Mapping*, 30, 734–748.

291 Drago, V., Foster, P.S., Skidmore, F.M. and Heilman, K.M. (2009), 'Creativity in Parkinson's Disease as a Function of Right Versus Left Hemibody Onset', *Journal of Neurological Sciences*, 276, 179–183.

292 Drago et al., 'Creativity in Parkinson's Disease'.

293 O'Brian, P. (1976), *Picasso: A Biography*. London: William Collins Sons and Co.

294 O'Brian, *Picasso*.

295 Rankin, K.P., Liu, A.A., Howard, S., Slama, H., Hou, C.E, Shuster, K. and Miller, B.L. (2007), 'A Case-controlled Study of Altered Visual Art Production in Alzheimer's and FTLD', *Cognitive Behavioural Neurology*, 20, 48–61.

296 Lakke, J.P.W.F. (1999), 'Art and Parkinson's Disease', *Advances in Neurology*, 80, 471–479.

297 Budrys, V., Skellerud, K., Petroska, D., Lengvenience, J. and Kaubrys, G. (2007), 'Dementia and Art: Neuronal Intermediate Filament Inclusion Disease and Dissolution of Artistic Creativity', *European Neurology*, 57, 137–144.

298 Kennedy, F. and Wolff, A. (1936), 'The Relationship of Intellect to Speech Defect in Aphasic Patients', *Journal of Nervous and Mental Disease*, 84, 124–145, 293–311.

299 Aldous, C.R. (2007), 'Creativity, Problem Solving and Innovative Science: Insights from History, Cognitive Psychology and Neuroscience', *International Education Journal*, 8, 176–186.

300 Miller, A.I. (1992), 'Scientific Creativity: A Comparative Study of Henri Poincare and Albert Einstein', *Creativity Research Journal*, 5, 385–418.

301 Damasio, A.R. (1994), *Descartes' Error: Emotion, Reason and the Human Brain*. London: Papermac.

302 Damasio, A.R. (1994), *Descartes' Error: Emotion, Reason and the Human Brain*. London: Papermac.

303 Heilman, K.M., Nadeau, S.E. and Beversdorf, D. (2003), 'Creative Innovation: Possible Brain Mechanism', *Neurocase*, 9, 369–379.

Chapter 8

304 Pablo Picasso to Geneviève Laporte, quoted in John Richardson (1991), *A Life of Picasso*, Volume I: 1881-1906. London: Pimlico. 317

305 O'Brian, P. (1976), *Picasso: A Biography*. London: William Collins Sons and Co.

306 Cox, N. and Povey, D. (1995), *A Picasso Bestiary*. London: Academy Editions.

307 Widmaier Picasso, O. (2004), *Picasso: The Real Family Story*. London: Prestel.

308 Olivier, F. (2001), *Loving Picasso: The Private Journal of Fernande Olivier*. New York: Harry N. Abrams.

309 Richardson, J. (1996), *A Life of Picasso*, Vol. 2. London: Pimlico.

310 Kéri, S. (2011), 'Solitary Minds and Social Capital: Latent Inhibition, General Intellectual Functions and Social Network Size Predict Creative Achievements', *Psychology of Aesthetics, Creativity, and the* Arts, 5, 215–221.

311 'The Paradoxes of creativity', in Perry, E.K., Collerton, D., LeBeau F. and Ashton H. (eds), *New Horizons in the Neuroscience of Consciousness*. Amsterdam: John Benjamins.

312 O'Brian, *Picasso*.

313 McCrae, R.R. (2007), 'Aesthetic Chills as a Universal Marker of Openness to Experience', *Motivation and Emotion*, 31, 5–11.

314 Silvia, P.J. and Nusbaum, E.C. (2011), 'On Personality and Piloerection: Individual Differences in Aesthetic Chills and Other Unusual Aesthetic Experiences', *Psychology of Aesthetics, Creativity, and the Arts*, 5, 208–214.

315 Mastandrea, S.M., Bartoli, G. and Bove, G. (2009), 'Preferences for Ancient and Modern Art Museums: Visitor Experiences and Personality Characteristics', *Psychology of Aesthetics, Creativity, and the Arts*, 3, 164–173.

316 Mastandrea, Bartoli and Bove (2009), 'Preferences for Ancient and Modern Art Museums'.

317 Leder, H., Carbon, C.-C. and Ripas, W.-L. (2006), 'Entitling Art: Influence of Title Information on Understanding and Appreciation of Paintings', *Acta Psychologica*, 121, 176–198.

318 Leder, Carbon and Ripas, 'Entitling Art'.

319 Kuchinke, L., Trapp, S. and Jacobs, A.M. (2009), 'Pupillary Responses in Art Appreciation: Effect of Aesthetic Emotions', *Psychology of Aesthetics, Creativity, and the Arts*, 3, 156–163.

320 Winkielman, P. and Cacioppo, J.T. (2001), 'Mind at Ease Puts a Smile on the Face: Psychophysiological Evidence that Processing Facilitation Elicits Positive Affect', *Journal of Personality and Social Psychology*, 81, 989–1000.

321 Cacchione, T., Mohring, W. and Bertin, E. (2011), 'What is it about Picasso? Infants' Categorical and Discriminatory Abilities in the Visual Arts', *Psychology of Aesthetics, Creativity, and the Arts*, 5, 370–378.

322 Cacchione, Mohring and Bertin, 'What is it about Picasso?'

323 Cacchione, Mohring and Bertin, 'What is it about Picasso?'

324 Mastandrea, S., Bartoli, G. and Carrus, G. (2011), 'The Automatic Aesthetic Evaluation of Different Art and Architectural Styles', *Psychology of Aesthetics, Creativity and the Arts*, 5, 126–134.

325 Zajonc, R.B. (1968), 'Attitudinal Effects of Mere Exposure', *Journal of Personality and Social Psychology*, 9(2), 1–27.

326 Cutting, J.E. (2003), 'Gustave Caillebotte, French Impressionism, and Mere Exposure', *Psychonomic Bulletin and Review*, 10, 319–343.

327 Leder, H., Belke, B., Oeberst, A. and Augustin, D. (2004), 'A Model of Aesthetic Appreciation and Aesthetic Judgements', *British Journal of Psychology*, 95, 489–508.

328 Ishuzu, Y. and Zeki, S. (2013), 'The Brain's Specialized Systems for Aesthetic and Perceptual Judgment', *European Journal of Neuroscience*, 37, 1413–1420.

329 Ishuzu and Zeki, 'The Brain's Specialized Systems'.

330 Richardson, *A Life of Picasso*, Vol. 2.

331 Candela, I. (2013), 'Picasso in Two Acts', in *Roy Lichtenstein: A Retrospective*. London: Tate Publishing.

332 Candela, 'Picasso in Two Acts'.

333 Widmaier Picasso, *Picasso*.

334 Widmaier Picasso, *Picasso*.

Picture Credits

Section 1

Benefits Supervisor Sleeping, 1995. Christie's Images Limited. Oil on canvas, 151.3 x 219 cm © 2016. Christie's Images, London / Scala, Florence © (Succession Picasso / DACS, London 2016).

Baboon and Young, 1952 (bronze), Picasso, Pablo (1881–1973) Musée Picasso, Paris, France / Bridgeman Images © (Succession Picasso / DACS, London 2016).

Plant with Little Bulls, 1959–60. New York, Metropolitan Museum of Art. Linoleum cut. block: 26 x 21¼ in. (66 x 54 cm); sheet: 29¾ x 24½ in. (75.6 x 62.2 cm). Printer: Printed by, Hidalgo Arnera; Publisher: Published by, Galerie Louise Leiris, Paris. The Mr. and Mrs. Charles Kramer Collection, Gift of Mr. and Mrs. Charles Kramer, 1979 (1979.620.43). © 2016. Image copyright The Metropolitan Museum of Art / Art Resource / Scala, Florence © (Succession Picasso / DACS, London 2016).

Las Meninas, No.31, 1957 (oil on canvas), Picasso, Pablo (1881–1973) / Museu Picasso, Barcelona, Spain / Bridgeman Images © (Succession Picasso / DACS, London 2016).

Cleansed, 1994 (oil on canvas), Howson, Peter (b.1958) / Private Collection / © Angela Flowers Gallery, London, UK / Bridgeman Images © (Succession Picasso / DACS, London 2016).

Les Demoiselles d'Avignon, 1907 (oil on canvas), Picasso, Pablo (1881–1973) / Museum of Modern Art, New York, USA / Bridgeman Images © (Succession Picasso / DACS, London 2016).

Girl with a Mandolin (Fanny Tellier), 1910 (oil on canvas), Picasso, Pablo (1881–1973) / Museum of Modern Art, New York, USA / Photo © Boltin Picture Library / Bridgeman Images © (Succession Picasso / DACS, London 2016).

Homage to Picasso, January–February 1912 (oil on canvas), Gris, Juan (1887–1927) / The Art Institute of Chicago, IL, USA / Gift of Leigh B. Block / Bridgeman Images © (Succession Picasso / DACS, London 2016).

Head of Marie-Thérèse, 1932–34 (oil on canvas), Picasso, Pablo (1881–1973) / Private Collection / Photo © Christie's Images / Bridgeman Images © (Succession Picasso / DACS, London 2016).

Seated Portrait of Marie-Thérèse Walter (1907–77) 11 March 1937 (oil and pastel canvas), Picasso, Pablo (1881–1973) / Musée Picasso, Paris, France / Bridgeman Images © (Succession Picasso / DACS, London 2016).

Photograph of Anish Kapoor's *Cloud Gate*, Getty Images © Anish Kapoor. All Rights Reserved, DACS 2016

Picture Credits

Photograph of Anish Kapoor's *Orbit*, Shutterstock © Anish Kapoor. All Rights Reserved, DACS 2016

Blind Minotaur Led by a Little Girl in the Night, 1934 (etching and aquatint on Montval paper), Picasso, Pablo (1881–1973) / Private Collection / Photo © Christie's Images / Bridgeman Images. Images © (Succession Picasso / DACS, London 2016).

Photograph of Esref Armagan, Esref Armagan.

Simon Bacon's works, Simon Bacon.

William Notman's compostite photograph, McCord Museum.

Bacchanale, 27 November 1959 (linocut), Picasso, Pablo (1881–1973) / Museum of Fine Arts, Houston, Texas, USA / gift of Mr. and Mrs. Joseph R. Lasser in honor of Dr. Michael DeBakey. / Bridgeman Images © (Succession Picasso / DACS, London 2016).

Section 2

The Four corners of the world, from *War and Peace*, 1952–54 (fresco on panel), Picasso, Pablo (1881–1973) / Musée National Picasso *La Guerre et la Paix*, Vallauris, France / Bridgeman Images © (Succession Picasso/DACS, London 2016).

Boy with a Pipe, 1905 (oil on canvas), Picasso, Pablo (1881–1973) / Private Collection / Bridgeman Images © (Succession Picasso/DACS, London 2016).

Woman with a Fan, 1905 (oil on canvas), Picasso, Pablo (1881–1973) / National Gallery of Art, Washington DC, USA / Bridgeman Images © (Succession Picasso/DACS, London 2016).

Science and Charity, 1897 (oil on canvas), Picasso, Pablo (1881–1973) / Museo Picasso, Barcelona, Spain / Index / Bridgeman Images © (Succession Picasso/DACS, London 2016).

Maternity, 1921 (oil on canvas), Picasso, Pablo (1881–1973) / Private Collection / Bridgeman Images © (Succession Picasso/DACS, London 2016).

Faun Revealing a Sleeping Woman (Jupiter and Antiope, after Rembrandt) 1936; Pablo Picasso 1881–1973 © Tate Photography © (Succession Picasso/DACS, London 2016).

The Massacre and the Problems of Depiction 2003 watercolor on 7 sheets of paper (18" x 24" each) 56½ x 72¼ cm overall © David Hockney. Photo Credit: Richard Schmidt Collection The David Hockney Foundation.

Untitled (Portrait of a Man), 1943 by Roy Lichtenstein © Estate of Roy Lichtenstein/DACS 2016.

Page 36 © Lee Miller Archives, England 2015. All rights reserved. www.leemiller.co.uk/

Page 37 © Lee Miller Archives, England 2015. All rights reserved. www.leemiller.co.uk/

Page 38 © Esmeralda the goat cast 1952 Corbis/Getty Images © (Succession Picasso/DACS, London 2016).

Page 69 left, photograph of Gertrude Stein © American Stock Archive/Getty Images.

Page 69 right © *Portrait of Gertrude Stein*, 1906 (oil on canvas), Picasso, Pablo (1881–1973) / Metropolitan Museum of Art, New York, USA / Bridgeman Images © (Succession Picasso/DACS, London 2016).

Index

Index

Index